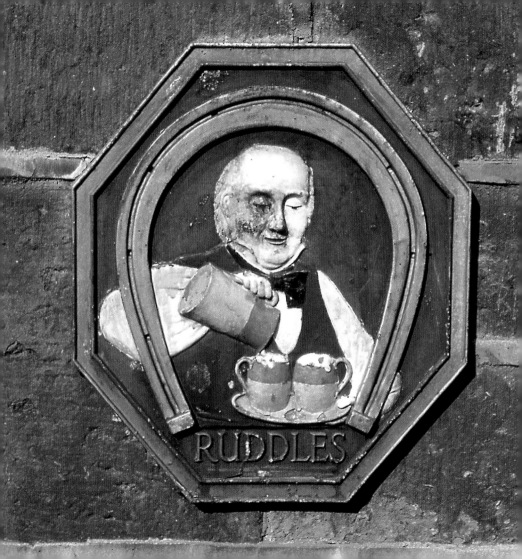

LOCAL HEROES
Pubs and Inns

Peter Ashley

Everyman Pocket Books
In association with English Heritage

Old Neptune, Whitstable, Kent
(p.1) See page 61
(p. 2) Ruddles was once synonymous with
Rutland. Now the only reminders may be
these iron plaques with Rutland's horseshoe
and an innkeeper making cappuccinos.

Local Heroes – Pubs and Inns

**Published by Everyman Publishers Plc
in association with English Heritage**

© 2001 Everyman Publishers Plc
Text and photographs © Peter Ashley

ISBN 1 84159 048 7

Design by Anikst Design
Printed in Singapore

Everyman Publishers Plc
Gloucester Mansions
140a Shaftesbury Avenue
London WC2H 8HD

contents

introduction ...*an effort has been made to season the array of famous and indispensable examples with some personal discoveries that I believe are not generally familiar to the public, and at the same time to represent every degree of English Inn, from the 'Baby Austin' to the 'Rolls Royce,' with some reference to usage and situation...*
 The Old Inns of England, A.E.Richardson

Professor Richardson was a delightful University College eccentric much given to fast driving and wearing 18th-century clothes whilst smoking a clay pipe. The quotation above was written in 1934, but I am indebted for its relevance to the tour that follows. In the same introduction, it becomes clear that the Professor must have been amongst the first to recognise that the English pub was as worthy of study as churches, manor houses or castles. Indeed, over the centuries, the brewing process has been inextricably linked to all three. The close proximity of so many inns to churches is no coincidence. Ale was brewed and stored under the watchful eye of the priest in the church house, and distributed on holy days. This building naturally evolved into so many of the village pubs we see today, some still retaining the name 'Church House Inn'. Inns and public houses are now firmly established as a particularly unique British institution, with fierce loyalties attached to them, and with over two million of us using them every day. What follows cannot possibly do justice to the fact there are as many different pubs as there are people who drink in them, so inevitably the choice becomes somewhat personal, with perhaps a concentration on the varied styles of central and southern England. This isn't a 'good pub guide'; we're not concerned (on the page at least) with guest bitters and salmon fishcakes, and we won't get involved in four-poster beds and ghost stories. It's about good buildings in

their environment, their atmosphere, and why they're where they are. Time has been called many times since Professor Richardson pulled up outside town and country inns in his prewar motor car. Now it's the 21st century, and although we may not have lost the buildings themselves, vast numbers have suffered irrevocably by having the heart of them utterly ruined by contemptuous bad taste and corporate greed. It's this that makes a list of candidates for a book of this size so difficult. There are many public houses, inns and hotels that are architecturally of great interest, which have, for whatever reason, been insensitively altered. So we have tried to include only places where the promise of the exterior is fulfilled, at least in part, on the inside.

Many pubs have been saved from ignominious change as a result of listing by English Heritage. They realise that we live in a new century and don't view listing as a deep-freezing process, taking into consideration, rather, the historical and architectural worth in any alterations. English Heritage can't do this alone, and always hope that interested groups and individuals will bring buildings that may be at risk to their attention.

Pubs also have to face new challenges that may threaten their very existence. At the time of writing, six rural pubs are closing every week, a situation not helped by a government that, whilst rightly protecting farmers during the foot-and-mouth crisis, forgot that the countryside is actually more than ramblers' footpaths across fields. The survivors will adapt as they have done over the centuries, but let's hope this doesn't mean turning every country pub into a chablis and monkfish 'gastropub' intolerant of local drinkers, or filling the towns with faux Dublin bars. Proper pubs are unique, they're personal, and they deserve our care and attention.

in the village
King's Head, Wadenhoe, Northamptonshire
Wadenhoe lies hidden on a bend of the River Nene between Oundle and Thrapston. This is the classic village inn, in a classic English village. Plain but snug, the 17th-century stone-built King's Head sits at the end of a lane that peters out at the river. Inside, the only sounds are murmurs of conversation, the scraping of chairs on quarry tiles and the occasional crash of a wooden 'cheese' as it hits table skittles in the public bar. Outside, roughly cut grass slopes gently down to moorings on the Nene.

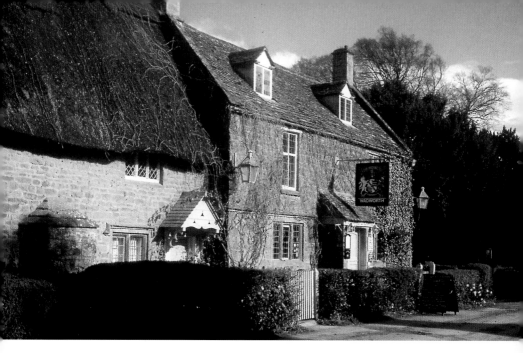

Falkland Arms, Great Tew, Oxfordshire A time capsule in the heart of Oxfordshire. In the 16th century this was The Horse and Groom, renamed when Lord Falkland inherited the manor in the years prior to the Civil War. During the battle of Newbury in 1643, he rode his horse suicidally into a hail of musket fire. The village was landscaped in the early 19th century by John Claudius Loudon; now one can sit in the flagstoned bar by the inglenook and see from the mullioned windows his very atmospheric use of dark evergreens contrasting with the yellowy brown ironstone. Inside, lamps and firelight reflect in the colourful original pub mirrors, extolling the undoubted virtues of Gold Flake and Bass.

‹ **Barley Mow, Kirk Ireton, Derbyshire** An inn that somehow resides in the collective folk memory as the way pubs ought to be. The gaunt outline of blackened stone gables guarded by tall trees belies the cheery interior glimpsed through the mullioned windows. A coal fire is reflected in the wooden panelling and built-in settles, and flickers on the glasses brought from a simple counter to a slate-topped table. This rambling Jacobean house became an inn 200 years ago, and is still a welcome break for walkers in countryside between Ashbourne and Wirksworth.

Wentworth Arms, Elmesthorpe, Leicestershire An architectural rarity; an inn designed by C.F.A. Voysey. Working from the 1890s to the First World War, Voysey was renowned for beautiful white-rendered houses that made superb use of natural materials, with stone mullioned windows and dramatic sloping roofs. This was his first public house commission, from the Earl of Lovelace in 1895. Typical Voysey trademarks abound, with dormer windows peeping out from a sweeping, hipped Swithland slate roof. Sadly, the interior was deprived of other features, most notably the green-tiled fireplaces and door hinges. The following year saw the building of his Wortley Cottages a little further along the lane over the railway bridge.

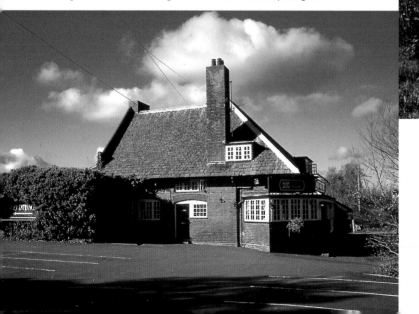

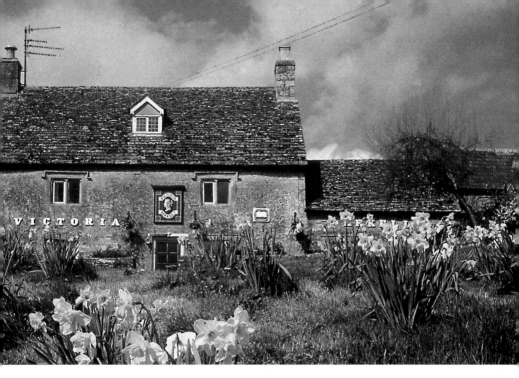

^ **Victoria, Eastleach Turville, Gloucestershire** Springtime in Gloucestershire, and the Victoria pub looking out over the twin hamlets that make up Eastleach. Walk over the gloriously clear River Leach on the clapper-style bridge and you're in Eastleach Martin. They both have a church, within yards of each other, but they only need this one pub, an unpretentious Cotswold inn that couldn't be bettered in the surroundings. Note the simple block Egyptian letters for the inn name that unconsciously help to maintain the integrity of the stone building, and the shaped dripstones over the upstairs windows to deflect the rain.

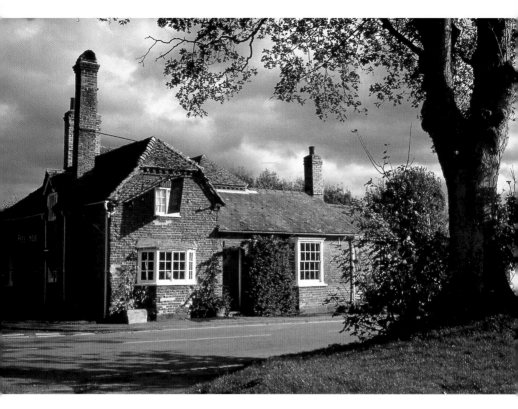

Queen's Head, Newton, Cambridgeshire Southwest of Cambridge, five roads meet at this brick, 17th-century converted farmhouse. The Queen's head on the sign is that of Anne of Cleves, whom Henry VIII managed to marry and divorce in one year (1540). Another Royal, George V, remarkably brought the Kaiser here in 1914. Did they play the 'Devil among the Tailors', an old pub game that necessitates swinging a ball attached to a pole by string in order to knock down wooden skittles on a table?

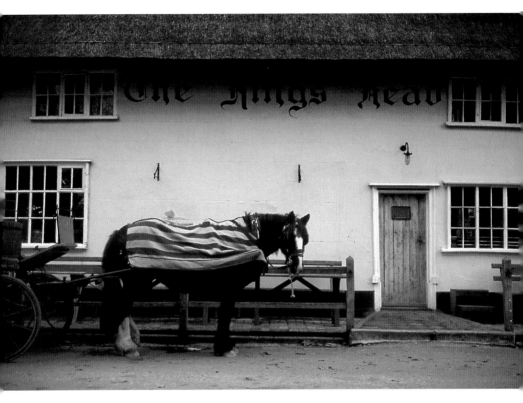

King's Head, Laxfield, Suffolk It's very easy to miss the King's Head. The B1117 winds through the Suffolk medieval wool town of Laxfield, past The Royal Oak tucked up next to the All Saints church, and a First World War Memorial with a curious 18th-century look to it. But if you go into the eastern end of the churchyard you'll see the Kings Head down through the trees and over the stream, making sense of its alternative name of 'The Low House'. A plain, unadorned thatched pub with a high-backed settle against the fire and beer drawn from casks in a room at the back. And if you're lucky, Jessie, or another of her patient friends, will complete the scene outside.

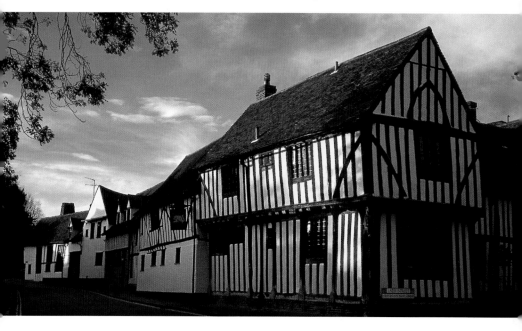

The Swan, Lavenham, Suffolk Lavenham is so stuffed with immaculate timber-framed buildings that it sometimes looks like a Hollywood film set for *Pinocchio*. Although obviously very picturesque in a chocolate-box way, one almost wishes for some relief by way of a few unrestored properties falling into the street and shoeless children playing hopscotch in dim alleys. The town grew between the 14th and 16th centuries with the prosperity of the clothing industry, and the Swan incorporates the original Wool Hall into its fabric.

Rugglestone Inn, Widecombe in the Moor, Devon No cellar, just a plain, workaday pantry with wooden shelves for assorted glasses and spirit bottles, and barrels racked up and waiting. No bar either, for this was the Rugglestone in 1975, little changed from its days as a simple cider house. I include it out of pure self-indulgence, because I was made very welcome here whilst living on Dartmoor. This was the quintessential rural pub; drink was brought to your table and rounds were acknowledged with a wink or tip of the glass. A wood-panelled wall was hung with posters for sheep sales and the calendar of a local haulier, a long case clock ticked the minutes away next to an oak settle, and 50s showcards for Bass and Babycham sat on the mantlepiece. A big table covered in brown oilskin hid a secret draw where an empty Bisto drum held the counters for keeping score in a card game I could never fathom. The Rugglestone is still there, still full of atmosphere, but now sporting amenities like bars and garden seats.

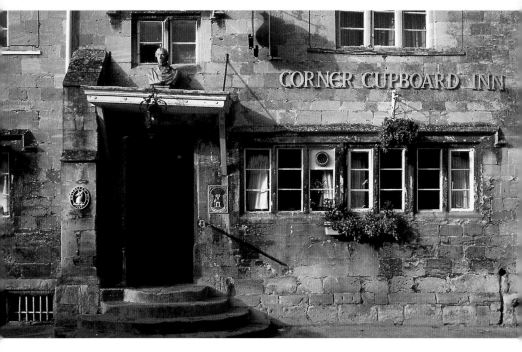

Corner Cupboard Inn, Winchcombe, Gloucestershire Until the early 11th century this was Winchcombeshire, and here, set in a gap in the Cotswold's northwestern edge formed by the River Isbourne, is its county town, seven miles up the hill from Cheltenham. In the 19th century this building was a farmhouse, and at the back, a malthouse can still be seen. It became an inn in 1872, but still retains 16th-century features: squared limestone, mullioned windows and a flight of rounded steps up from the street. A bust of Disraeli stares out above the porch.

The Masons Arms, Branscombe, Devon Branscombe lies between Sidmouth and Seaton. The Masons Arms is one of those inns that takes its character not only from the furnishings, but equally from the spirits of the drinkers who have sought good ale and company here for over 500 years. Firelight from a huge spit-roasting fireplace in the flagstoned bar dances to the sound of 'shove ha'penny' being played, and as a grandfather clock marks the passing hours, drinkers' money is still collected in a brass 'drop in' penny till.

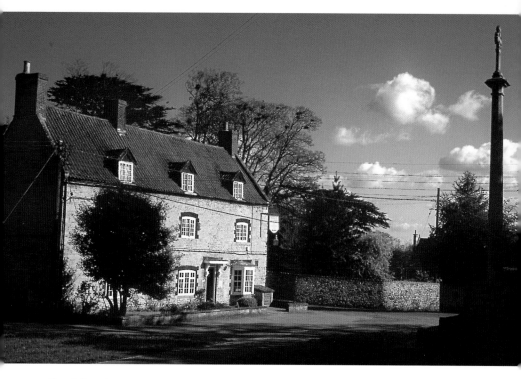

Hare & Hounds, Fulbeck, Lincolnshire Fulbeck is one of a string of villages that cling to the edge of the limestone cliff that runs up through the length of Lincolnshire from Stamford to the Humber estuary. The most notable gap is at Lincoln, where the cathedral marks the start of its final run northwards. The villages all reflect the geology in their buildings, and the Hare & Hounds inn is a perfect example with its stone walls roofed with red pantiles. It plays its part in this typically English scene, looking out on the village green with the war memorial and the gate to the church of St. Nicholas.

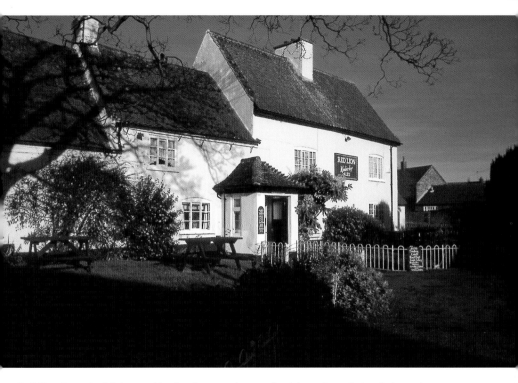

Red Lion, Bottesford, Leicestershire Another superb example of the red pantiled roof, the main unifying feature of the counties of Lincolnshire and Nottinghamshire that nearly surround Bottesford on the slim finger of Leicestershire that pokes up between them. Pantiles were introduced into the East Coast ports from the Netherlands in the 17th century, and their limited distribution into this part of the world was dictated by the extent of navigable waterways. On each side of the painted sign can be seen the sliding first-floor windows so typical of the period.

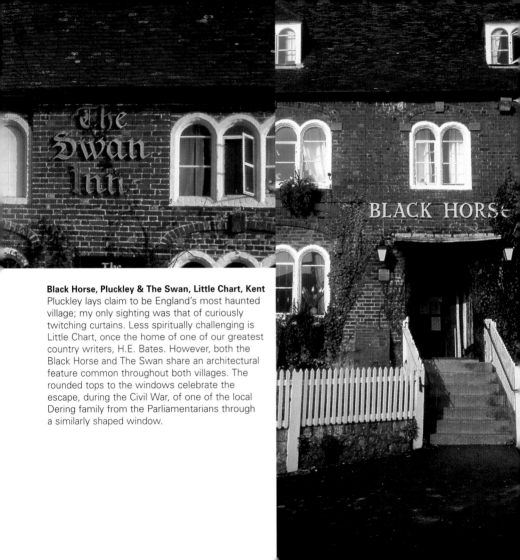

Black Horse, Pluckley & The Swan, Little Chart, Kent
Pluckley lays claim to be England's most haunted village; my only sighting was that of curiously twitching curtains. Less spiritually challenging is Little Chart, once the home of one of our greatest country writers, H.E. Bates. However, both the Black Horse and The Swan share an architectural feature common throughout both villages. The rounded tops to the windows celebrate the escape, during the Civil War, of one of the local Dering family from the Parliamentarians through a similarly shaped window.

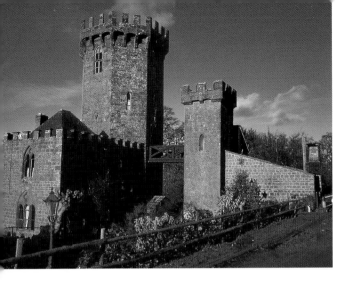

Castle Inn, Edge Hill, Warwickshire Charles I raised the Royalist standard here on Edge Hill prior to the first major battle of the Civil War on 23 October, 1642. Almost 100 years later the antiquary, Sanderson Miller, built this ironstone tower as a scene-setting gatehouse for his home below the hill at Radway Grange. Guests arriving here by coach experienced a suitably Gothic welcome as they were suddenly plunged down through the trees on a steep and winding drive to the Grange. Now the castellated tower is incorporated into the Victorian Castle Inn, where the almost obligatory phantom Cavalry officer rides his equally ghostly horse through the bar.

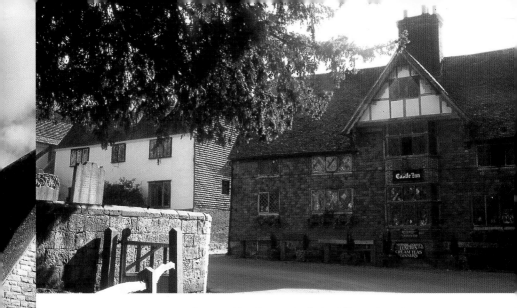

^ **Castle Inn, Chiddingstone, Kent** This is hidden Kent, and a National Trust village deep amongst Wealden woodland. A row of carefully preserved 16th- and 17th-century buildings line up on the hill opposite the church, high on film location finders' lists. (It acted as E.M. Forster's 'Summer Street' in Merchant Ivory's *Room with a View*.) The Castle Inn of 1720 stands at the corner, with bare-tiled floors, walls hung with tiles, and leaded windows reflecting the churchyard yews.

< **Chequered Skipper, Ashton, Northamptonshire** In the closing years of the 19th century, the rare Chequered Skipper butterfly had few habitats, but one of them was a tract of wooded limestone country in northeast Northamptonshire. When Charles Rothschild, an entymologist of some renown, became aware of the fact, he bought the entire locality, building on its fringes an estate village to accompany his new house, Ashton Wold. He presented it all to his new bride as a wedding present. The village dates from 1900, and boasts workers' cottages that were among the first to have modern bathrooms and electricity, generated down at the mill on the Nene and supplied by wires laid underground. The vernacular style, by an architect called Hackvale, extended to dovecotes, a model farm and this inn overlooking the green. Juliet Smith in her *Shell Guide to Northamptonshire* wrote: 'One almost expects merrie Elizabethan countrymen to be quaffing their ale outside.'

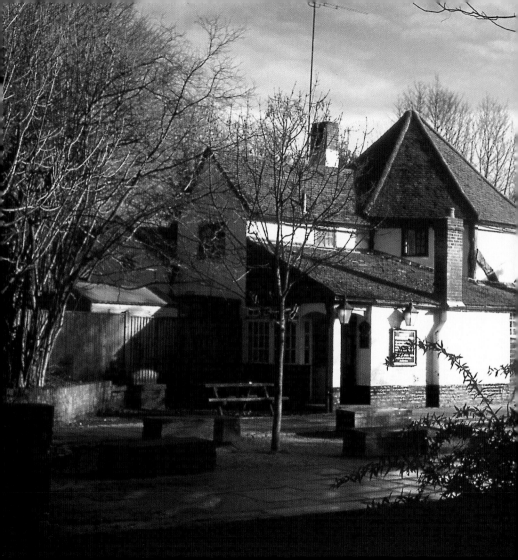

on the town
Ye Olde Fighting Cocks, St. Albans, Hertfordshire
A path winds down to the River Ver from a cathedral built of recycled red Roman brick, and opposite the mill is a timber-framed inn that lays claim to be one of the oldest in England. Its octagonal shape would support the thinking that these are the re-sited timbers of an 11th-century dovecote from King Offa's monastery, and its use as a cock-fighting pit 300 years ago is still easy to imagine.

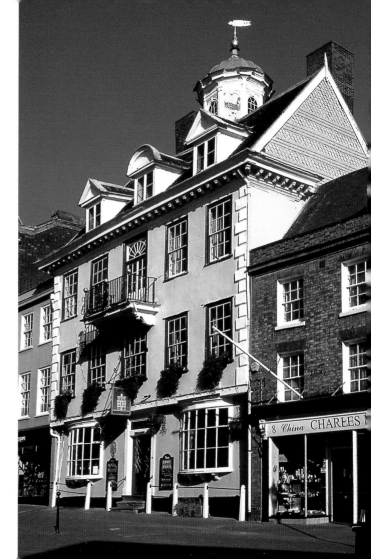

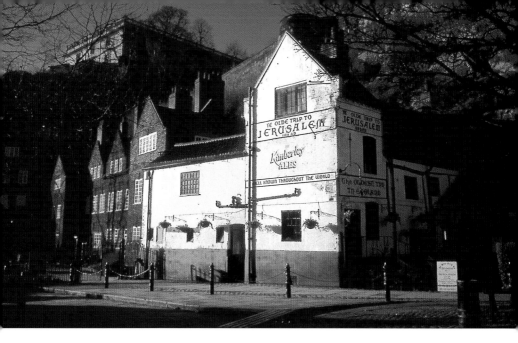

∧ **Ye Olde Trip to Jerusalem, Nottingham** The tobacco-stained rooms at the back of the Trip to Jerusalem are quite literally caves burrowed into the sandstone cliff behind. Where the pub emerges blinking into the light below, Nottingham Castle is 17th century, but its not difficult to imagine its 12th-century origins.The name refers to the Crusaders leaving here for the Holy Land in 1189, although 'Trip' makes it sound rather like a bank holiday charabanc outing. The red brick building to the left of the inn is the Brewhouse Yard Museum.

< **Cupola House, Bury St. Edmunds, Suffolk** Thomas Mucro, an apothecary, built this stunning house in 1693. His initials and the date are on the weathervane flying in the breeze on top of the 'lanthorn' or cupola. Five years later Bury St. Edmunds was visited by Celia Fiennes on the East Anglian leg of her rambling tour around England. She wrote in her journal of the cupola that it was '...at least 60 steppes up from the ground and gives a pleaseing prospect of the whole town,...' The view was of timbered buildings with pitched tiled roofs, and she was obviously impressed with this new addition to the street towering over them: ' ...severall streets but no good buildings; except this... the new mode of building,...' It has been a public house since at least 1917, when Greene King, whose brewery is one of the town's great characters, rolled their barrels into the vast cellars underneath.

The Skittles Inn, Letchworth, Hertfordshire Letchworth was the world's first garden city, a town planned from scratch with Arts and Crafts houses, a corset factory and healthy open-air spaces. Opened in 1903, it quickly became sought after by those sporting smocks and shorts who hoped to create Utopia in the fields of Hertfordshire. George Orwell spoke his mind about Letchworth in his *Road to Wigan Pier* (1937) when he wrote that the estate had attracted '...every fruit juice drinker, nudist, sandal wearer, sex maniac, Quaker, nature cure quack, pacifist and feminist in England.' They elected for Letchworth to be an alcohol-free zone, but still needed a public house where they could discuss their ideals and the day's corset making. The Skittles became their meeting place, where Cadbury's drinking chocolate and Cydrax, instead of beer, was dispensed over a green-tiled bar. It became 'The Settlement', an adult education centre, in 1923.

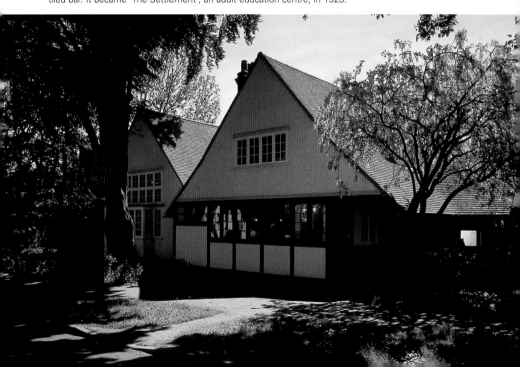

The Nutshell, Bury St. Edmunds, Suffolk Possibly the smallest pub in Britain, and it doesn't need more than one decent round of drinks to fill it. One of its many charms lies in the unconscious collage created on the walls by generations of drinkers, supplementing the sepia photographs of the town with foreign bank notes, cigarette packets and items torn from newspapers. And a San Francisco railway timetable.

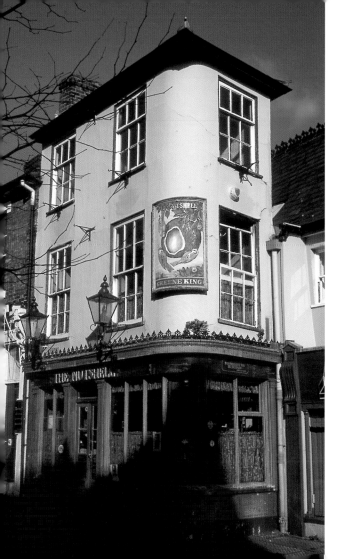

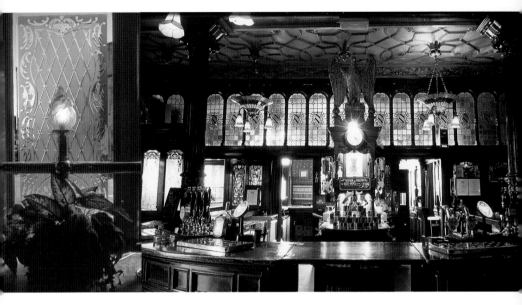

Philharmonic, Hope Street, Liverpool The letters on the Hope Street frontage explain that this pub was built as the Philharmonic Dining Rooms, the 'Phil' concert hall being opposite. It comprises everything the Victorians had learnt about decoration. To enter on a sunlit afternoon, with early doors drinkers yet to arrive, brings a gasp of amazement. Electroliers sparkle under stained-glass ceilings, screens glow with heraldry, and Baden-Powell and Lord Roberts stare out at the serried ranks of black polished beer pumps. Brass rails hold frosted-glass torchflame lamps, shiny multi-patterned tiles line the walls and an eagle glowers from the top of the clock. Even the gents is still graced with 1890s Rouge Royale by Twyfords. A magnificent portfolio of work by Walter Thomas, brewery architect to Robert Cain. The woodwork was crafted by joiners when they were laid off from their work on the great Atlantic liners.

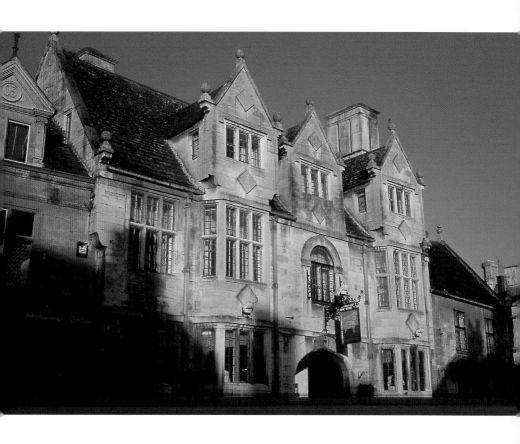

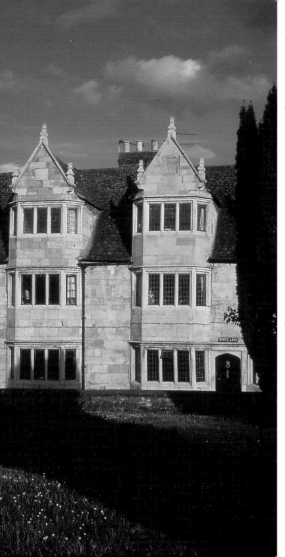

≪ **The Talbot, Oundle, Northamptonshire**
Oundle retains the charm of a traditional country town, thanks largely to the presence of a famous public school that spreads throughout the limestone streets. The Talbot, an imposing inn dated 1626, forms part of a group of buildings that, at its heart, includes the Post Office, a bank and the war memorial. Mullions, transoms and ball finials frame an arch that still retains the iron guards that protected the stonework from carriage wheels. A stone mounting block for horseriders is still on the pavement. The stairs inside were plundered from Fotheringhay Castle four miles away, the scene of Mary Queen of Scots' bloody execution.

< At the other side of the needle-spired church from The Talbot is the frontage of a former hostelry, The White Lion, now overtaken by inky schoolboys. An inn of 1641 bulging out over the pavement.

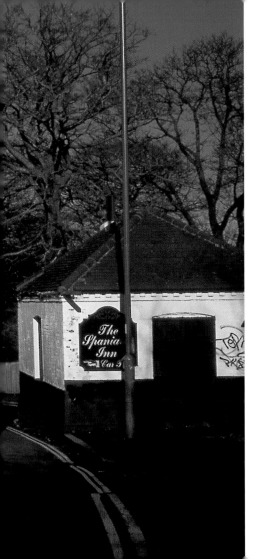

in the capital
The Spaniards Inn, Hampstead Heath, London

Panelled rooms, sloping floors, real fires in winter, the ever popular Spaniards possibly takes its name from an ambassador at the court of James I. For most of its 400-year history this was a remote spot on the Heath haunted by highwaymen. Indeed, Dick Turpin stabled his horse in the tollgate opposite that now brings traffic trying to get through the intervening gap down to a crawl.

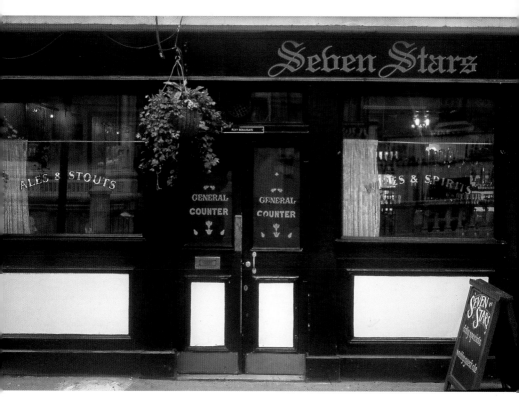

Seven Stars, Carey Street, London With its location behind the Law Courts on the Strand, the Seven Stars tends to be full of lawyers, alternately either celebrating or commiserating with their clients. They hunch over cheese and chutney sandwiches, earnestly briefing each other under either the gilt advertising mirrors or the 1937 film poster for *Action for Slander*. It is a simple, wooden-fronted, wooden-floored pub with a counter and refreshingly little else, other than a pedigree starting in 1663, an inevitable Dickens connection, and precipitous stairs to the lavatory.

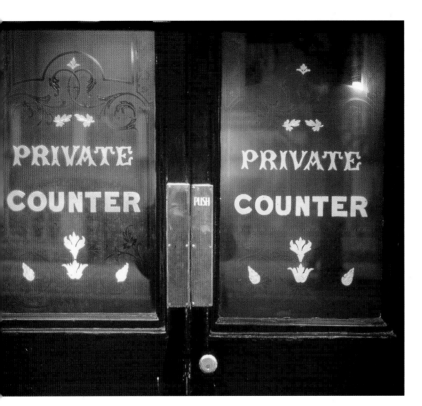

The Salisbury, St. Martin's Lane, London Theatreland, and at its heart an overblown, over made-up actress displaying her charms in St. Martin's Lane. Or to use another theatrical analogy, a dressing-up box overflowing with acid-etched windows, bronze figurines, brass-topped tables and flowers that turn into electric lamps. The ceiling is in something curiously called 'lincrusta', which oddly is not a brand of pie pastry, but a type of relief wallpaper invented by Frederick Walton in 1877.

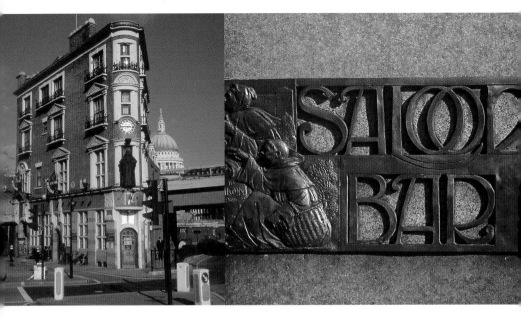

The Black Friar, Queen Victoria St, London This thin wedge of a pub can be found opposite Blackfriars station. The building dates from 1875, but in the 1900s architect H. Fuller Clarke and sculptor Henry Poole created an astounding Arts and Crafts ground floor. Taking full advantage of the fact that this was the site of a Dominican monastery, they stuffed the place with monkish references. A pot-bellied friar prays for an extension under the corner clock, and inside, more jolly friars cavort across faux medieval freizes. Best of all, I like the cutout copper signs on the wall, the proper hand-drawn lettering for 'Worthington Ales on Draught' and directions to the 'Saloon Bar' with even more friars helping to point the way.

by the river

Bromley Arms, Fiskerton, Nottinghamshire The River Trent wanders aimlessly around Staffordshire, Derbyshire and Nottinghamshire before finally deciding to work its way northwards to the Humber. Here the Bromley Arms serves a small village quayside as the ever widening river approaches Newark. The inn stands among 19th-century houses hiding behind brick walls, and once looked after the needs of a working river. Now its an ideal spot for the peaceful contemplation of pleasure boats on their mooring stanchions or on the quay. A weather-beaten crane projects over the water opposite the green lush meadows of East Stoke.

THE ANCHOR

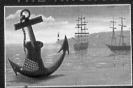

SHEPHERD NEAME

SHEPHERD
NEAME

Beer
GARDEN

HURLIMANN
SWISS LAGER

SHEPHERD
NEAME

Hot & Cold
FOOD

Beer
GARDEN

MASTER BREW
BITTER

≪ **The Anchor, Faversham, Kent** A bare floorboarded pub that still serves the community, working or taking their pleasure on Faversham's quayside. A muddy tidal creek winds in from The Swale to the very heart of this most enjoyable market town, the picturesque remnants of its former glory as a port very much in evidence. The quay may no longer be strewn with spilt grain or stacked with bricks and flour sacks, but once in a while the unmistakeable smell of brewing in the town will still draw those who understand these things into the dim recesses of The Anchor.

‹ **The Dove, Hammersmith** In the summer it's like musical chairs at the Dove, with everyone jostling to get a seat on the riverfront. Appropriate really, for a pub where James Thomson composed Rule Britannia upstairs. It's the kind of pub that has always attracted writers and artists; William Morris lived virtually next door at Kelmscott House, using the riverside setting for the beginning of his 1891 *News from Nowhere*, and both Ernest Hemingway and Graham Greene stepped in from the narrow alley to the cool dark rooms. I confess to once spending a not inconsiderable length of time here, preferring winter nights when the fire and conversation blazed and everything was wreathed in the toffee-scented tobacco smoke that emanated from a local at the bar.

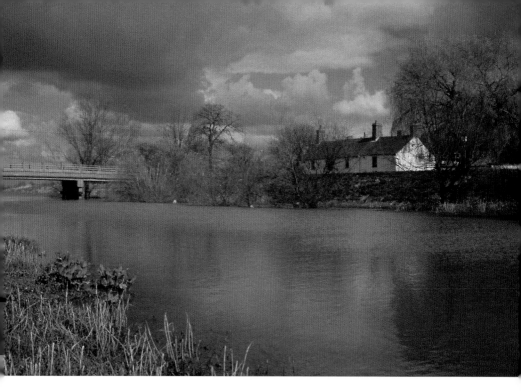

The Anchor Inn, Sutton Gault, Cambridgeshire This atmospheric inn hides behind the bank of the New Bedford River, or 'Hundred Foot Drain', out on the western edge of the Isle of Ely. The river course was dug in the mid-17th century as part of the great draining of the fens, and the original inn was built to provide lodgings and sustenance for the muddy and ague-ridden workers. Biting winds still corrugate the pike-haunted levels, but in The Anchor all is well, with log fires, gas light and Michael Rothenstein lithographs on the walls.

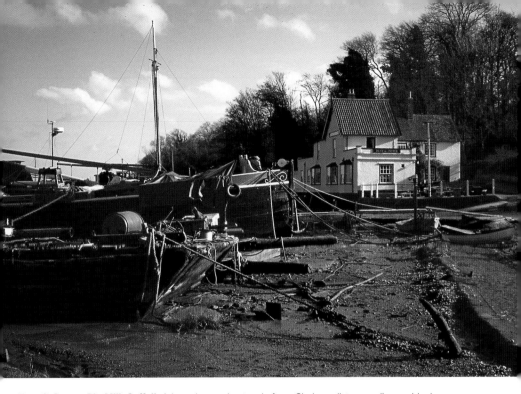

Butt & Oyster, Pin Mill, Suffolk A lane descends steeply from Chelmondiston, ending suddenly at Potters Reach on the Orwell estuary where everything is either on the water, dripping from receding tides or only just keeping its feet dry. Here the pages of Arthur Ransome's *We didn't mean to go to sea* come to life, with this smuggler's pub surrounded by boats, barges and fish boxes. The high tide reaches up the walls of the 17th-century Butt & Oyster where you can stand on flagstones and gaze at all this teeming marine life, and across the estuary to the woods of Orwell Park. 'Butt' has a number of definitions, including a particular kind of flounder, but the sign opts for an ale or wine cask as in 'a butt of Malmsey'.

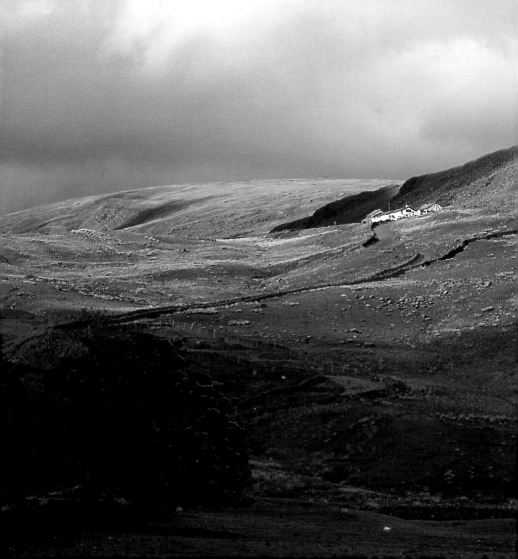

out in the country

Kirkstone Pass Inn, Cumbria One of the highest in England, the inn stands at the top of a tortuous road known as 'The Struggle' that climbs up from Ambleside. When the stagecoach ran over the pass to Penrith, passengers had to disembark at the worst stretch until the inn was reached, justly earning its previous name the Traveller's Rest. In winter, how welcome the smell must have been of smoke billowing down the pass from its chimneys while in the stone-floored rooms the fires would have hissed with the wet spilling from stovepipe hats. The windows of the inn are deeply inset into the rendered stonework, the better to withstand the driving rain off the fells. The building is 17th century, only becoming an inn in the 19th century.

The Compasses, Littley Green, Essex Barrels of beer are brought up here from the brewery that sits below in the fields at Hartford End, just south of Felsted. Then they're rolled into a little brick pantry a step down from the bar. An unspoiled pub in an unvisited corner of Essex, with a tiled floor, simple chairs and tables, and a high wooden dado lining the walls. I said in my introduction that I wouldn't talk about food, but here the 'Huffer' is as much a fixture as the coal fire and piano. Find out for yourself what they are, but I had a ham and onion one with freshly mixed mustard.

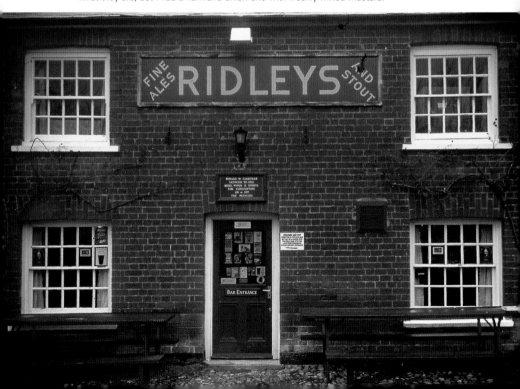

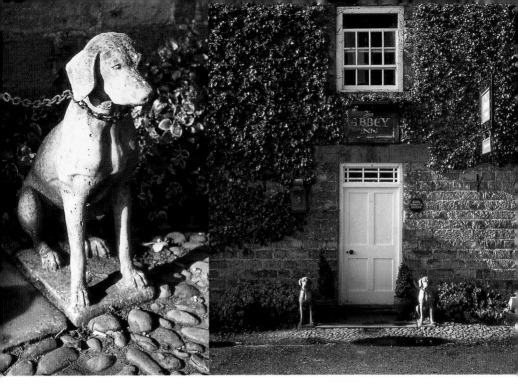

^ **Abbey Inn, Byland Abbey, North Yorkshire** Chained, stone dogs guard the entrance to the Abbey Inn. Its windows reflect the massive curve of the ruined west window of Byland Abbey, one of England's most prominent landmarks. The Cistercian order built here in the early 12th century. Some of the abbey stone can be seen in the inn, together with large, warming fireplaces and flagstoned floors.

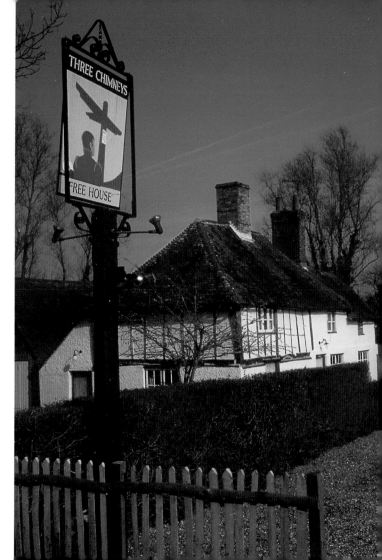

Three Chimneys, Biddenden, Kent The sign only partially explains the name of this two-chimney inn. In the 18th century, French prisoners of war from Sissinghurst Castle were permitted to take walks as far as the meeting of three ways (les trois chemins) where this timber-framed pub of 1420 still stands alone at the junction. Wood panelling and low beams keep the faith, with candlelit tables and flagstoned floors.

Salutation Inn, Norham, Northumberland Early pubs of this name used 'Salutation' to mean the Angel Gabriel saluting the Virgin Mary. The Reformation brought about a hurried reappraisal, and the inn signs now showed a soldier greeting a citizen, which in turn led to two hands shaking. In general, its name denotes a meeting place, and up here on the road from Berwick to Coldstream is the coaching stop for Norham, down the hill on the south bank of the Tweed. This is border country, and the building style is already Scottish, with dormer windows set up into the roof.

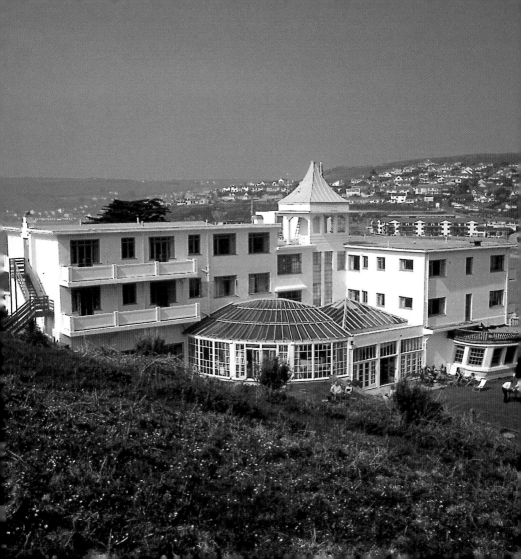

beside the sea
Burgh Island, Bigbury-on-Sea, Devon

A smuggler-haunted island cut off at high tide, a medieval inn and an art deco hotel – perfect inspirations for an Agatha Christie novel, as indeed they became, in *And Then There Were None* and *Evil Under the Sun*. Burgh Island stands separated from the Devon mainland by a strip of sand that becomes the sea bed at high tide, and then it can only be reached by boat or by the curious and unique sea-tractor, a kind of seaside promenade shelter on big rubber tyres.

At the high point of the island are the remains of a huer's hut, where a lookout fisherman would raise a 'hue' as in 'hue and cry' to alert his comrades that shoals of pilchards were appearing out to sea. And here is their pub, The Pilchard, a 14th-century building that has all the flavours of its salty past.

Although, with consideration, you are free to walk the island footpaths, it is in fact privately owned. Everything here is really the back garden of architect Matthew Dawson's white slab of art deco hotel. It was opened in the 30s by Archibald Nettlefold (of industry giant Guest, Keen & Nettlefold) and quickly became a 'racy' venue for the in crowd, with the likes of Noel Coward, Edward and Mrs. Simpson and, of course, Agatha Christie. (Sunlight reflecting on tinkling cocktail glasses with waiters gliding around to *These foolish things* being played on a white grand piano. I expect.) It fell into serious disrepair, with collapsed sun roofs and shattered stained glass, until rescued and sensitively restored in 1986.

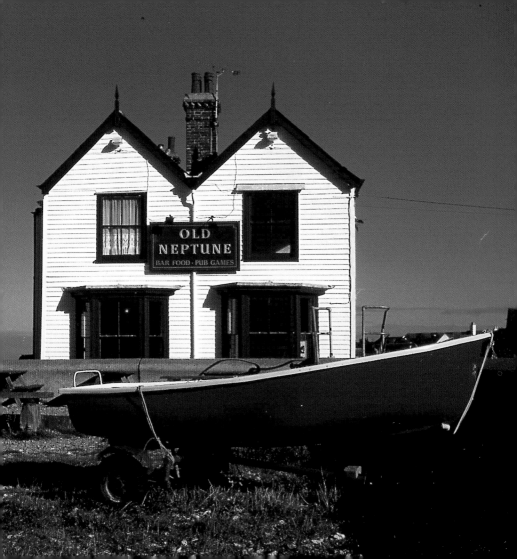

acknowledgements At Everyman: David Campbell, Sandra Pisano and Clémence Jacquinet. At English Heritage: Val Horsler and Simon Bergin. At Anikst Design: Judith Ash and James Warner. Many pub landlords and breweries were extremely helpful. In particular I would like to thank The Swan Hotel in Southwold, the Burgh Island hotel in Devon, the Philharmonic in Liverpool, the Old Neptune in Whitstable, the Falkland Arms in Great Tew, Glenn Clarke at Greene King and The Dove Pier in Hammersmith. Thanks also to the Letchworth Museum. Special mention should be made to the following: Lucy, Ben and George Ashley, Kathy Ashley, Leigh Hooper, Tony Unsworth and Rupert Farnsworth for encouraging my interest in pub interiors and Elizabeth Raven-Hill for untiring help and support.

bibliography *The Shell County Guides,* Faber & Faber. *The Buildings of England Series,* Penguin Books. *The Old Inns of England,* A.E.Richardson, Batsford 1934. *English Country Pubs,* Derry Brabbs, Weidenfeld & Nicolson 1986. *The Village Pub,* Roger Protz & Homer Sykes, Weidenfeld & Nicolson 1992. *Evening Standard London Pub Guide,* Angus McGill, Pavilion. *Villages of Vision,* Gillian Darley, Paladin Books 1978

< **Rhydspence Inn, Whitney-on-Wye, Herefordshire** The Reverend Francis Kilvert, when curate at nearby Clyro, wrote in his diary for the evening of May Day in 1872: ' ... I walked home under the stars. About midnight I passed over the Rhydspence border brook,...The English inn was still ablaze with light and noisy with the songs of revellers...'.

Overleaf:
The Falcon Hotel, Uppingham, Rutland
(see page 69)

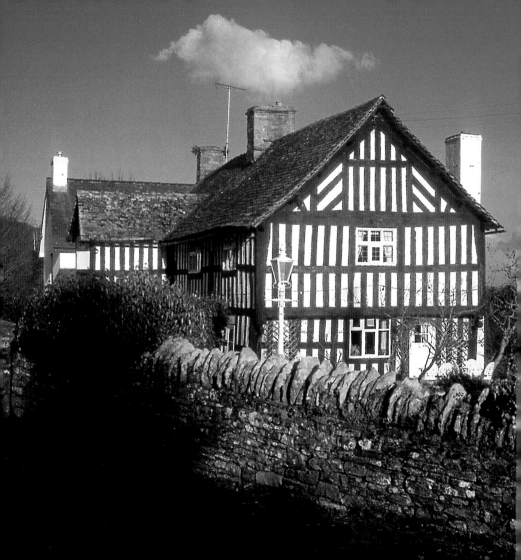

BEARD & Cº'S
CELEBRATED
ALES & STOUT

KING'S HEAD
COMMERCIAL INN
AND
POSTING HOUSE

HOTEL
RECEPTION

^ **East Sussex** A freshly painted wall of mathematical tiles

< **Louth** Late afternoon in this Lincolnshire town, with deepening shadows emphasising the stolidness of the raised block letters on the early Victorian frontage of the King's Head

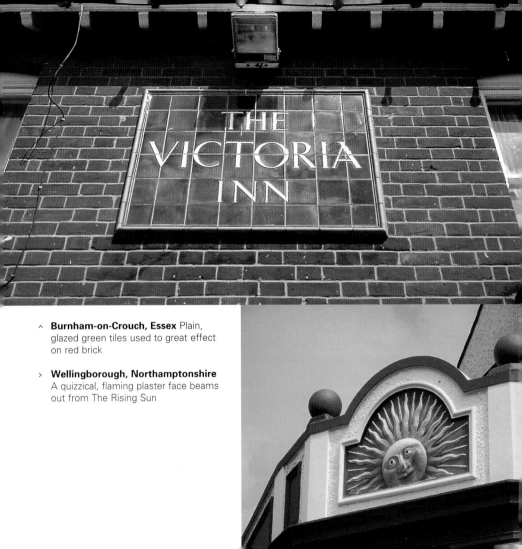

∧ **Burnham-on-Crouch, Essex** Plain, glazed green tiles used to great effect on red brick

> **Wellingborough, Northamptonshire** A quizzical, flaming plaster face beams out from The Rising Sun

Kings Lynn, Norfolk The signmakers' art is rapidly disappearing; there are only a handful of people for whom the quality of well-crafted lettering still means something. Here is an example photographed in the early 70s in the Tuesday Market, now either burnt for firewood or hopefully on someone's kitchen wall.

Gilt lettering above the door in **Tewkesbury, Gloucestershire**

∧ **Winchcombe, Gloucestershire** These magnificent porcelain plaques for a defunct brewer, very likely by Royal Doulton, can still be seen all over the South West. This example, outside the Corner Cupboard Inn, looks as if it's fresh from the kiln.

‹ **Lyme Regis, Dorset**
Cutout iron feathers
and a painted motto
surmount the soaring
bay windows on the
Royal Lion, a reminder
of Georgian patronage

in the detail

^ **Nottingham** A gilt and glass licensee sign above the door at Ye Olde Trip to Jerusalem. Compare it with the computer generated plastic strip above

> **Ledbury, Herefordshire** Prince of Wales feathers on the timber-framed front of The Feathers Hotel

>> **Oxford** An oriel window for the White Horse in Broad Street

>>> **Glastonbury, Somerset** Multi-coloured stained glass in the George & Pilgrim

« **The Bell, Stilton, Cambridgeshire** Stilton cheese is only made in a handful of dairies in Leicestershire and Nottinghamshire, some distance from this village on the Great North Road. Cheeses were brought here on their way to the London markets, and in the 1740s the sportsman and entrepreneur, Cooper Thornhill, of The Bell, entered into a contract with Mrs. Frances Pawlett, a cheesemaker from Wymondham. From then, Stilton became the name of the cheese and its marketing centre. Coach passengers who broke their journeys here were served with the king of cheeses and its reputation was assured. The inn itself was built in stone brought a few miles from a Northamptonshire quarry in 1515, and altered in 1642. A web of curling wrought-iron sprouts from the walls to support a truly magnificent painted sign.

‹ **Angel & Royal Hotel, Grantham, Lincolnshire** This is one of the earliest surviving medieval inns in England. Originally the property belonged to the Knights Templars, and later to the Hospitallers. Here, as a traveller, you could receive hospitality or, if you were Richard III, send a death warrant to the Duke of Buckingham. The 15th-century façade is rich in detail, with a parapet of diamond decorated panels, carved stone heads and a gilded angel supporting an oriel window on its wings. Parts of the cellar date from as early as 1213. It is still possible, amongst the traffic of what was once the Great North Road, to imagine the York-bound stage clattering up the final incline of Guildhall Street to the arched entrance.

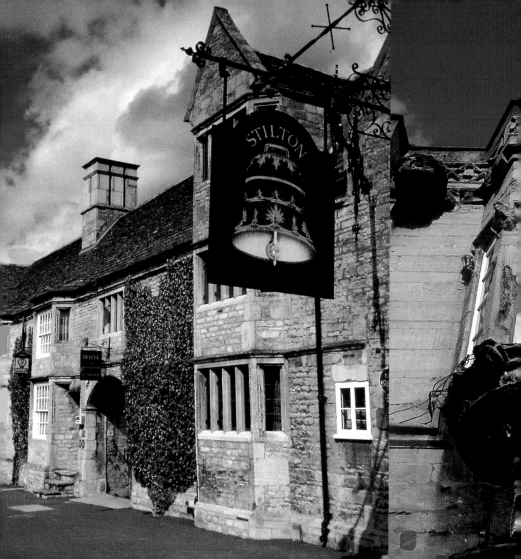

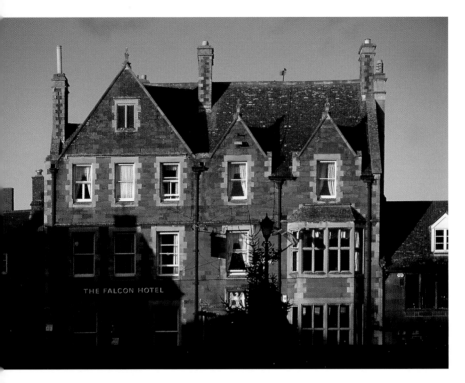

THE FALCON HOTEL

Falcon Hotel, Uppingham, Rutland This is the sort of delightful small market town where bakers jolly along with bookshop owners and old-fashioned ironmongers put fireguards and wheelbarrows on the pavements. The market square has the parish church on one side, next to a post office that amazingly still looks like one, with the Falcon taking up most of the north side. The 1870 gabled ironstone front hides the original 17th-century coaching inn, and the place where carriages once rumbled in is now filled with sofas and public schoolboys forced to take tea with their parents. Look out for the sash window, now marooned amongst the cakes, that once overlooked the yard.

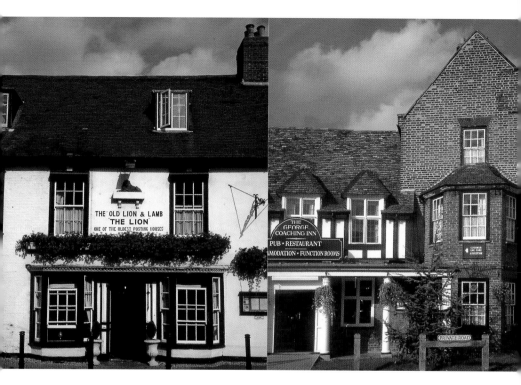

The Lion & The George, Buckden, Cambridgeshire The Lion at Buckden served London-bound coach traffic on the Great North Road, and its fellow opposite, The George, took care of the northbound traffic. Perhaps they helped each other out at busy times, with kitchen boys in long aprons running with legs of mutton, tripping over cart ruts in the road. The Lion once served as a guesthouse to Buckden Palace next door, home to the bishops of Lincoln until 1838, and is well worth coming off the A1 for. The George has a long roadside frontage, three storeys with fifteen windows set in 18th-century brick. The bay windows would have provided an excellent view of coaches approaching from the south.

down the road

The George, Stamford, Lincolnshire Guide books before the First World War often finished chapters on Rutland or Lincolnshire with lines like '...we make the best of five miles through the failing light home to the 'George'. It still retains the atmosphere of a traveller's inn from more leisured ages, with blazing log fires and wood-panelled rooms. The front door covers what was once the arched entrance where stage coaches ran through to the yard at the back, with the rooms either side of the opening still marked according to their original function as waiting rooms: 'York' and 'London'. The building itself is a warren of rooms that have grown almost organically over the years as the hotel has been extended and altered.

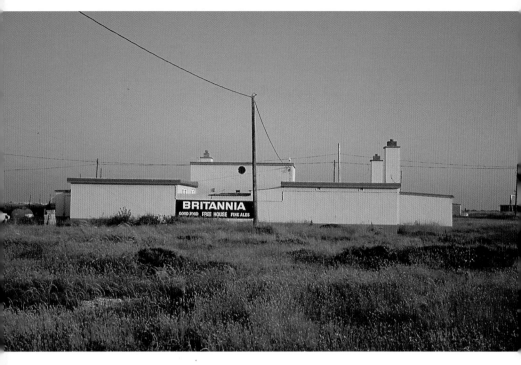

Britannia, Dungeness, Kent Everything except the lighthouses and a grotesque nuclear power station, crouches low in this extraordinary, bare landscape. There is feeling of impermanence about the black tarred bungalows, some grown organically from old railway carriages, that share the acres of shingle with beached fishing boats. The Britannia fits perfectly into all of this. No primness here. No pretentions. Just a simple set of almost camouflaged plain rectangles not daring to raise their heads, and a plain, well-lettered sign that seems to be simply saying: 'Here I am, I'm a pub'.

Pier Hotel, Harwich, Essex Most will know of Harwich only by trunk road signposts that guide drivers to the continental ferries, but these move out into the Stour estuary from Parkeston Quay, leaving the old town waiting to be discovered up on the top of its narrow peninsula opposite Felixstowe. If you like atmosphere and the details of the past, the old town of Harwich is full of surprises. Here you will find coloured buoys marooned in yards waiting for repair, a bare brick lighthouse looking out over streets and alleys lined with Georgian and Victorian houses, and a 17th-century Naval Yard crane.

On a corner opposite the old passenger pier are two examples of Harwich architecture encapsulated in neighbouring buildings. The weatherboarded inn, with its expansive oriel window, is pure Essex vernacular, originally the Angel and now an annexe to the startling hotel next door.

The Pier Hotel, with its balcony and third-floor belvedere, is maritime jolliness at its best. It arrived in response to the Great Eastern Railway reaching Harwich in 1854. A building that flies the flag of blue skies and white clouds even on the dullest day.

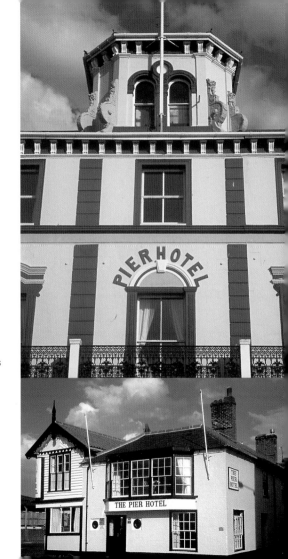

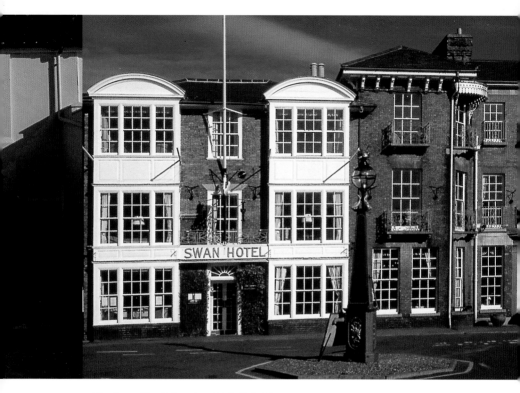

The Swan Hotel, Southwold, Suffolk It's very heartening to find inns and hotels that are still pivotal points of towns, home to local Rotarians and dining clubs, centres of local gossip and politics. On the Suffolk coast, the Swan has served the townsfolk of Southwold for centuries. The original medieval inn went the way of the rest of the town in the Great Fire of 1659, but was rebuilt just in time to quench the thirsts of bellringers celebrating the restoration of Charles II. The 19th century saw more alterations, including the distinctive sash-windowed bays topped with curved pediments. The neo-Georgian extension to the right surprisingly dates from only 1938, with wrought-iron balconies that must be perfect for hanging plimsolls wet from the sea out to dry.

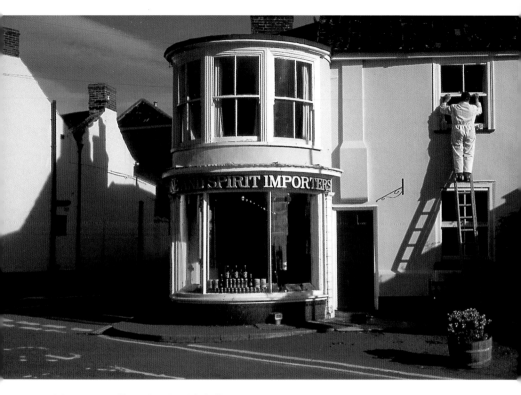

Adnams Wine Shop, Southwold, Suffolk Not a pub exactly, but who could resist it? At least it's attached to the Red Lion pub, and it does sell alcohol. There is a vaguely nautical air about the magnificent bow window that could easily house a retired sea captain and his telescope. The Adnams Wine Shop started life as the chemist's shop of Joseph Arthy, who on his arrival in Southwold in 1825, married the very agreeably named Mary Anne Perfect.

Old Neptune, Whitstable, Kent The sea god Neptune has certainly been a frequent visitor to his namesake on the beach at Whitstable. This present building dates from 1898, after a devastating storm had swept away its predecessor. It subsequently survived inundations in 1938 and in 1953, when a storm surge powered by ferocious northwesterly winds brought barrels of oysters floating around the streets and fishing boats crashing into basements. Now it is more likely to be floods of day-trippers at weekends, but on a quiet, sunlit autumn morning the Old Neptune fulfils its promise of a truly seaside inn.

CLOSE ENCOUNTERS WITH
MARINE LIFE

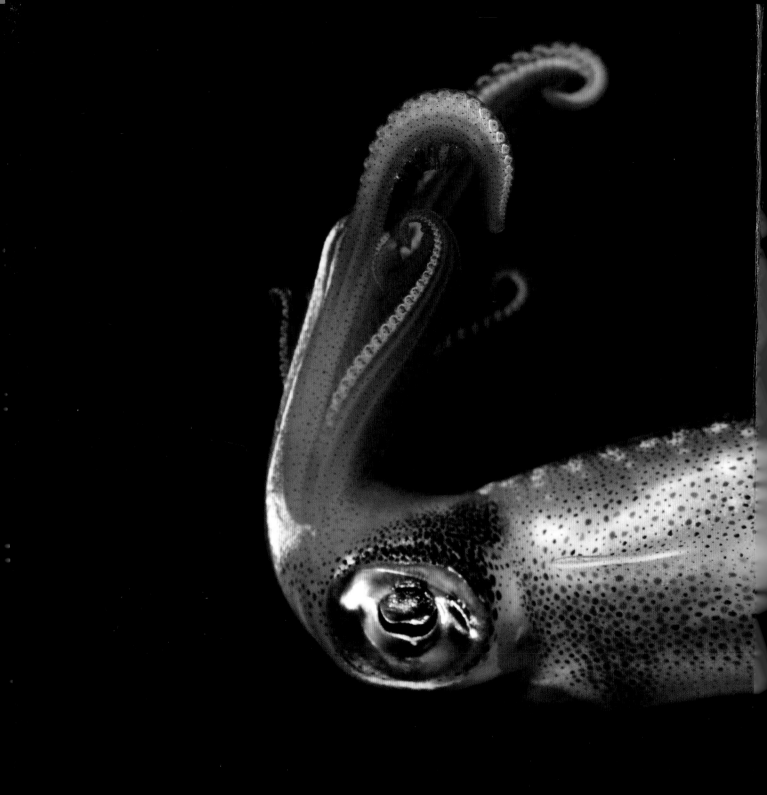

CLOSE ENCOUNTERS WITH

MARINE LIFE

NIGEL MARSH

To my wonderful and always
supportive parents, Jack and Jean
Marsh, who are both sadly missed.

ACKNOWLEDGMENTS

Thanks to all the great dive operators who have taken me to their marvellous local dive sites. And special thanks to all the incredible dive buddies who have shared my underwater adventures. And finally to my wonderful wife and favourite dive buddy, Helen Rose, I look forward to us enjoying many more amazing underwater encounters in the future.

CONTENTS

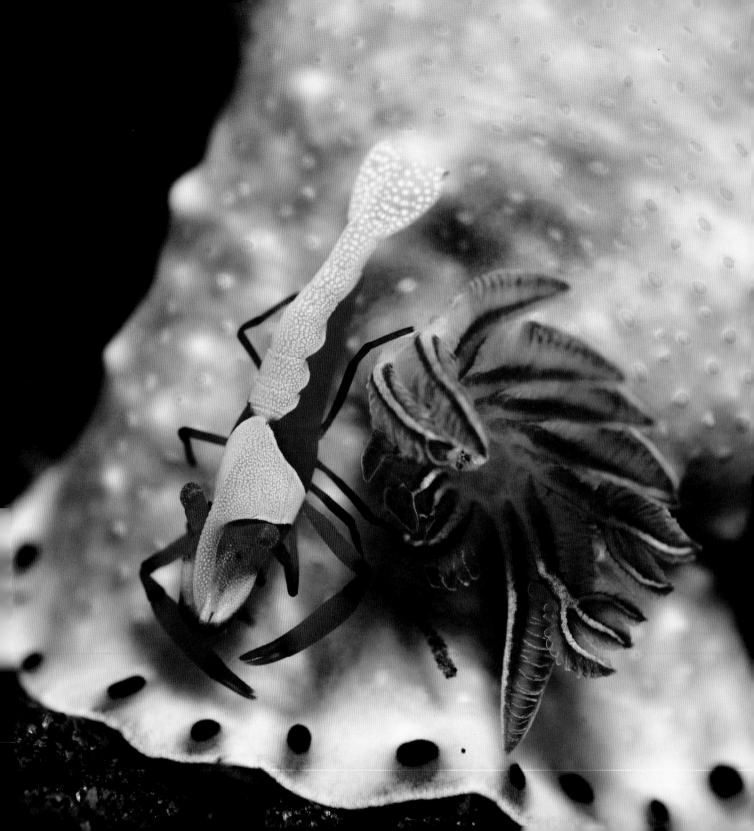

INTRODUCTION

Slipping on my brand new mask, I took a deep breath and plunged into the cool water. At first all I could see was sand, but after a minute I spotted several small fish darting about the bottom. The fish had me enchanted and they were simply going about their daily lives and mostly ignoring me. I was only nine years old, and doing my first ocean snorkel, and I was instantly hooked on this fascinating marine world.

Soon I found myself over a rocky reef, only 1m (3.3ft) deep, but with many more fish. Spellbound watching all the fish, it took me a few seconds to notice a large dark shape moving over the rocks and heading straight for me. At first I thought it was a shark, but then realised it was a huge stingray, and at 2m (6.6ft) wide it was almost twice the size of me.

I froze, worried I was about to be attacked by this massive animal. However, something extraordinary happened instead. The ray, now only a few metres away from me, suddenly stopped. We stared at each other for what seemed like minutes, but must have only been a second or two. Then the ray flapped its wide pectoral fins, swiftly turned and swam off as quickly as it could.

I didn't linger either, and turned tail and fled. Swimming briskly back to the shore I couldn't wait to tell my parents about my incredible close encounter with the enormous stingray.

More than 40 years later and I am still telling stories about my close encounters with marine life in my profession as a photojournalist. I have been very fortunate to document my diving experiences in articles for dive magazines, books and on video during the past 30 years, and in that time have explored many wonderful dive destinations around the world. And while I have enjoyed exploring reefs, wrecks and caves, the highlights of my diving adventures have always been the close encounters with marine life.

This book is a collection of some of those wondrous close encounters with marine life. Over the years I have had encounters with creatures both big and small. And while a close encounter with a shark, whale or seal always gets the heart pumping, many of my favourite experiences have been with the smaller and often rarer or more obscure critters of the marine world.

Within the pages of this book are hundreds of images of my close encounters with marine life. Accompanying each image is either a story about the animal or a tale of an unforgettable encounter. The encounters have been split into 12 chapters based on my perceived characteristics of the animals. Also included are tips on getting close to marine life, so that the reader can enjoy many close encounters with the amazing animals of the marine realm.

GETTING CLOSE TO MARINE LIFE

The oceans of the world are home to an incredible range of creatures. Currently more than 210,000 marine species have been described, but it has been estimated that about 1.6 million species are found in our oceans. That is an extraordinary amount of marine life for divers to encounter.

Each time a diver enters the ocean they can encounter marine life; be it fish, crustaceans, echinoderms, worms, molluscs, sharks, rays, reptiles or mammals. Getting close to many of these species is not difficult, as most are oblivious to divers or tolerate our close presence. Many other species are much more difficult to view as they are either shy, cryptic, tend to stay hidden away, or prefer to avoid divers altogether. While divers can simply sit back and watch marine life swim by, there are a few helpful tips to get you close to the action.

Imagine you are a fish, octopus or crab and see a giant clumsy creature with one eye, flailing arms, giant fins and blowing bubbles charging at you. You would naturally swim off or hide. And this is what many marine animals do when rapidly approached by a diver. To get close to marine life, first learn to slow down. Slow your swimming, movements and breathing. You will be more relaxed in the water, and also find the animals around you are more relaxed.

Take your time when approaching an animal, be it a turtle, stingray or cuttlefish. Let the animal become accustomed to your presence, and allow them to realise that you are not a potential predator. Some animals are comfortable with a slow direct approach, but others, such as sharks, are often best approached from the side.

Some marine animals, such as manta rays and Grey Nurse Sharks, are often curious and the best way to get close to them is to ignore them and allow them to inspect you. Other animals, especially seals, like to play, and the best way to get them to come close is to entertain them, by waving your hands, spinning around and even doing somersaults.

Whales and dolphins are probably the most difficult creatures to get close to. Most encounters with these animals are dictated by the animal itself, and encounters are often a matter of either being in the right spot at the right time or diving in locations where they gather. Encounters with large and potentially dangerous sharks are rare, except when they are attracted close with baits.

Getting close to marine animals is often easier at popular dive sites where the wildlife has become accustomed to divers and doesn't see humans as a threat. At these sites you can get very close to fish that would otherwise be skittish. This conditioning behaviour is very apparent when exploring new dive sites where the fish have never seen a diver before. At these sites the fish are curious of intruders, but also very cautious.

Observing marine life is often easier without a camera, as you can sit several metres away and watch the action without intruding into the creature's comfort zone. However, the golden rule of underwater photography is to get as close to the subject as possible, as you need to cut down the amount of water between the camera and subject. Even the clearest of water is full of suspended particles, which can cause backscatter in photos. Water also leeches out colours, so the closer you are to the subject, the more colour and clear the image.

Diving with a camera often changes the behaviour of a diver, as they go from watching marine life to chasing

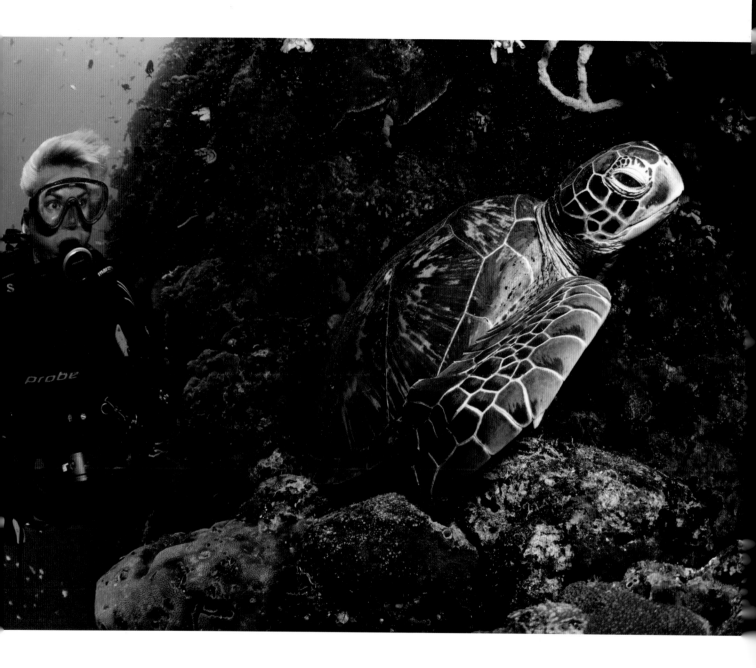

it, cornering it and often harassing it. No wonder many marine creatures swim off at the sight of a camera-wielding diver swimming frantically towards them.

However, by using a bit of restraint, and showing the animal a little respect, you can get very close to marine life and capture wonderful images.

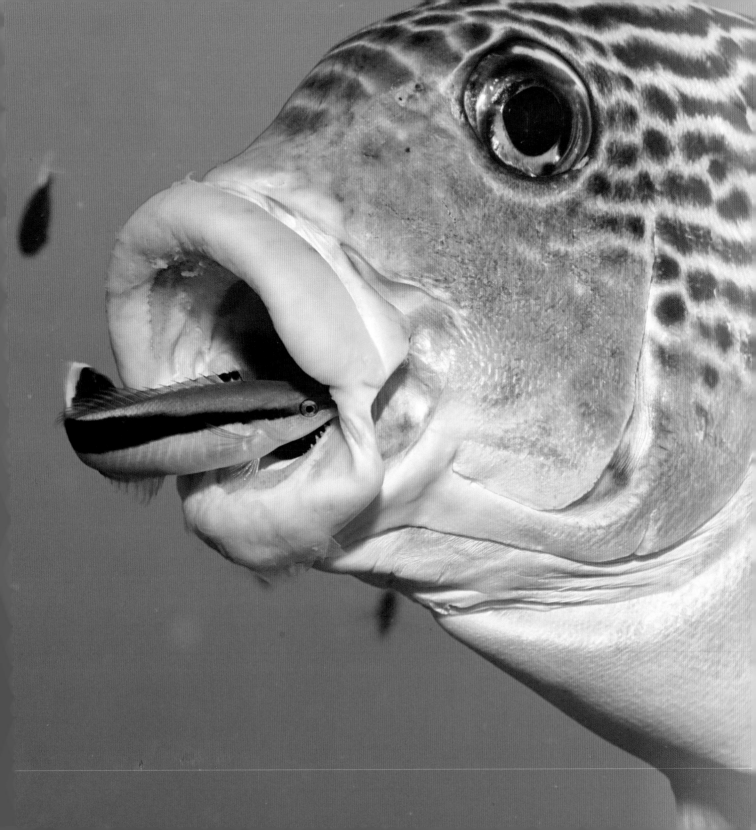

THE BOLD

Boldness is not a very sensible trait for most marine animals to exhibit, as boldness can quickly get you consumed. Most marine creatures are quick to take flight when a potential predator swims by, be it a shark, trevally or clumsy diver. However, a number of marine animals are very bold and make for some very interesting close encounters.

• • • • •

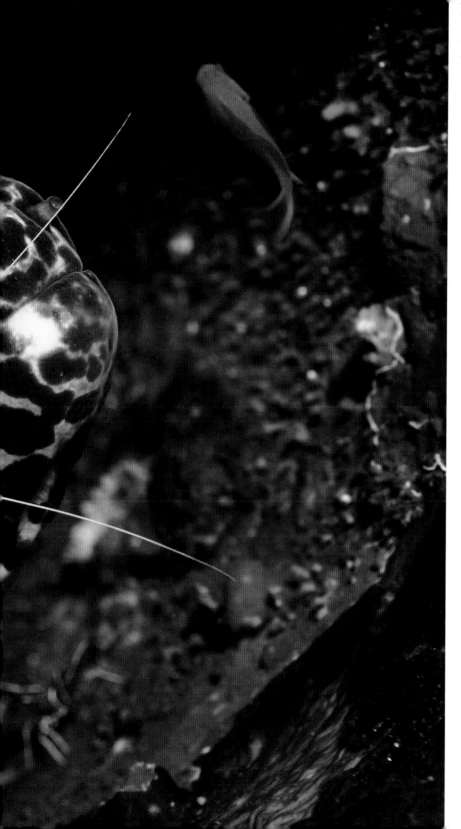

CLEANER SHRIMPS

There are numerous species of shrimps in the oceans of the world, but some of the most interesting are the cleaner shrimps. These shrimps provide a service to other marine life, by climbing over their bodies and even boldly entering their mouths to remove parasites. As shrimps generally make a tasty treat to most marine animals, these cleaner shrimps have picked a very dangerous occupation, but fortunately they rarely get eaten.

◀ *THE MORAY FLATMATE*

The most common cleaner shrimp found on reefs throughout the Indo-Pacific region is the pretty White-banded Cleaner Shrimp (*Lysmata amboinensis*). Groups of these crustaceans are seen in caves, waiting for fish customers to come calling. However, these shrimps often find themselves sharing their home with a moray eel, which tends to get all their business by keeping other customers away. I encountered this Honeycomb Moray (*Gymnothorax favagineus*) off Bali, Indonesia, hogging the services of a White-banded Cleaner Shrimp.

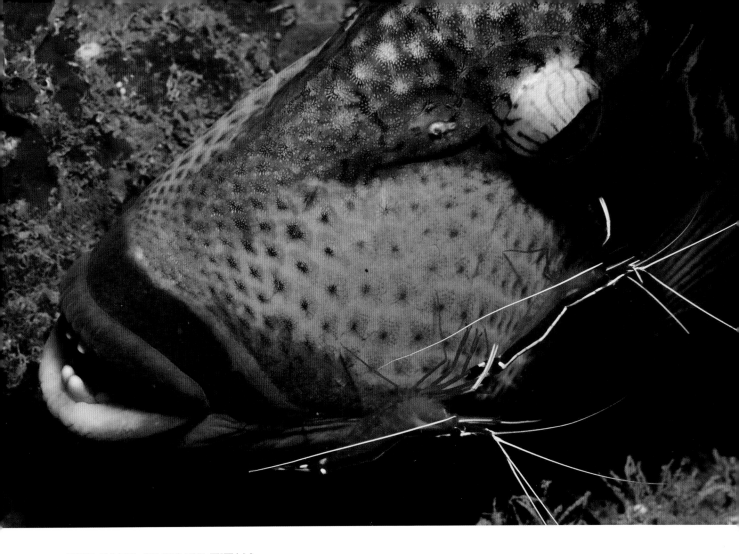

▲ THE OVER-PREENED TITAN

You don't often see Titan Triggerfish (*Balistoides viridescens*) visiting cleaning stations. They have sandpaper-like skin rather than scales, so may not need to be cleaned as regularly as other fish, or maybe they just don't like the attention. However, I did encounter one that loved a clean off Port Moresby, Papua New Guinea.

Finding a busy cleaning station operated by several White-banded Cleaner Shrimps, I watched this Titan Triggerfish monopolising their services. It wedged itself into the ledge while the shrimps went to work, but refused to move once the shrimps had finished. It eventually realised that the shrimps were not going to do any more cleaning and swam off, only to reappear a minute later. The shrimps thought it was another fish and jumped straight to work. Once finished the triggerfish reluctantly swam off, but it was quickly back again. I don't know how long this routine went on for, as I eventually moved on, very amused that this triggerfish loved to be preened so much.

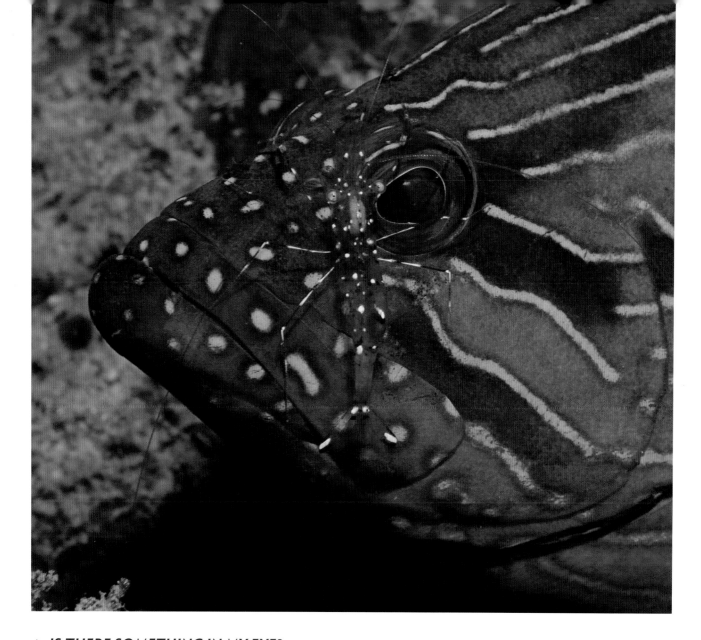

▲ *IS THERE SOMETHING IN MY EYE?*

Rock shrimps (*Urocaridella* sp.) also perform cleaning duties on many fish species. These transparent shrimps are found in large groups and will swim off the bottom to perform a rocking dance to attract clients. While common, rock shrimps are often overlooked as their transparent bodies make them difficult to see and photograph. Sometimes you find an individual that is hard to miss, like this one climbing over the eye of a Bluelined Rock Cod (*Cephalopholis formosa*), photographed at the Perhentian Islands off Malaysia.

▼ SHRIMP MANICURE

Cleaner shrimps not only clean fish, but will also clean divers if given the opportunity. Some dive guides remove their regulator and allow White-banded Cleaner Shrimps to enter their mouth and clean between their teeth. Not the most efficient way to floss! The cleaning services offered by Anemone Shrimps (*Periclimenes tosaensis*) are less invasive. These small shrimps will often jump onto divers to see if they need cleaning, as my wife Helen found when she placed her hand next to this sea anemone when diving at Mabul, Malaysia.

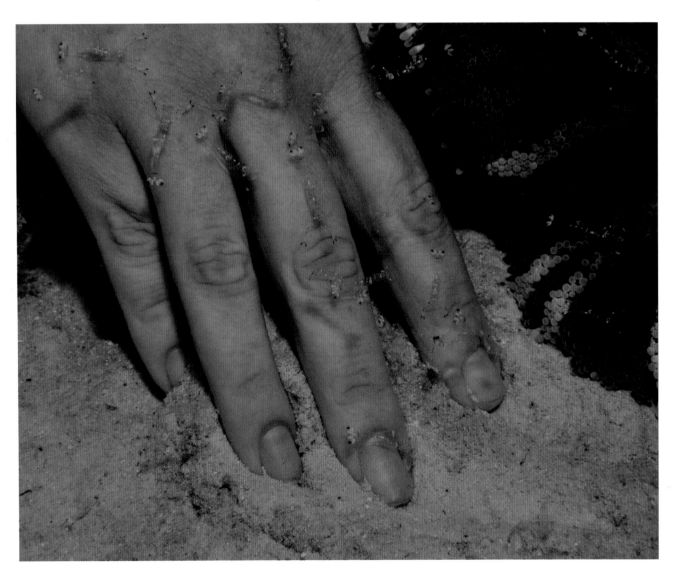

CLEANER FISH

Shrimps are not the only animals that provide cleaning services, as many fish also perform this important duty. About 50 species of fish are known to clean other fish, sharks, rays and turtles. Several members of the wrasse family are the best-known cleaners, and set up cleaning stations to offer their services. Cleaner fish typically remove parasites, old skin and even food stuck between teeth.

▼ DAMSEL IN DISTRESS

The most widespread cleaner fish is the Common Cleaner Wrasse (*Labroides dimidiatus*). Finding and watching these cleaner fish in action is not difficult, but getting images of them at work is a lot harder. While the cleaner fish themselves are quite bold and will often inspect divers, their clients are generally much more camera shy. Occasionally you get a fish that is so engrossed in being cleaned that it completely ignores you, like this Golden Damsel (*Amblyglyphidodon aureus*) encountered off Port Moresby, Papua New Guinea.

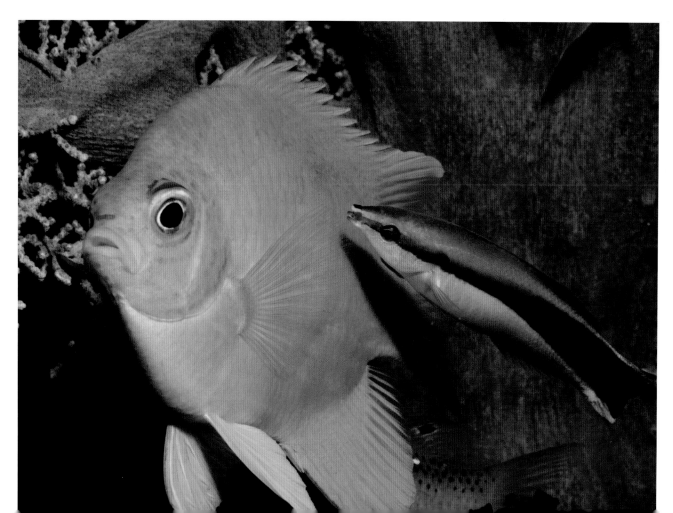

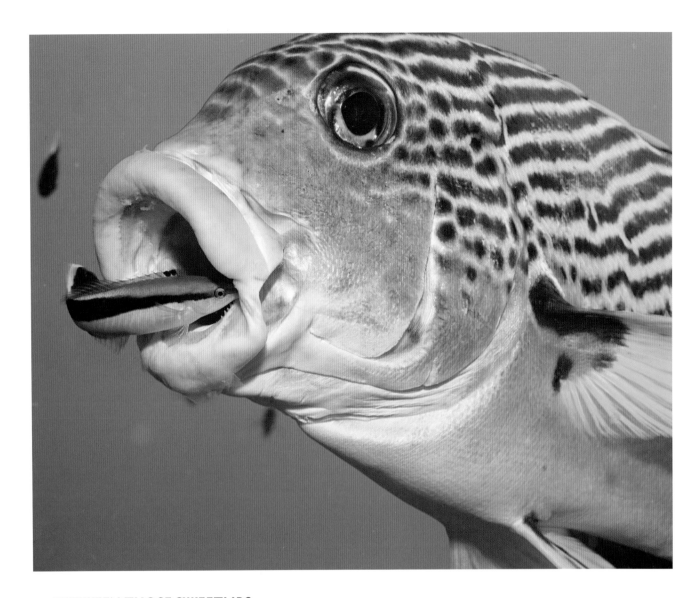

▲ BETWEEN THOSE SWEETLIPS

I always feel nervous for cleaner fish when they boldly enter the mouth of larger fish to give their teeth a clean. You generally have to sit a few metres back to watch this behaviour, as the larger fish obviously feel very vulnerable in this situation and quickly close their mouth if a diver gets close. Fortunately for me this Diagonal-banded Sweetlips (*Plectorhinchus lineatus*) was accustomed to divers visiting its home on the Ribbon Reefs, Australia, and allowed me to capture this intimate moment with a Common Cleaner Wrasse picking at its teeth.

EAR WAX CLEANER ▶

Common Cleaner Wrasse will often inspect divers, but are not known to clean humans. This was my general opinion until I dived the island of Koh Tao, Thailand. Diving at a site called Japanese Gardens, I had been warned to watch out for aggressive Titan Triggerfish, so was quite alarmed when I felt something picking at my ear. I turned around expecting to see a huge triggerfish with my ear in its mouth, but instead found my ears were being serviced by Common Cleaner Wrasse.

I had to get some photos of this unheard of behaviour. Between swatting away the fish picking in my ears, which quickly become very annoying, I indicated to my wife Helen to stay still for a few seconds so I could get some photos of the cleaner fish in action. I managed a couple of images, but there was only so long we could stand having these small fish picking in our ears.

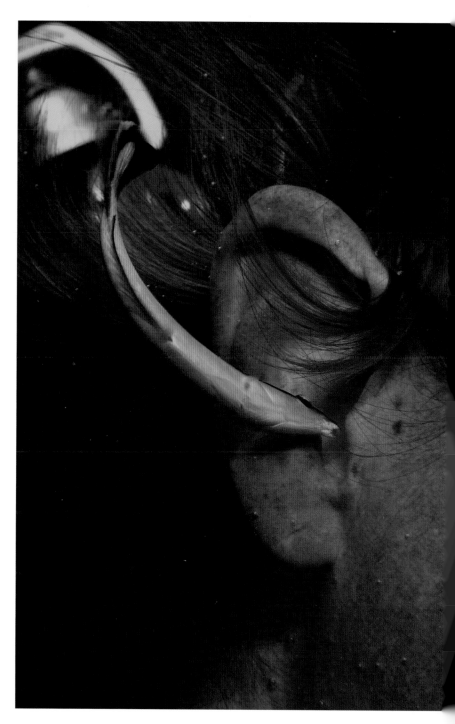

LONGFINS

The longfins, as the name suggests, are a family of fish with longer than normal fins. Found throughout the Indo-Pacific region, about 20 species of longfins have been described. They vary greatly in size and shape, some gather in schools and others are solitary, and most have stunning patterns. Often found sheltering in caves and ledges, some longfins are shy, but others are very bold.

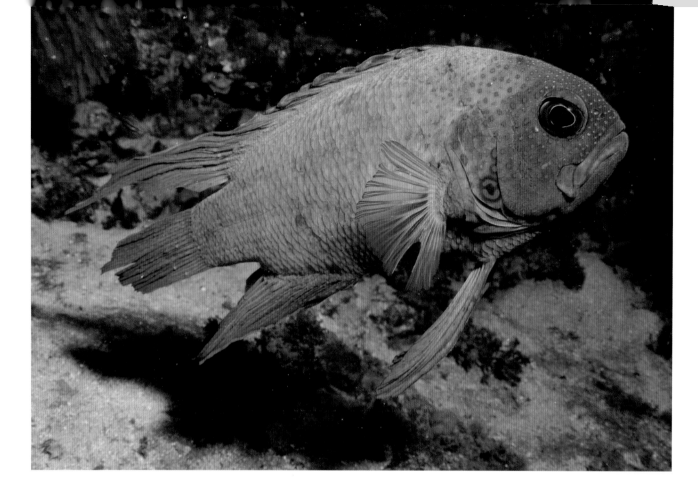

◀ THE STUNNING COMET

The most spectacular member of the longfin family is the beautiful Comet (*Calloplesiops altivelis*). It is also rather shy and likes to hide in caves and crevices. Rarely seen by divers, I have had many close encounters with Comets over the years but have usually found them to be very reluctant subjects. This one, encountered at Lembeh, Indonesia, was the exception to the rule, being anything but shy as it performed boldly for my camera.

PSYCHEDELIC DEVIL ▲

The two largest members of the longfin family are only found in Australia and are known as blue devils. The more common of the pair is the Southern Blue Devil (*Paraplesiops meleagris*). Blue devils are very bold fish, and while they reside in caves they often sit at the entrance to watch the passing action. And they do literally sit, resting on the bottom propped on their large fins. A very bold fish, the Southern Blue Devil will often allow a diver to get very close. They also have a psychedelic polka-dot blue pattern, which can play havoc with an auto-focus lens, which I discovered when photographing this one off Perth, Western Australia.

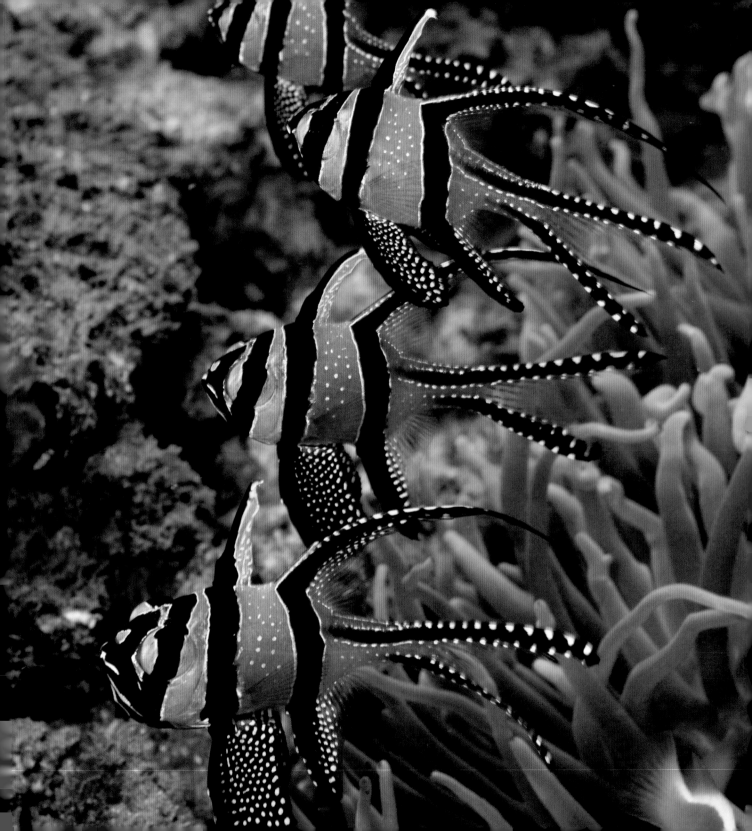

CARDINALFISH

Cardinalfish are small reef fish that are common throughout the Indo-Pacific region. About 250 species are known, and most are overlooked by divers as they are small and often have bland coloration. However, a few members of this family are very striking in appearance, which makes them highly prized photographic subjects. Cardinalfish are also worth a closer look as they are mouth brooders.

◄ THE PRETTY INVADER

The most highly sought-after member of this family is the stunning Banggai Cardinalfish (*Pterapogon kauderni*). Once found only off Indonesia's Banggai Island, this species has been spread to other parts of the country by aquarium collectors. It is now extremely common at Lembeh, Indonesia, where I encountered this group. Banggai Cardinalfish often form large schools, and like to hover over corals and sea anemones.

A MOUTHFUL OF EGGS ►

The most unusual thing about cardinalfish is their reproduction strategy, with the males keeping eggs in their mouth in a process known as mouth brooding. Finding a male cardinalfish with a mouthful of eggs is not too difficult – just look for the fish with a swollen jaw. Every few minutes the male will open his mouth to suck in water to breathe and flush the eggs. To see the eggs takes time and patience, as often the mouth is open so briefly that the eggs are barely exposed. At other times the fish opens wide for a full show, while sometimes the male will spit some of the eggs out to give them a full flush, which is documented in this image of a Plain Cardinalfish (*Apogon apogonides*) taken off Mooloolaba, Australia.

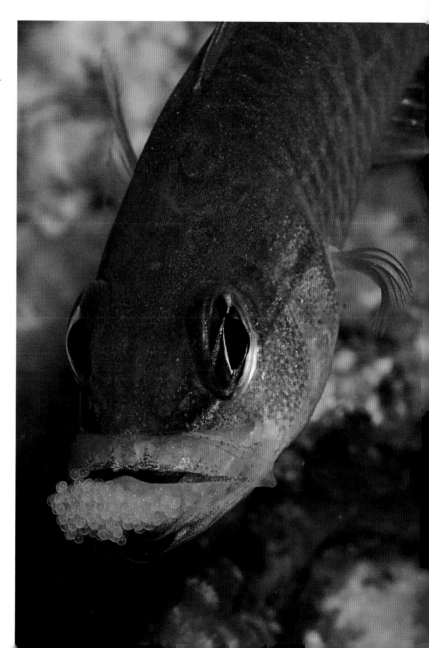

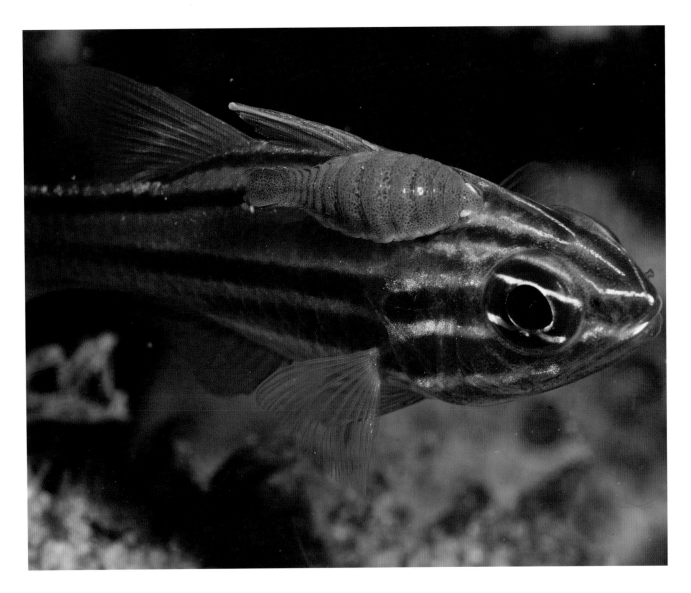

▲ AN UNWELCOMED BLOODSUCKER

Like most divers I often overlook cardinalfish, unless I notice a male with eggs in its mouth. However, I couldn't overlook this Narrow-striped Cardinalfish (*Apogon angustatus*) with an isopod attached to its head while exploring a reef off Bundaberg, Australia.

Being slow swimmers, cardinalfish are prime targets for parasitic isopods. These nasty little crustaceans attach to fish and feed on their flesh and blood. This poor cardinalfish was not the only one with an isopod attached, as several other members of its group were also hosting one of these unwelcome bloodsuckers.

SUCKERFISH

The suckerfish must be the laziest fish in the ocean. While they can swim, they have instead developed a modified dorsal fin that acts like a suction cap to allow them to stick to other marine life and get a free ride. This family contains eight members that not only hitchhike, but also steal food from their host. Suckerfish have chosen a very bold lifestyle and generally have no fear of divers. Getting close to them often depends on how nervous their host is.

▼ TURTLE HUGGERS

The waters around many Asian countries are sadly almost devoid of sharks, which have been killed in unsustainable numbers for the shark fin trade. This has left the resident Slender Suckerfish (*Echeneis naucrates*) with a big problem – a lack of hosts to ride on. At Moalboal, Philippines, I found that this void was filled by the resident Green Turtles (*Chelonia mydas*). Every turtle I encountered seemed to be overloaded with Slender Suckerfish – some only had one or two, but others were carrying a dozen or more. It did allow for very close encounters with the suckerfish, as the friendly turtles were very accustomed to the presence of divers.

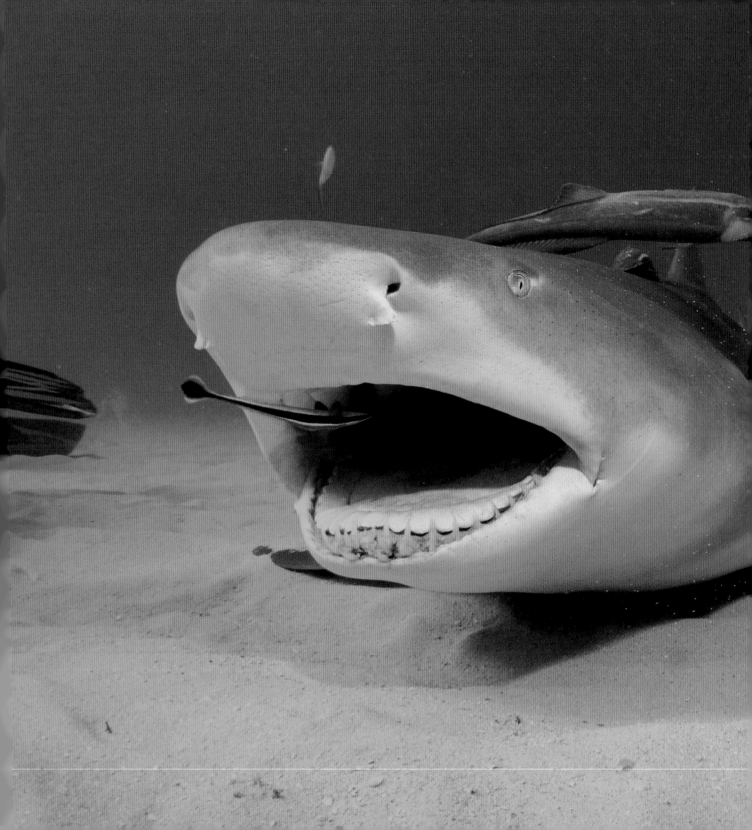

◄ MOUTH CLEANING

Unlike in Asia, there is no shortage of sharks in the Bahamas, so the resident suckerfish have plenty of hosts. I encountered this group of Slender Suckerfish clinging to a Lemon Shark (*Negaprion brevirostris*) off Grand Bahama. These large sharks often rest on the bottom, sucking in water to breathe as they take a break from swimming. While suckerfish appear to be nothing more than large parasites, they also provide important cleaning services to their hosts, although these are rarely observed. With the Lemon Sharks resting on the bottom I could actually witness the Slender Suckerfish cleaning their hosts, and I was very surprised to see the sharks open their mouths wide to allow the suckerfish to clean their jaws.

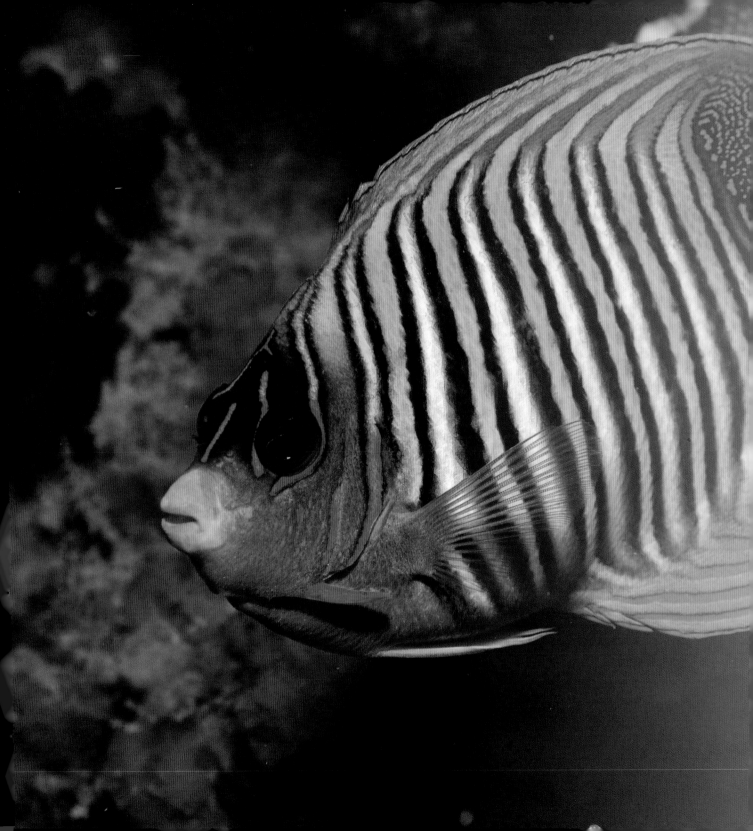

THE BEAUTIFUL

It is often said that beauty is in the eye of the beholder, which is certainly true when it comes to marine life. I find all marine life beautiful, but there are certain animals that have a grace and charm that makes them very appealing to the eye. Close encounters with these creatures are very rewarding, as they remind us that we reside on a wonderful and remarkable blue planet.

● ● ● ● ●

NUDIBRANCHS

Many divers are completely addicted to nudibranchs, and considering they are related to plain and ugly garden slugs, this is an extraordinary fact. Nudibranchs are marine sea slugs of the mollusc family, with their unusual name meaning 'naked gills' in Latin, as most species have exposed branch-like gills on their backs. About 2,300 species of nudibranchs have so far been described, and getting close to these slow-moving critters is never a problem.

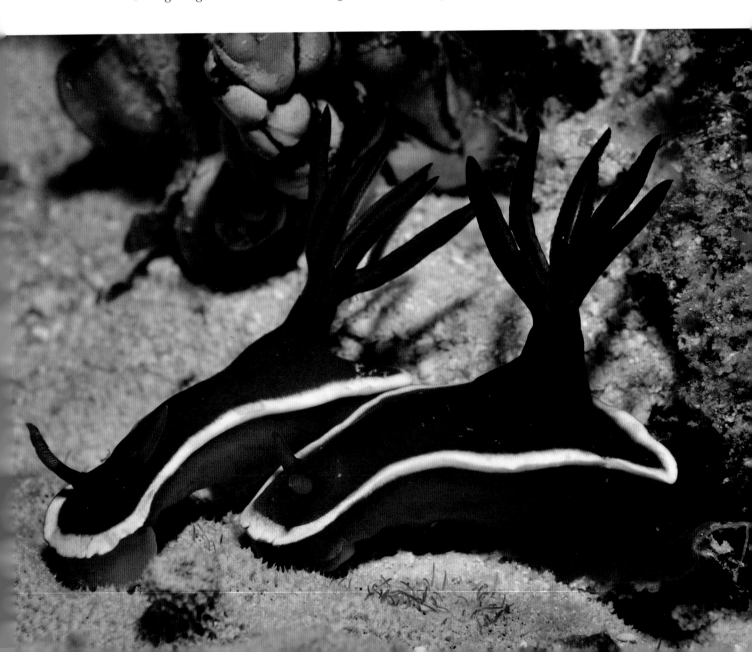

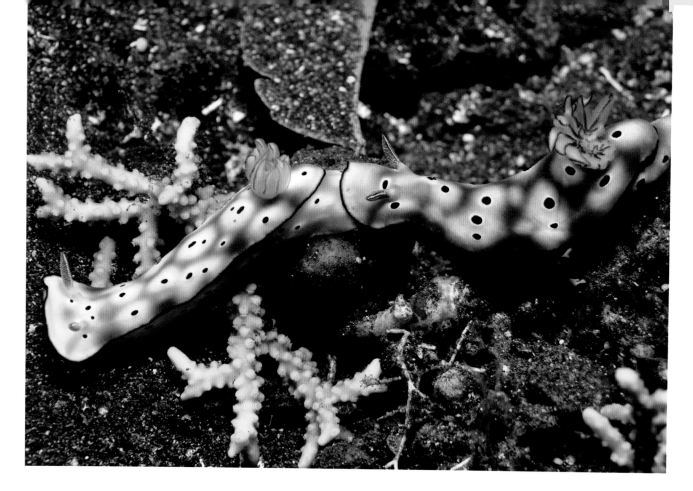

◄ A ROYAL FEAST

Over the years I have photographed thousands upon thousands of nudibranchs. While I always enjoy observing these garish sea slugs, I prefer to photograph nudibranch behaviour, so keep an eye out for ones that are active. Finding nudibranchs doing something is never too difficult, as they seem to spend most of their time mating, laying eggs and feeding. I found this pair of beautiful Royal Hypselodoris (*Hypselodoris* sp.) feasting on a sponge off Kapalai, Malaysia.

▲ SEA SLUG CONGA-LINE

Apart from mating, laying eggs and feeding, nudibranchs also engage in a variety of other interesting behavioural traits. A number of species are often found tailgating, which looks like a weird sea slug conga-line. I found these two Tryon's Risbecia (*Risbecia tryoni*) while diving off Bali, Indonesia. It is thought that nudibranchs tailgate as a prelude to mating, or it may be simply herd mentality, the follower hoping the frontrunner will lead it to food. I have encountered numerous tailgating nudibranchs, and have followed many, but I am yet to see these conga-line dancers break their rhythm to mate or feed.

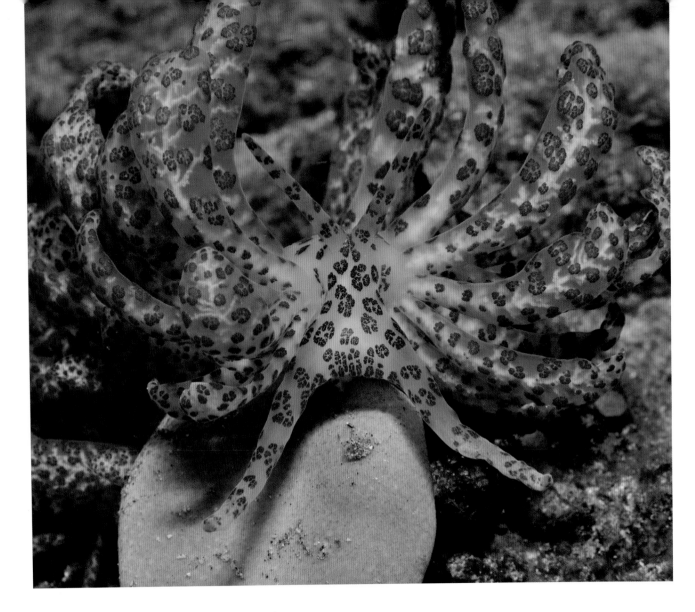

▲ THE SOLAR-POWERED SEA SLUG

There are many strange-looking nudibranchs, with one of the most impressive of these sea slugs being the Solar-powered Nudibranch (*Phyllodensium longicirrum*). I have encountered this species at numerous locations throughout the Indo-Pacific region, and photographed this one while diving off Timor-Leste. This nudibranch not only looks strange, but also does some strange things. For a start it can store toxic chemicals from the food it eats in its cerata (those fleshy fingers on its back) in order to deter predators. Plus those cerata also act as solar panels, providing additional nutrients from zooxanthellae that grow on them. There are many other nudibranchs that are just as strange and beautiful.

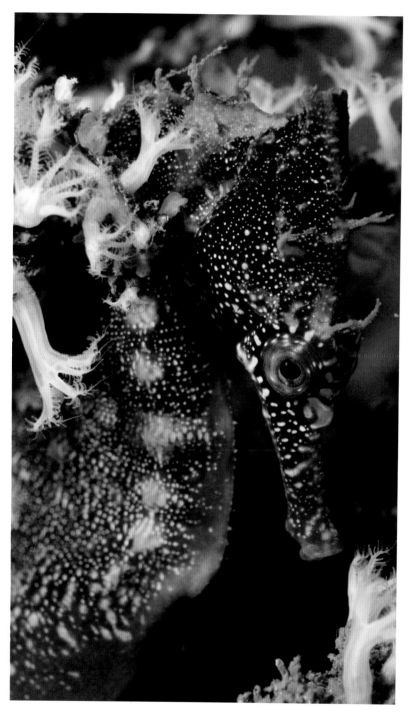

SEAHORSES

Is there any creature in the world more beautiful than the seahorse? While very handsome, seahorses have a bizarre sex life with the male getting pregnant and carrying the eggs in a brooding pouch until they hatch. About 54 species of seahorses have been discovered, and in recent years a number of pygmy species have been found. Getting close to seahorses is never hard, but some pygmy species are very difficult to find.

◄ SOFT CORAL STABLE

The first seahorse species I encountered was the pretty White's Seahorse (*Hippocampus whitei*). Only found in a relatively small area off the east coast of Australia, they are quite common in bays such as Port Stephens, New South Wales, where this one was photographed hiding in a soft coral. Although they are generally solitary, I had a remarkable encounter one time at Port Stephens when there were literally hundreds at a site called Little Beach. I don't know what caused the population explosion, but there were so many White's Seahorses that you had to be careful not to step on one when entering the water!

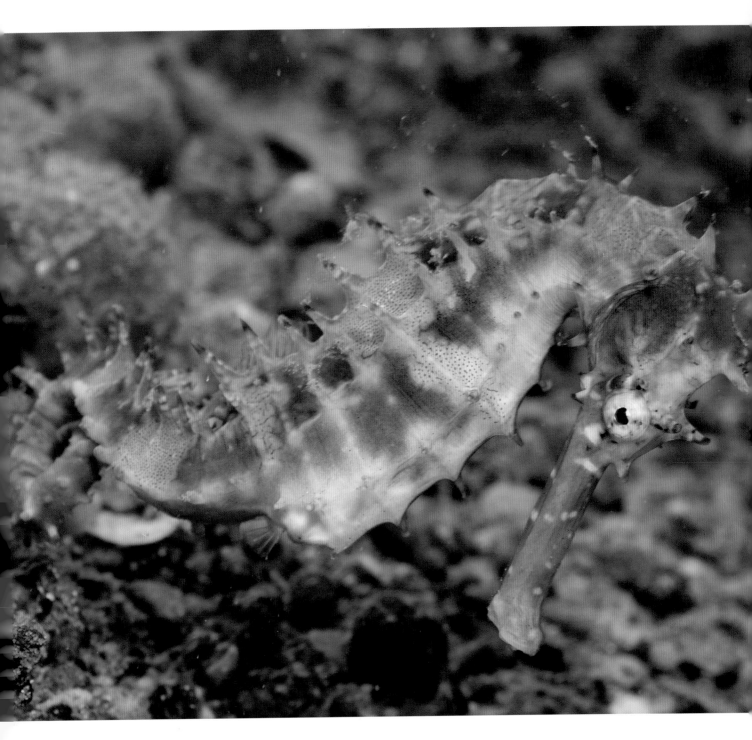

◄ *OUT FOR A GALLOP*

Seahorses are typically found clinging to corals, sponges and seaweed with their prehensile tails. They regularly move around to find a mate and also to feed. I encountered this lovely Thorny Seahorse (*Hippocampus histrix*) out for a very slow 'gallop' when diving in Sogod Bay, Philippines. The seahorse curled up its tail and was flapping its small fins rapidly to swim slowly down the slope. It eventually settled next to a feather star and started to feast on tiny shrimps, which it sucked down with its elongated snout.

PRETTY IN PINK ►

The most difficult and frustrating members of the family to find, observe and photograph are the minute pygmy seahorses. Eight species of these tiny seahorses have so far been described, and most are less than 2cm (0.8in) tall. The first discovered, and the most widespread, is the delightful Bargibant's Pygmy Seahorse (*Hippocampus bargibanti*). Only found on one type of gorgonian fan (*Muricella* sp.), these tiny critters have a skin pattern and nodules that match their chosen home, making them incredibly difficult to find. They are also generally found in pairs, but no matter how long I searched I couldn't find the partner of this beautiful pink Bargibant's Pygmy Seahorse, which I photographed off Port Moresby, Papua New Guinea.

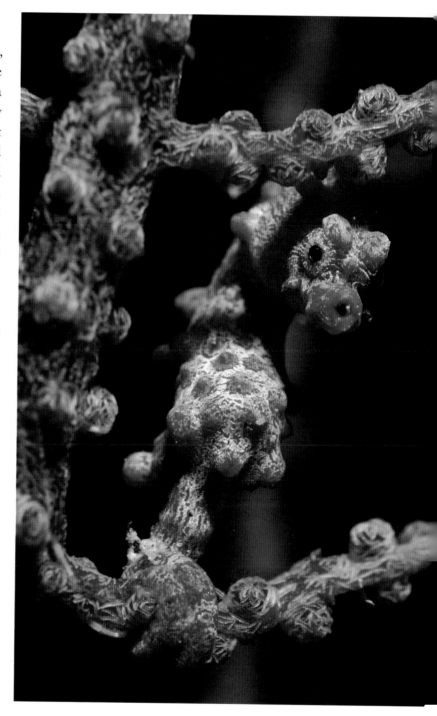

▼ THE FAN DANCER

The camouflage of pygmy seahorses is quite extraordinary, and even when they are pointed out you can quickly lose sight of these tiny animals. Sometimes they give themselves away by swimming or dancing, like this Denise's Pygmy Seahorse (*Hippocampus denise*). A very sharp-eyed dive guide located this one off Bali, Indonesia, and as we watched it slowly swayed back and forth like it was dancing to a secret beat.

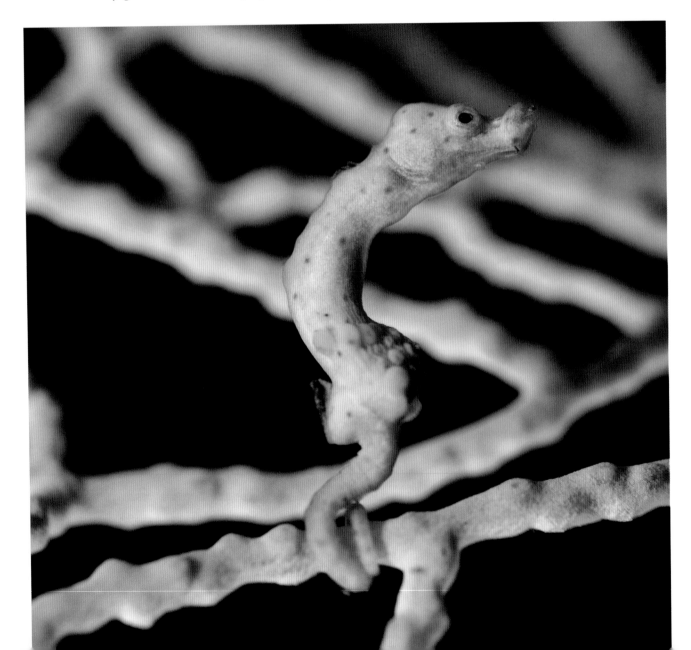

SEADRAGONS

The magnificent seadragons are only found in the cool waters of southern Australia. These beautiful relatives of the seahorses look very similar to their cousins, but lack the prehensile tail and are covered in weed-like growths. Three species of seadragons have been discovered, but only two are regularly seen by divers. Although these creatures grow to more than 30cm (12in) in length, their superb camouflage makes them difficult to locate.

▼ STUCK ON YOU

Seadragons follow a reproduction strategy similar to that of seahorses, with the male looking after the eggs. Instead of using a brooding pouch, the male sticks the eggs to its tail, as can be seen on this Weedy Seadragon (*Phyllopteryx taeniolatus*) encountered off Eaglehawk Neck, Tasmania. The purple eggs take about a month to hatch, and young seadragons are sometimes found hidden among kelp and seaweed.

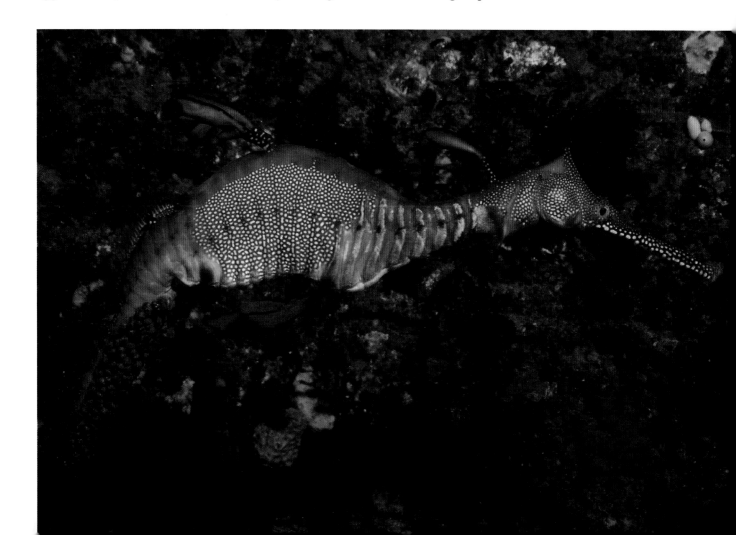

▼ NIGHT TIME SNACK

Often the easiest way to find a Leafy Seadragon (*Phycodurus eques*) is to look for their food – mysid shrimps. It may seem strange that the best strategy is to look for tiny shrimps that are only a few millimetres long, especially when the Leafy Seadragon grows to 35cm (14in) in length. However, with its weed-like appendages, 'leafies' are so well camouflaged that even small fish hide among their growths. I have spent many dives in southern Australia looking for Leafy Seadragons, and only found this one on a night dive at Edithburgh, South Australia, because I found a swarm of mysid shrimps. Locating the shrimps I flashed my torch around the nearby seaweed and found this beautiful seadragon consuming every shrimp that came within range of its snout.

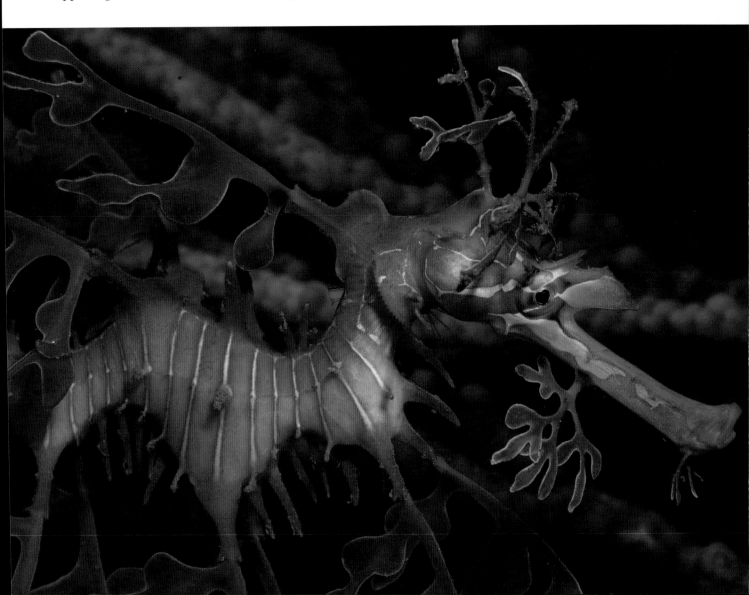

BASSLETS

Basslets are closely related to gropers, but are brightly coloured and much smaller than their large cousins. Only found in the Indo-Pacific region, basslets are always seen in large schools that gather over coral heads. These pretty fish are wonderful to watch as they dart about feeding on plankton.

▼ HAREM MASTER

All basslets are born as females and live in a school with one dominant male. The males are more colourful than the females, so easy to spot as they patrol their harem. If the male dies, a dominant female changes sex and takes his place. I encountered this harem master, a lovely Redbar Basslet (*Pseudanthias rubrizonatus*), at Mooloolaba, Australia. I always enjoy photographing basslets, but they can be a little flighty. The males are especially busy, tending their flock of females, checking on rival males, grabbing food as it floats past, and watching out for predatory fish.

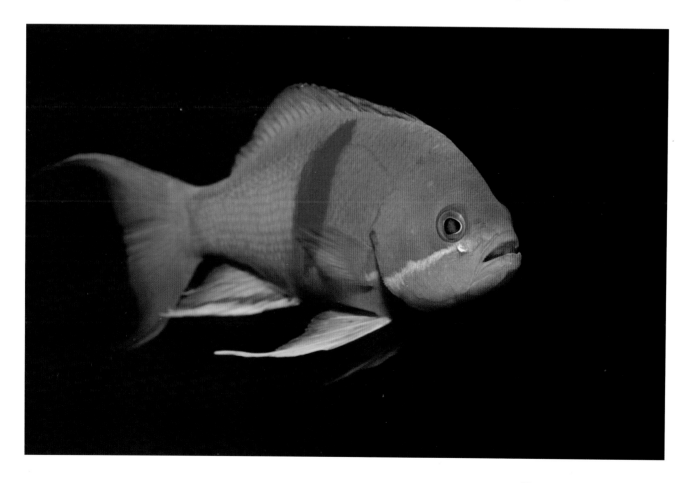

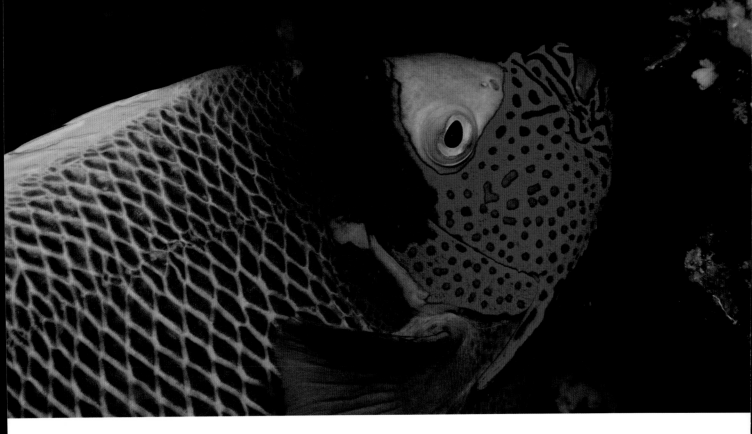

ANGELFISH

Some of the most beautiful fish that divers encounter on coral reefs are the lovely angelfish. These multi-coloured creatures have a style and grace of their own and are wonderful to watch as they patrol the reef. About 85 species of angelfish are known, and they feed on a variety of different food items depending on the species.

▲ PICKY EATER

While angelfish are lovely to look at, they rarely do anything exciting like fighting or mating in front of divers. About the most interesting thing you will see angelfish doing is eating. Diving in the Maldives I encountered this lovely Yellow-mask Angelfish (*Pomacanthus xanthometopon*) inspecting the ceiling of a cave for things to eat. This species eats sponges, algae and tunicates, and it was interesting to watch it picking and choosing tasty morsels. It was so focused on feeding that it allowed me to get very close for this portrait.

44

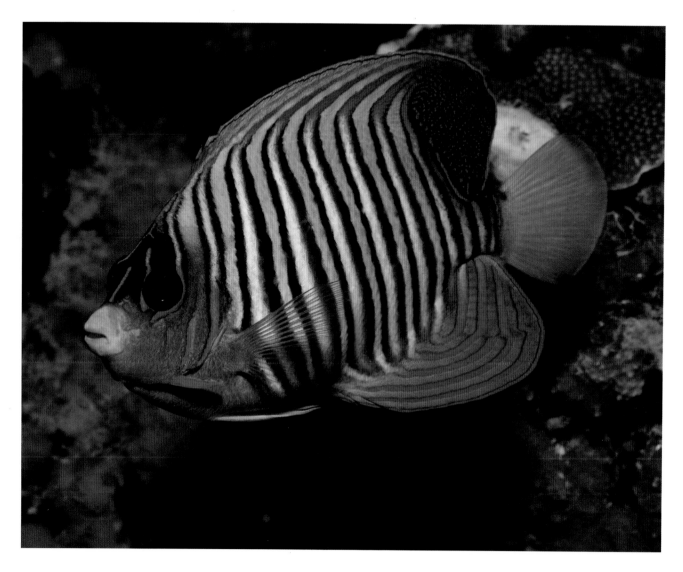

▲ TEST-PATTERN FISH

Angelfish have incredible patterns and even have radically different juvenile colour phases. Arguably the most spectacular is the stunning Regal Angelfish (*Pygoplites diacanthus*). This beautiful species is common throughout the Indo-Pacific region, and its pattern is more elaborate than any test pattern. I always enjoy observing Regal Angelfish, but they are elusive fish to photograph, and will quickly disappear into a hole if they feel threatened. Occasionally I have been fortunate to encounter a curious Regal Angelfish, like this one photographed off Port Moresby, Papua New Guinea, that remained still long enough for me to appreciate its brilliant patterns.

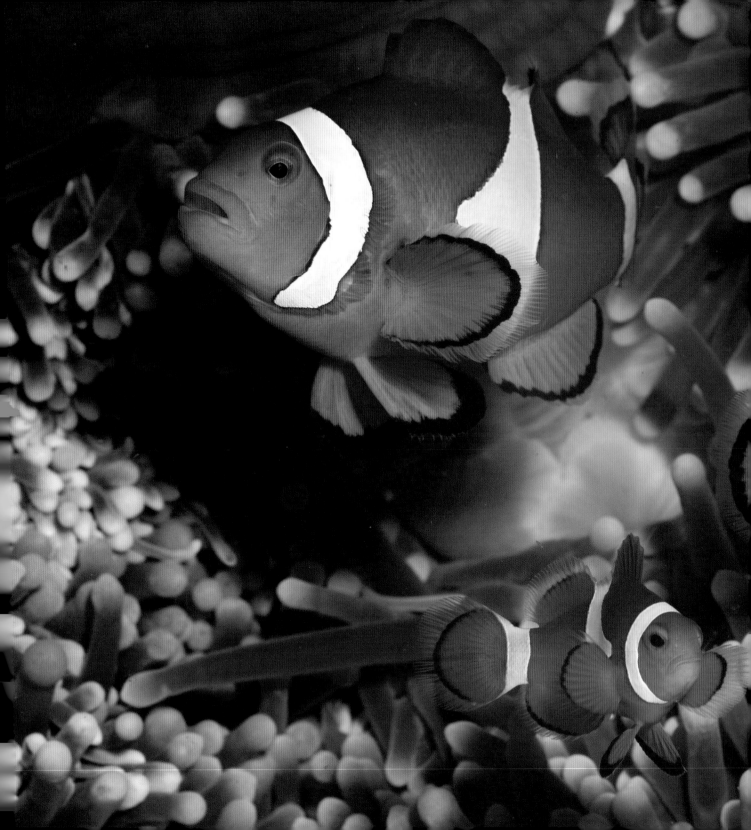

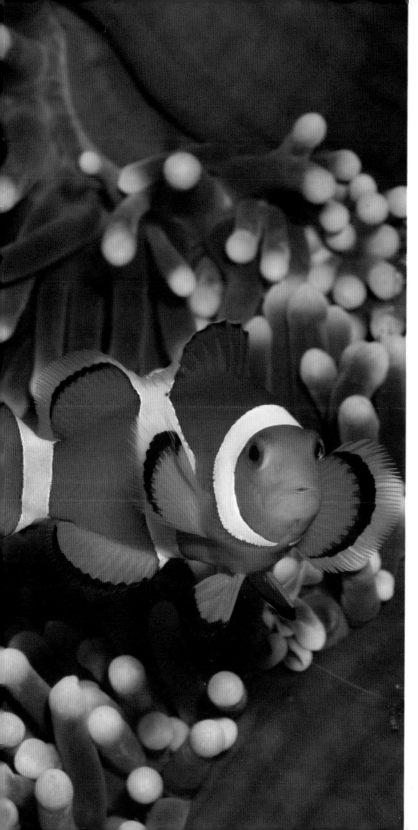

ANEMONEFISH

There are many beautiful fish in the sea, but one particular family has captured the hearts of people around the world since the film Finding Nemo – the lovely anemonefish. Members of the damselfish family, 30 species of anemonefish are found throughout the Indo-Pacific region, living in a symbiotic relationship with sea anemones. Anemonefish are easy to get close to, but some are shy and hide in the tentacles of their home, while others are very territorial.

◄ NEMO HAS A SEX CHANGE

The most popular and one of the most beautiful of all the anemonefish is the Western Clown Anemonefish (*Amphiprion ocellaris*). Common throughout South-East Asia, I encountered this typical group while diving at Sogod Bay, Philippines. At top is the large female, on the right is her male partner, and the small fish at the bottom is not their offspring, but a juvenile male in waiting. You see there was one small problem with the film *Finding Nemo* – when Nemo lost his mother, his father should have changed sex to take on that role!

The sea anemone is ruled by a very dominant female anemonefish. She has a smaller male partner who she breeds with, and he looks after the eggs. They also live with a brood of smaller juvenile males, which help to clean and defend the sea anemone. When the female dies, her male partner changes sex to become a female, while one of the juvenile males steps up to take his place.

▼ THE DOTING DAD

Anemonefish fathers are very attentive parents when looking after the fertilised eggs that contain their developing young. The only part the mother anemonefish plays in the process is laying the eggs under the protective folds of the sea anemone. As the eggs develop the father constantly checks them, cleans them and picks off any bad eggs. He even fans and flushes them to ensure a good oxygen supply, as can be seen in this image of a Pink Anemonefish (*Amphiprion perideraion*) encountered on the Ribbon Reefs, Queensland, Australia. However, these parental responsibilities have their limits, as once the babies hatch (six to ten days after being laid) they are on their own, drifting with the currents until they find a new sea anemone home.

LEOPARD SHARK

*Most people wouldn't consider a shark to be beautiful, but then most people haven't encountered a Leopard Shark (*Stegostoma fasciatum*). With a decorative leopard-like skin pattern and a very docile nature, Leopard Sharks are amazing creatures to encounter. Found throughout the Indo-West Pacific region, they grow to a length of 2.5m (8.2ft) and are also known as Zebra Sharks on account of the young having zebra-like stripes.*

▼ SPEED BUMPS

Leopard Sharks are not the easiest of sharks to find, as over most of their range they are rarely seen. However, there is one spot where they gather in large numbers – a stretch of coast off the eastern seaboard of Australia from Gladstone, Queensland, to Byron Bay, New South Wales. Throughout this area are reefs where Leopard Sharks gather in large numbers, but the main hot-spot is at a site called Manta Bommie off Brisbane, where this image was taken. At this location divers can see dozens of Leopard Sharks, often resting on the bottom side-by-side, like living speed bumps. However, they only gather in this region during the warmer months. When the water cools they head north to the warmer waters of the Great Barrier Reef.

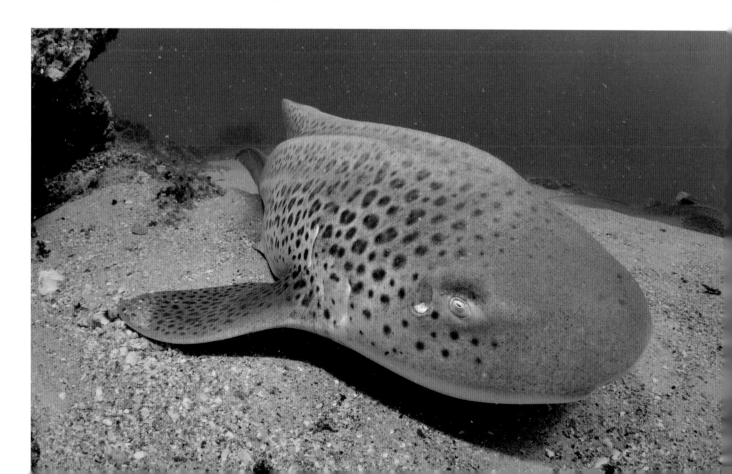

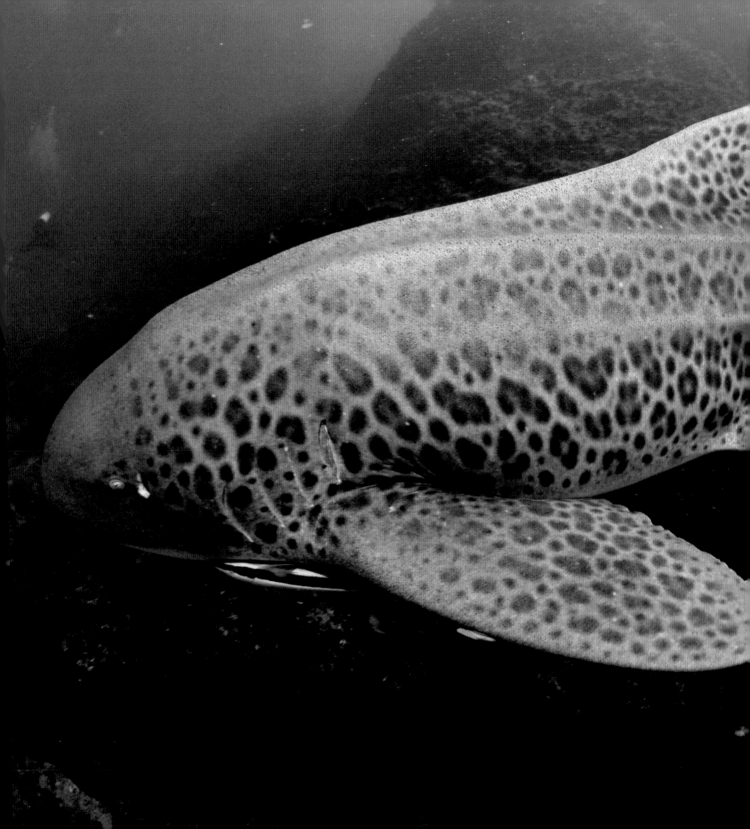

◀ LOOKING FOR LOVE

Leopard Sharks feed at night on molluscs, crustaceans and fish, and generally rest on the bottom during the day. They can be quite active by day, like this one encountered at Byron Bay, especially when love is in the water. Leopard Sharks seem to get romantic off Brisbane at the start of summer, as I discovered on a dive at Flat Rock. Jumping into the water the last thing I expected to see were 40 Leopard Sharks cruising around the reef. At first I thought they were just swimming around because there was a current, but when I saw a group of males closely following a female I knew I was witnessing something very rare – shark courtship. I stayed with the sharks for more than an hour, and saw plenty of following behaviour, but unfortunately no mating, which probably happens away from prying eyes.

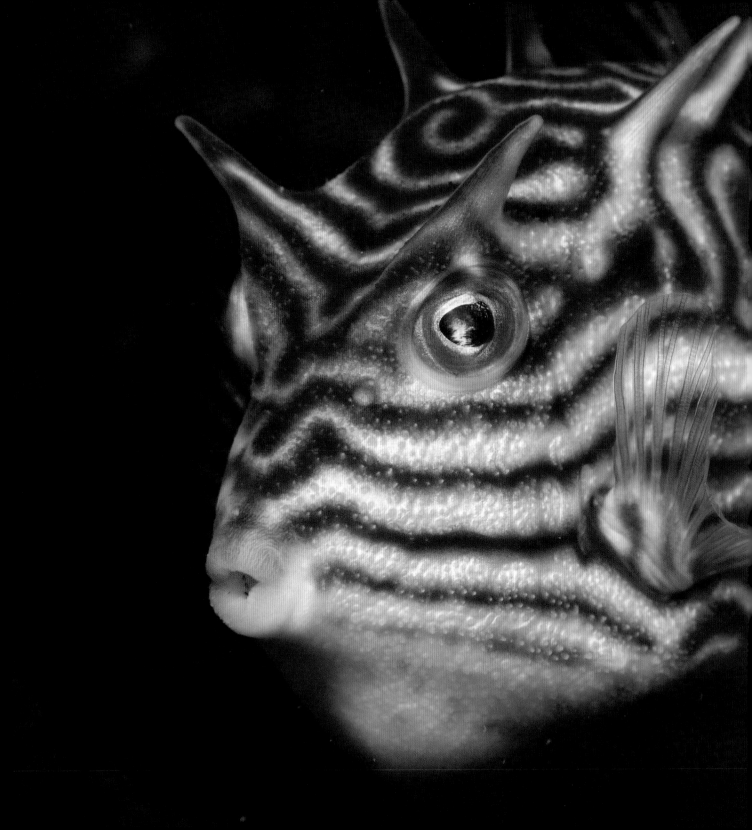

THE CUTE

The oceans are full of amazing animals, but there are some that are just plain cute. These creatures' cuteness comes from their adorable looks – large eyes, kissable lips, pretty patterns and fancy features. Many of these critters are also very docile, which adds further to their cuteness factor.

● ● ● ● ●

CUTTLEFISH

The smartest invertebrates of all also happen to be the cutest – the wonderful cuttlefish. These remarkable members of the mollusc family are closely related to octopus and squid, and grouped together in the class cephalopod. More than 120 species of cuttlefish have been identified and they vary in length from 5cm (2in) to 1m (3.3ft). Often referred to as the chameleons of the sea, cuttlefish can instantly change the colour and texture of their skin to blend into any background.

▼ THE GUNSLINGER

Cuttlefish capture prey such as fish, crabs and shrimps by using their two long feeder tentacles. Most cuttlefish are too shy to feed in front of divers, or possibly divers scare off their prey. The exception, however, is the Flamboyant Cuttlefish (*Metasepia pfefferi*), which doesn't seem to care about the presence of divers and feeds on regardless. The Flamboyant Cuttlefish in this image was encountered feeding at Anilao, Philippines. It was fascinating to watch it in action, as these small cuttlefish don't swim as much as their cousins, instead slowly walk across the bottom using their arms and body mantle like feet. This one was feeding on tiny shrimps and once the prey was within range the cuttlefish would shoot out its feeder tentacles like an underwater gunslinger.

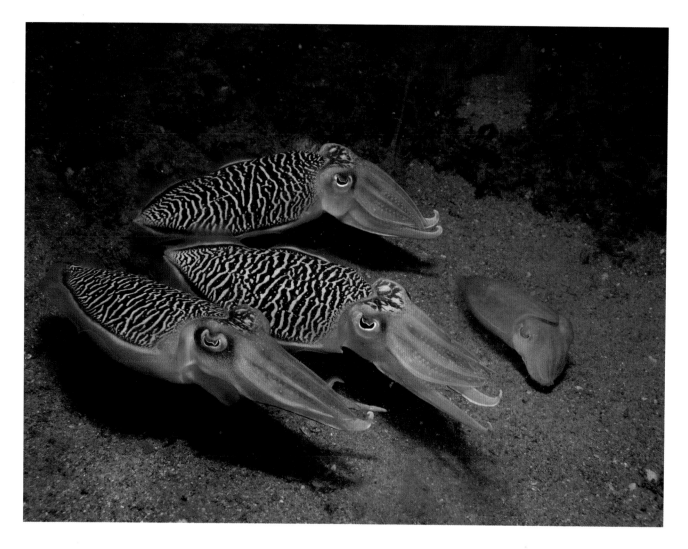

▲ MATING RITES

Cuttlefish only live for one to two years, but they pack a lot into their short lifespan, including very elaborate mating rituals. When the time comes to breed the males compete, with only the biggest and strongest winning a mate. In this image, taken at Port Stephens, Australia, three male Mourning Cuttlefish (*Sepia plangon*) are battling to win the hand, or tentacle, of the smaller female on the right. The males display to each other, showing off their finest colour patterns and puffing themselves up to look bigger. They rarely come to blows, as the smaller males eventually stand down and search for another fight they have more chance of winning. The winning male may have to fend off dozens of other males during the breeding season in order to ensure that his genes get passed on to the next generation.

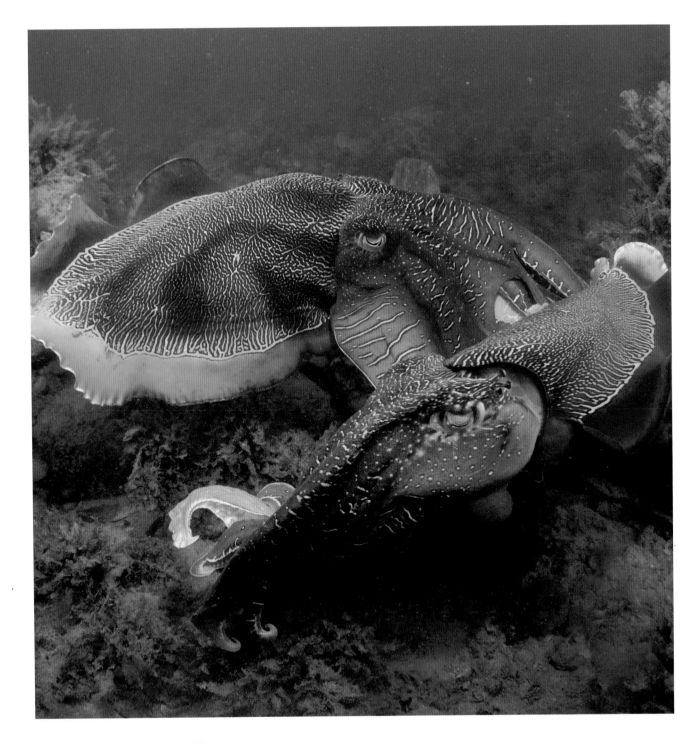

◄ BATTLE OF THE GIANTS

The largest member of the cuttlefish family is only found in southern Australia and is appropriately called the Giant Cuttlefish (*Sepia apama*). These large molluscs can grow to more than 1m (3.3ft) in length and are easy to approach as they are very curious creatures. The best place to see Giant Cuttlefish is around Whyalla, South Australia, as thousands gather to breed in this area each winter.

This annual breeding gathering is quite a spectacle, and easily accessible from the shore. One of the most interesting parts of the event is watching the huge males battling for the right to mate. These males flatten their bodies to make themselves look bigger and flash a dazzling display of different shades and patterns over their bodies, as can be seen in this image. They slowly swim around each other, deciding which is the largest and most powerful. These displays can last several minutes, and eventually one of the males concedes defeat and swims off to contest another battle.

CROSS-DRESSING CUTTLEFISH ►

When mating, a pair of cuttlefish lock together in a tangle of arms, as can be seen in these Giant Cuttlefish at Whyalla, Australia. While embracing, the male inserts a modified arm into the body cavity of the female and deposits a package of sperm. The female then lays her eggs under a ledge and sadly dies. In a fascinating twist, the male cuttlefish depicted in this image didn't win the right to mate by being the biggest or strongest – he got to mate by cross-dressing!

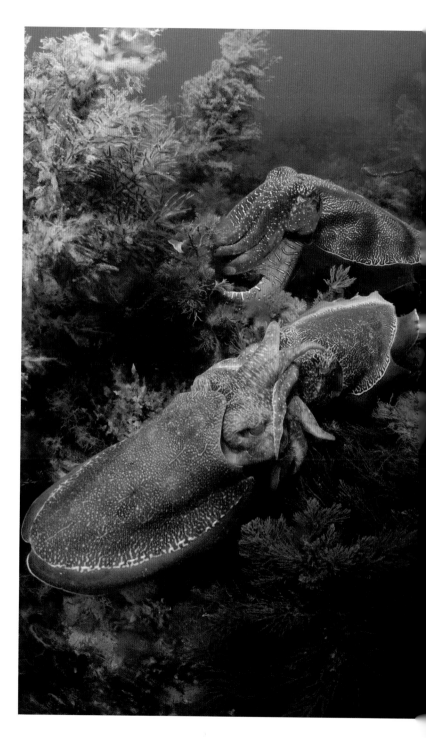

57

Cuttlefish are renowned for their intelligence, and small Giant Cuttlefish males have to use their wits to outsmart the big males. These males have learnt to disguise themselves as females. This allows them to sneak under the guard of the large males and get close to the girls. While the big male is thinking that he suddenly has two girlfriends, the small male is busy reverting to male colours and mating with the female. In this image the big male is the one looking on behind them. It took him more than a minute to catch on, at which point he chased off the smaller male.

▼ FROM THE SAND

The cuttlefish family contains a number of small species which have the word 'squid' in their name, including the bottletail squid, bobtail squid and pygmy squid. These small cuttlefish are nocturnal, unlike other cuttlefish that are active during the day, and many spend the daylight hours hidden in the sand. One of the cutest of these small cuttlefish is the brilliant Striped Pyjama Squid (*Sepioloidea lineolata*). Only found in southern Australia, this gorgeous creature grows to a maximum length of 7cm (2.8in). It took me many years of diving in southern Australia before I encountered my first Striped Pyjama Squid, but I finally found quite a few at Edithburgh, South Australia, which is where this one was photographed. I was instantly captivated by their striking pattern and small white eyes that watched me very carefully as I took photographs. I soon discovered that Striped Pyjama Squid are quite shy and don't like bright lights, as they all quickly reburied and waited for me to go away.

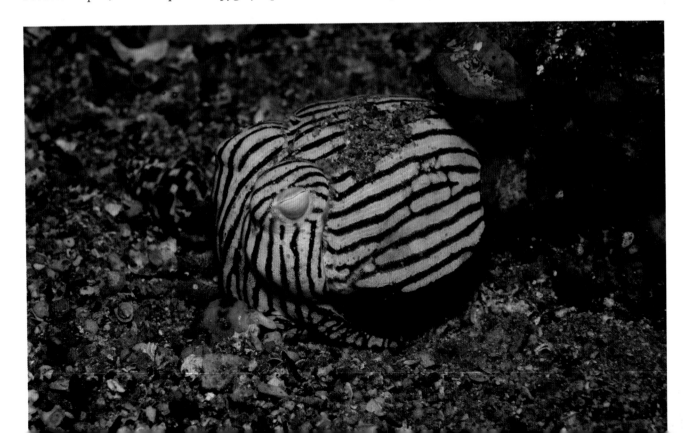

HARLEQUIN SHRIMPS

*Many brightly coloured shrimps are very cute, but the cutest of the bunch is the exquisite Harlequin Shrimp (*Hymenocera picta*). Found on coral reefs throughout the Indo-Pacific region, these beautiful shrimps are like no other with their purple spots, paddle-like claws and flag-like antennae. Harlequin Shrimps generally shelter under rocks and corals, making them difficult to find, and are always found in a male and female pair.*

▼ SEA STAR SNACK

The best indication that Harlequin Shrimps are in the area is if sea stars with missing limbs are found. These little shrimps feed exclusively on sea stars. Their favourite part of the sea star is the soft tube feet, but they can consume the entire sea star by tearing it apart with their powerful claws. Often the sea stars will shed an arm to escape, which they later regrow. I encountered this pair off Bali, Indonesia. In this image the female on the right is nibbling on a discarded arm, while the male is still feeding on the sea star.

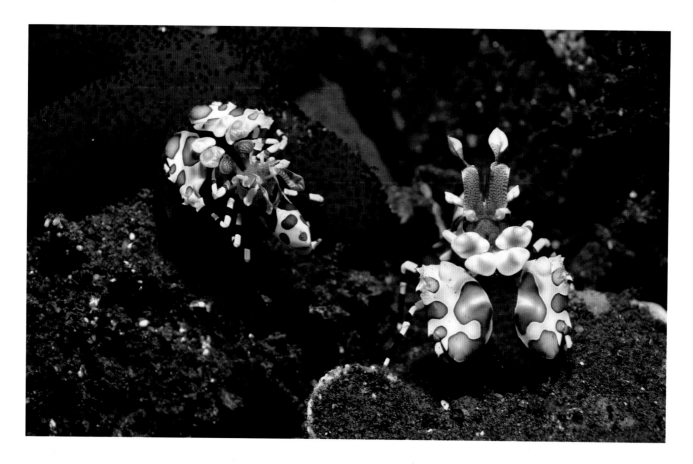

BLENNIES

With big eyes and lips that always seem to have a smile, it is easy to see what makes blennies very appealing. About 800 species make up the blenny family, and most of these fish are very small. Blennies typically have an elongated body and some can even be mistaken for eels. Most blennies live in holes, which can be in coral, rocks or sand, but they leave their holes to feed and are often encountered on a high perch.

◀ PEEK-A-BOO

Photographing blennies can sometimes be a challenge. When they are in their home, with just their head exposed, they feel safe enough to allow divers to approach very close, as they can quickly escape if required. Others are happy to sit on a rock and let you get close once they realise you are no threat. Some like to play hide-and-seek with divers. I encountered this Banded Blenny (*Salarias fasciatus*) while exploring Lembeh, Indonesia, following it across the reef as it popped in and out of the corals. The blenny finally became accustomed to my presence, and allowed me to get close enough for this portrait in a peek-a-boo moment.

▼ CROWDED LOOKOUT

Blennies are often encountered perched high on a coral outcrop. From this vantage point they can survey the area and keep an eye out for food. Many blennies feed on tiny plankton and zooplankton, and regularly dart off the bottom to snatch a tasty morsel. Diving in Lembeh, Indonesia, I found this Triplespot Blenny (*Crossosalarias macrospilus*) positioned on a prime lookout location. Just as I was about to photograph the blenny it was suddenly joined by an unexpected friend – a small Cylindrical Grubfish (*Parapercis cylindrica*). The blenny was not impressed with the company and swam off to find its own private lookout.

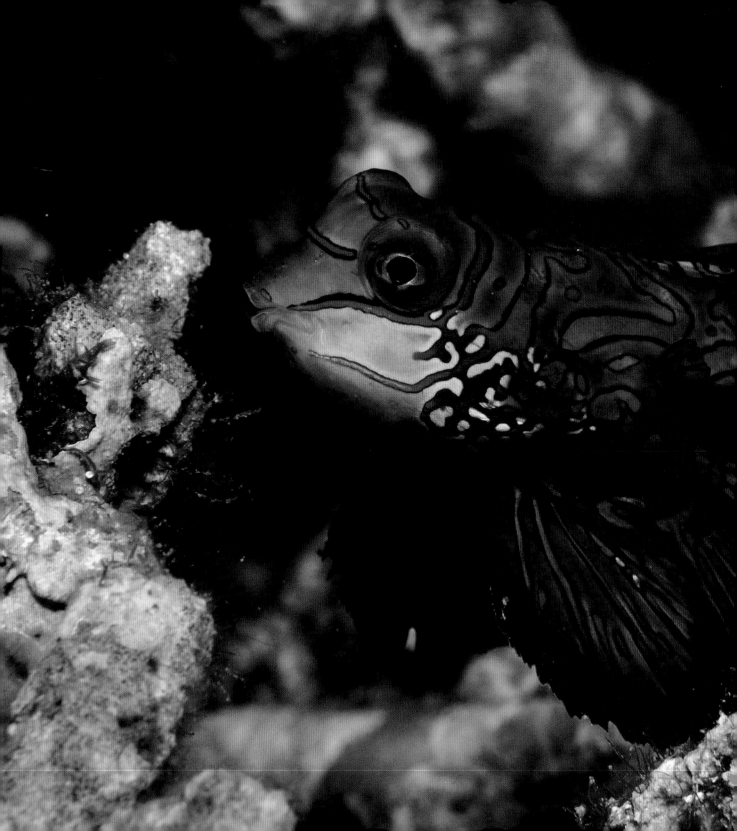

DRAGONETS

Dragonets are some of the prettiest fish a diver can encounter in the Indo-Pacific region. The dragonet family contains 140 species, and all these small fish lack scales and instead have slimy skin. This slime is thought to deter predators as it has a strong odour, and is also the reason for their other nickname of stinkfish. Most dragonets are bottom-dwellers that move slowly in search of food, which generally consists of small crustaceans.

◀ IN THE MANDARIN'S COURT

Almost all dragonets have elaborate patterns, but the most colourful member of this family is the Splendid Mandarinfish (*Synchiropus splendidus*). These gorgeous creatures have an incredible psychedelic pattern that really makes them stand out from the crowd. Splendid Mandarinfish spend most of the day hidden in branching hard corals. Most divers encounter them at night when they emerge to feed and mate.

It is extremely rare to see these cute little fish during the day, so I was very surprised to find a dive site in Lembeh, Indonesia, where the Splendid Mandarinfish are active during daylight hours. This image was taken at that wonderful dive site, which is known as Bianca. It was a magical experience to see dozens of these usually nocturnal fish slowly weaving among the branching coral. They were so relaxed that they continued to feed, as captured in this image.

GOBIES

With more than 2,000 species, the gobies represent the largest known fish family. These small fish are nearly always brightly coloured and look cute, so are great to photograph or simply observe. Many gobies live in burrows, but other species reside on corals. Although they are small, finding gobies is never a problem as they are everywhere on coral reefs, but getting close to them can be tricky at times.

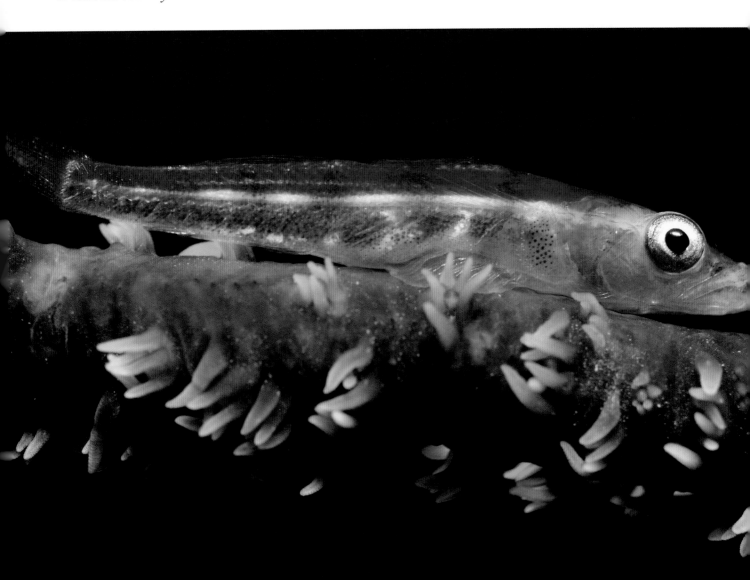

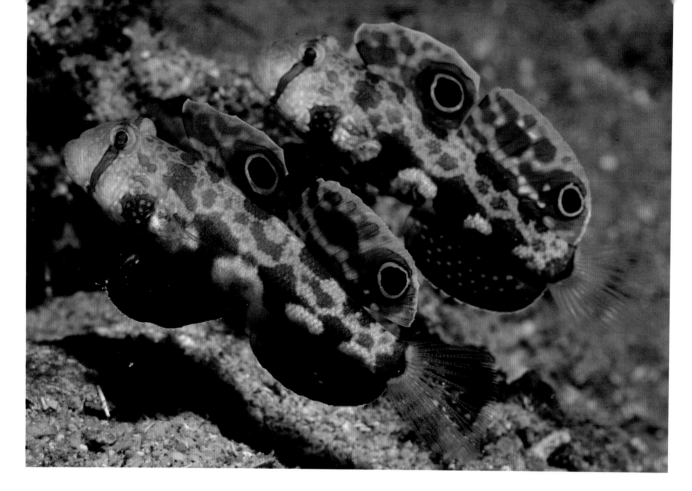

◀ LIFE ON THE WHIP

Sea whips (*Junceella* sp.) are elongated corals that look like a whip and are generally found in places with currents. The sea whip polyps feed on plankton and the sea whip itself often plays host to many small animals. A close look at a sea whip will reveal the presence of small cowries, shrimps and crabs, with the most common resident being the pretty Sea Whip Goby (*Bryaninops yongei*). I encountered this one while exploring the Ribbon Reefs, Australia. These small fish cling tenaciously to the sea whip using their pectoral fins, which act like a suction cap.

▲ CRAB CONFUSION

One of the cutest gobies found on reefs throughout the Indo-Pacific region is the Twin-spot Goby (*Signigobius biocellatus*). I encountered this delightful pair slowly moving across the bottom off Tufi, Papua New Guinea. Twin-spot Gobies live in the sand and move across the bottom using a rocking motion. This species is also known as the Crab-eye Goby as some think its rocking motion and fin spots are to make it look like a crab, although as crabs are prey for numerous other species this strategy doesn't make much sense. It is more likely that these are false eye-spots, designed to confuse a predator so they don't know which end is the head.

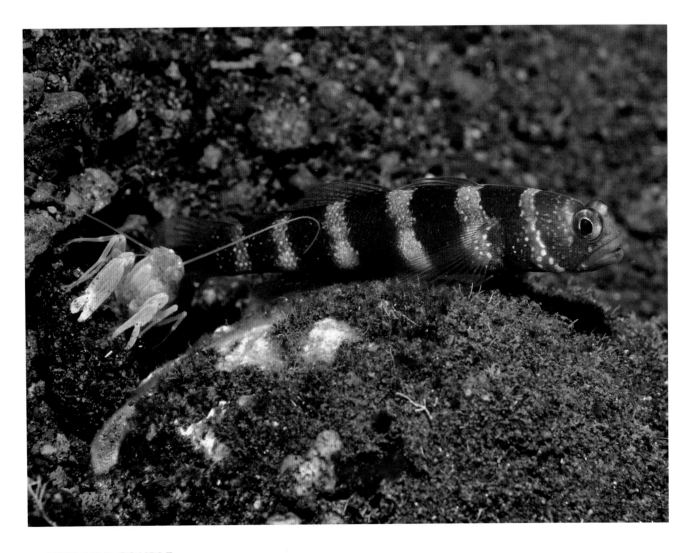

▲ THE ODD COUPLE

Many symbiotic relationships can be seen in the sea, with one of the easiest to observe being the strange relationship between shrimpgobies and snapping shrimps. This odd couple share a hole in the bottom, the goby providing guard duty while the shrimp maintains the home. How they formed this relationship is unknown, but commonly a pair of shrimps live with a pair of gobies. Always entertaining to watch, divers can often get quite close to the action by staying quiet and keeping movement to a minimum. Any sudden movement and the goby flicks its tail and the shrimp disappears. I encountered this Double-barred Shrimpgoby (*Amblyeleotris periophthalma*) and Fine-striped Snapping Shrimp (*Alpheus ochrostriatus*) off Bali, Indonesia.

66

DARTFISH

Close relatives of the gobies, dartfish differ in having prominent dorsal and anal fins. These pretty small fish live in holes in the bottom and hover above their burrows to feed on zooplankton. There are more than 40 species of dartfish, and most are wary of divers.

▼ FIN FLICKERS

The most common and also the prettiest member of the dartfish family is the lovely Fire Dartfish (*Nemateleotris magnifica*). These small fish are generally found in male and female pairs, but sometimes a small group can be found living together in the one burrow.

Fire Dartfish are often difficult to get close to, but this pair off Timor-Leste were unconcerned by my presence. Getting close I could watch them flicking their flag-like dorsal fins back and forth, which is thought to be a form of communication between these cute fish.

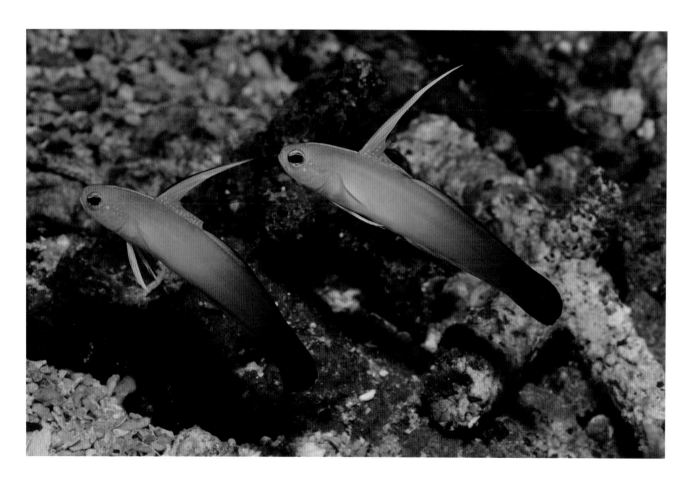

LEATHERJACKETS

Leatherjackets, or filefish, don't have scales like most fish species and instead have sandpaper-like skin. More than 100 species of leatherjacket have been described, with most species found in Australia. Some members of this family are shy and hide amongst the coral, but others are very bold and curious, and have been known to swim right up to divers and stare them in the eye.

▼ KISSING COUSINS

The cutest member of the leatherjacket clan would have to be the Pygmy Leatherjacket (*Brachaluteres jacksonianus*). Growing to a length of just 9cm (3.5in), this tiny creature is found only in the waters of southern Australia. Pygmy

Leatherjackets come in a range of colours and can change coloration to suit their background. I encountered this lovely golden pair off Sydney. They are especially cute at night, as they sleep by biting onto a piece of seaweed to avoid drifting off with the current.

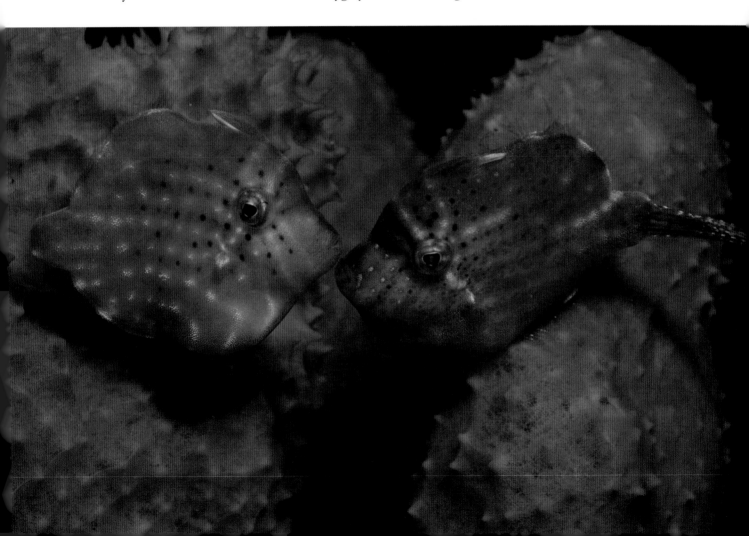

BOXFISH

With permanently puckered lips, boxfish are super cute fish that always look like they are ready for a kiss. These cuboid critters with protective plating are common on reefs, and being slow swimmers are often easy to approach. The boxfish family contains 23 species, including the equally cute trunkfish and cowfish.

▼ ROLL THE DICE

Boxfish are at their cutest when young, as they are more colourful, their eyes are bigger and their lips more pouty. The juvenile boxfish that divers most commonly encounter is the Yellow Boxfish (*Ostracion cubicus*). I encountered this one off Lady Elliot Island, Australia, and slowly followed it around as it ducked in and out of the coral. Every few minutes it would turn around to see where I was. Juveniles of this species look like living dice.

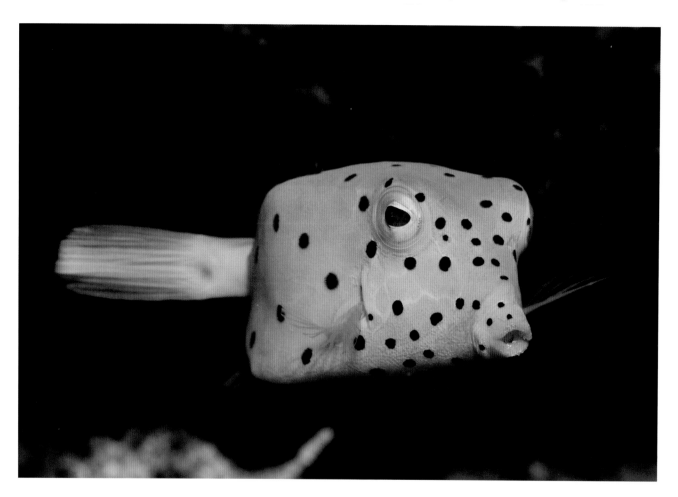

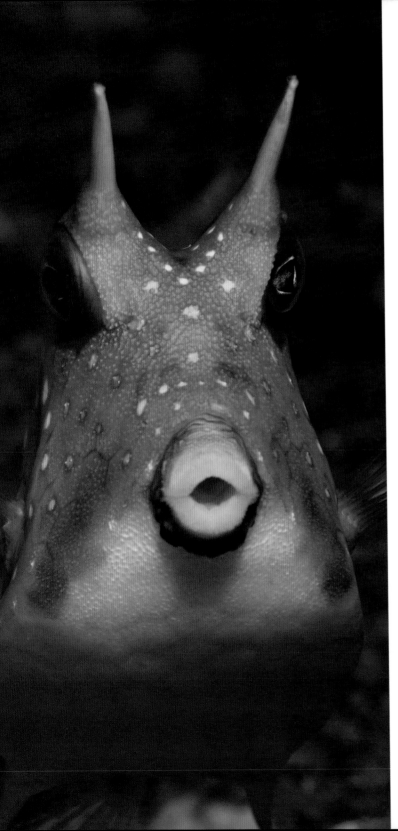

◀ STOP AND STARE

Cowfish are basically boxfish with horns, with these horns typically projecting from the head and body. Often found on sandy bottoms, cowfish feed on small invertebrates which they find by blowing away the sand. Most cowfish are easy for divers to approach and observe, and will often feed while a diver watches. I encountered this Longhorn Cowfish (*Lactoria cornuta*) off Anilao, Philippines, displaying another common cowfish behaviour – stop and stare. These curious fish will often stop what they are doing to stare at a diver, or turn around if being followed. This behaviour is great for photographers as it gives you a few seconds to capture a wonderful portrait of these fish.

SOUTHERN PUNK ▶

A number of unique cowfish are found in the waters of southern Australia. These cowfish are even more brightly coloured than their tropical cousins, with the males and females having different colours. I encountered this female Shaw's Cowfish (*Aracana aurita*) off Hobart, Tasmania. The male of this species has bright blue and yellow markings, but I much prefer the females with their browns, whites and creams. The Shaw's Cowfish also has more horns than most other species, which gives it more of a 'punk' look. Sometimes these horns work against them, however, as I once had to free one from a crevice after it had got wedged upside down by its horns!

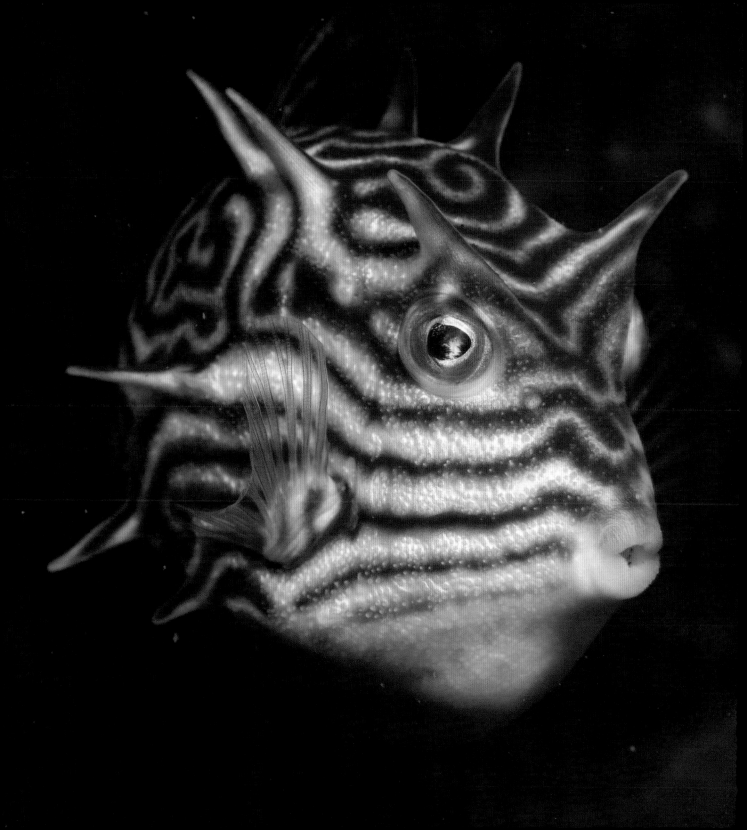

HORN SHARKS

People with a fear of sharks need to have a close encounter with a horn shark, as these small sharks are docile and completely harmless. Nine species of horn sharks have been described, and all have tiny teeth that are designed to crush the shells of molluscs and crustaceans. The only threatening part of a horn shark is their spines in front of the dorsal fins, but these blunt with age.

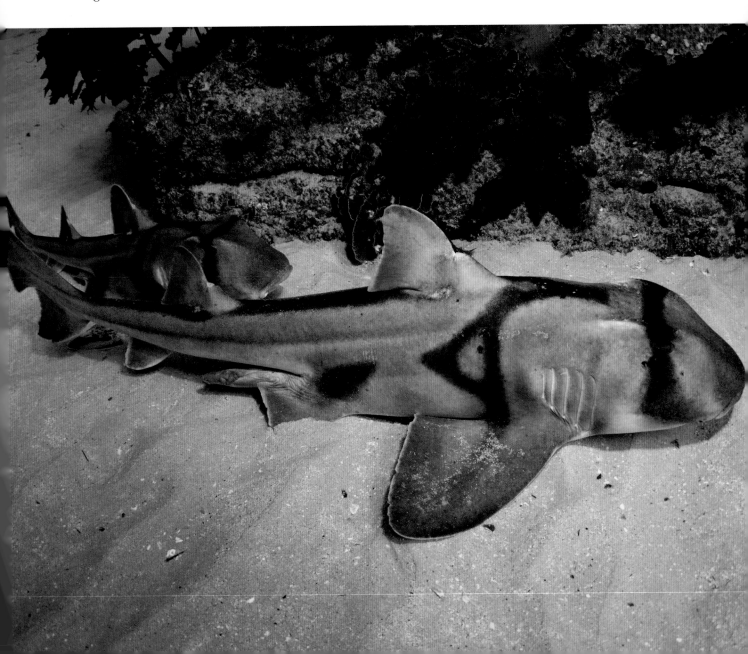

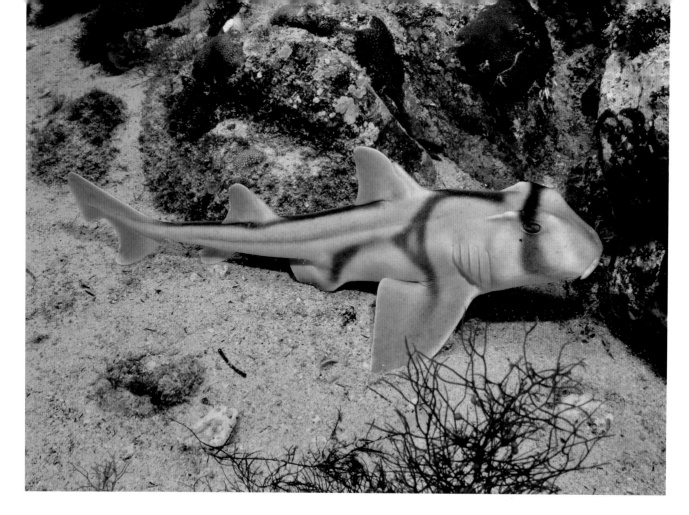

◀ A MASS GATHERING

The most common horn shark species found in Australia is the Port Jackson Shark (*Heterodontus portusjacksoni*). It is found widely in the country's southern waters and is the largest member of the family, growing to a length of 1.6m (5.2ft). Port Jackson Sharks are very easy to approach as they spend the day resting on the bottom or sheltering in caves. These sharks are most commonly seen in winter, when they gather en masse to breed. One of the best places to see this gathering is Jervis Bay, New South Wales, where this image was taken.

▲ A YOUNG SHARK

It is very rare to see juvenile sharks, as they are often eaten by larger relatives, but divers frequently encounter young Port Jackson Sharks in southern Australia. The species breeds from August to November, and after mating the females lay numerous spiral-shaped eggs, possibly as many as 16 over several weeks. The eggs then take about ten months to hatch, with the young Port Jackson Sharks about 23cm (9in) long when they emerge. The young sharks, which are much paler than the adults, are sometimes found in large groups, but I found this one all by itself at Montague Island, New South Wales.

73

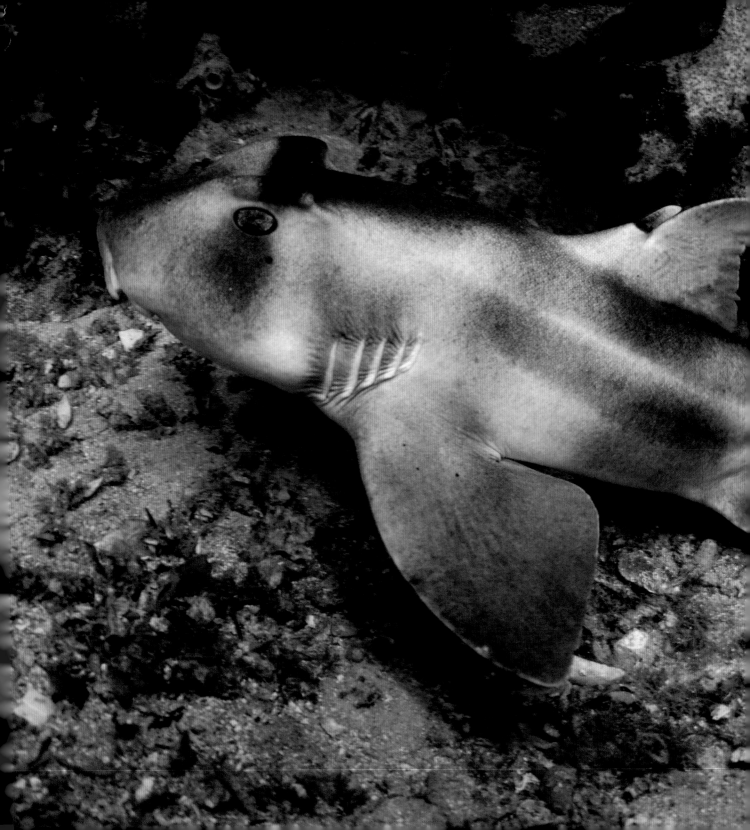

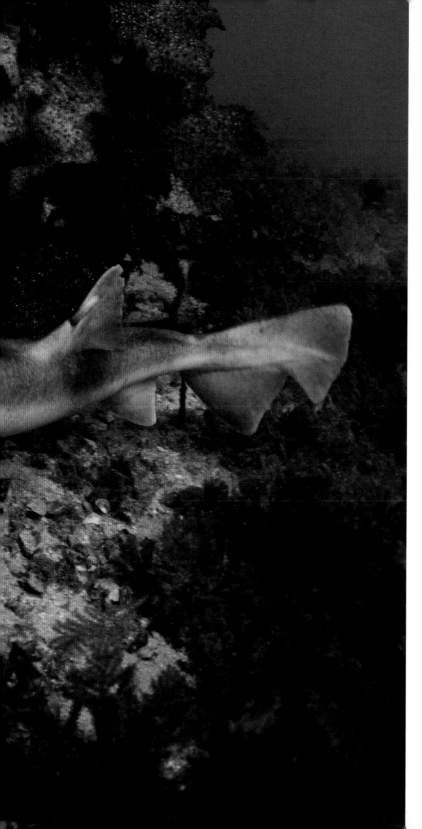

◀ THE EGG EATER

An elusive species of horn shark only found in New South Wales is the delightful Crested Horn Shark (*Heterodontus galeatus*). This species is most commonly encountered south of Sydney, especially during the winter months when they come into shallow water to breed. And at this time of year they have been observed eating something precious belonging to their cousin, the Port Jackson Shark.

I encountered the Crested Horn Shark in this image at Jervis Bay, as it was swimming around the kelp. I followed it for some time hoping to see it feeding, but it eventually settled on the bottom and started to slumber. However, other divers have observed Crested Horn Sharks devouring the eggs of Port Jackson Sharks. With hundreds of Port Jackson Sharks gathering in Jervis Bay to breed during winter, the Crested Horn Sharks, which usually feed on invertebrates, take advantage of the abundant supply of eggs. Studies have shown that 89 per cent of Port Jackson Shark eggs are eaten by a variety of marine animals, so their cousins are not the only culprits.

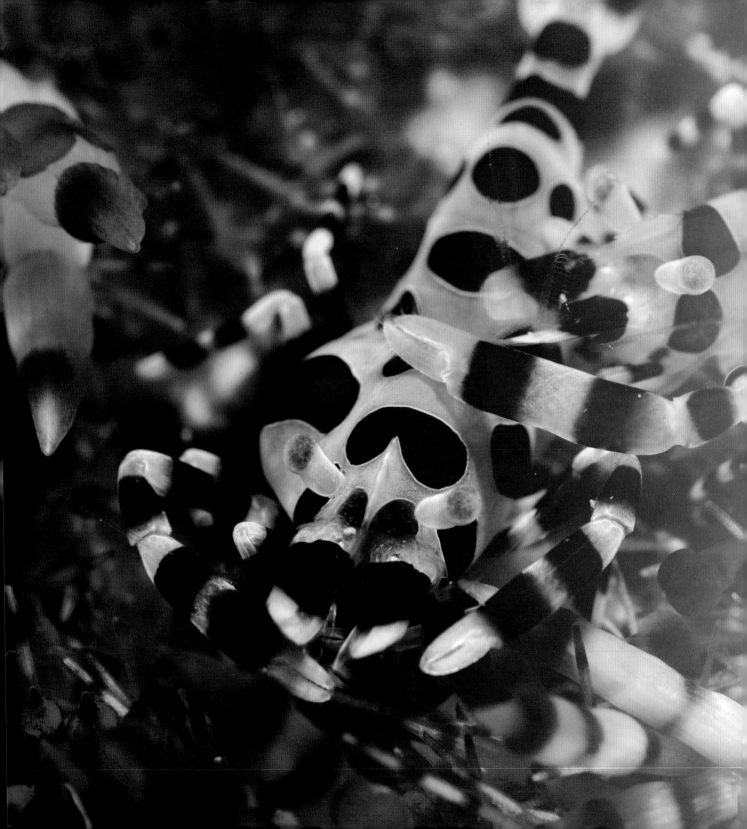

THE CRYPTIC

Many marine animals are very cryptic in their behaviour or via their camouflage. Some of these animals are shy and wary of predators, so have a cryptic nature to avoid getting eaten. Others use their cryptic camouflage skills to help them obtain food. These cryptic creatures are sometimes difficult to find, but confident in their camouflage they are nearly always easy to get close to.

• • • • •

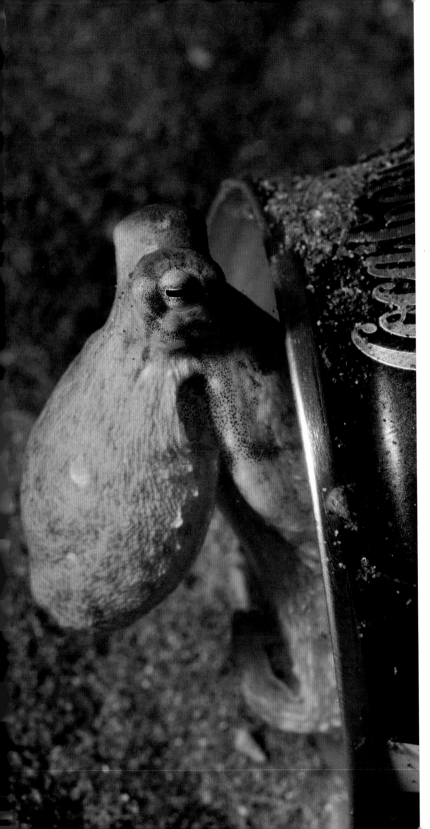

OCTOPUS

The most cryptic of all sea creatures would have to be the octopus. These molluscs are the masters of camouflage, able to change their skin colour and texture to match their surroundings. They use camouflage to avoid being eaten, but it also helps them to sneak up on prey. The octopus family contains more than 300 species that vary greatly in size and appearance. Most octopus are easy for divers to approach and many of these fascinating creatures enjoy interacting with divers.

◀ THINGS GO BETTER WITH

Southern Australia is home to a huge variety of octopus species, with most found nowhere else on the planet. Octopus in this area live in the sand, under rocks, in caves, in cracks, and even discarded cans. I encountered this Southern Keeled Octopus (*Octopus berrima*) residing in a can under Blairgowrie Pier, Melbourne. A popular fishing pier, many fishers give little regard to the environment and throw their rubbish into the sea. Fortunately, these discarded cans provide a home for octopus. I had a wonderful dive under the pier at night and found every discarded can – which was dozens – was home to a Southern Keeled Octopus. A thoughtless act turned to good use.

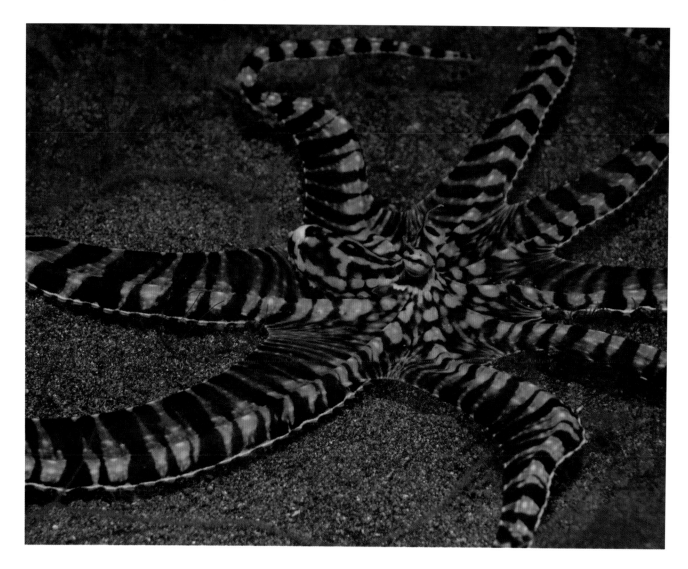

▲ *THE AMAZING MIMIC*

One of the most interesting of all the octopus was only discovered in 1998 – the incredible Mimic Octopus (*Thaumoctopus mimicus*). Only found in the Indo-West Pacific, this species lives on sandy bottoms and is often active by day. Camouflage against plain sand is not an easy trick, so this clever creature instead mimics dangerous animals to keep predators away. Studies have shown that the Mimic Octopus can imitate 15 different animals, including lionfish, sea snakes, stingrays and sea jellies. I encountered this one wandering over the sand at Anilao, Philippines. I spent more than ten minutes with it, but I obviously wasn't threatening enough as it didn't mimic any other creature, apart from an octopus.

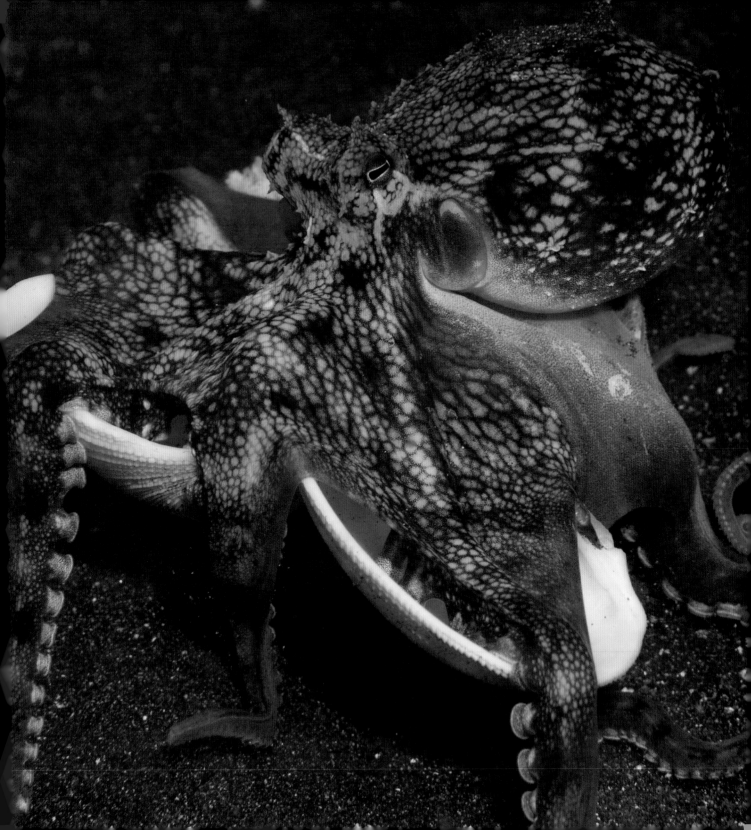

◀ THE MOBILE HOME

Octopus are very intelligent creatures and can easily solve puzzles, and the most intelligent member of the family must be the Coconut Octopus (*Octopus marginatus*). Found throughout South-East Asia, this is the only invertebrate that uses tools. I encountered this one at Lembeh, Indonesia, walking around with its home. The octopus had gathered three half cockle shells as a home, and rather than someone claiming them while it was looking for food, the octopus carried the shells with it. After walking around for several minutes the octopus finally settled on the bottom and closed the shells around itself for protection. Coconut Octopus also use coconuts, tins and rocks in this way.

▲ PICNIC BLANKET

Octopus stalk prey in a number of ways. Mostly they sneak up and attack, entangling their prey with their arms. However, I witnessed another method they use while diving in the Maldives, which I like to call the picnic-blanket technique. I encountered this Day Octopus (*Octopus cyanea*) creeping across the rocky bottom when it suddenly stopped and enveloped a rock with its arms. With its arms splayed, it looked like someone had thrown a picnic blanket over the rock. The octopus was trying to trap prey hidden under the rock. As I watched, it used this hunting technique three more times, but it didn't appear to catch anything. By then, a few more divers had gathered around to watch the octopus at work, and it got nervous and disappeared into a hole.

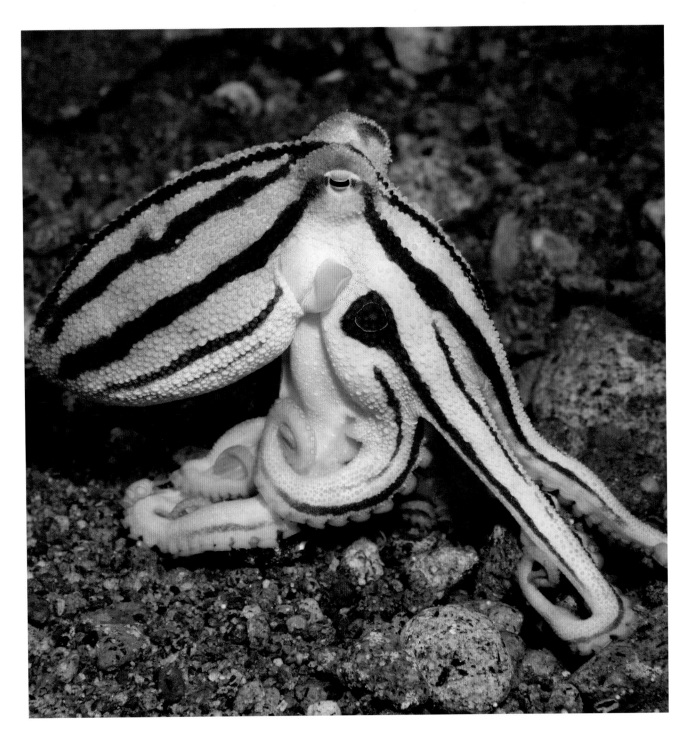

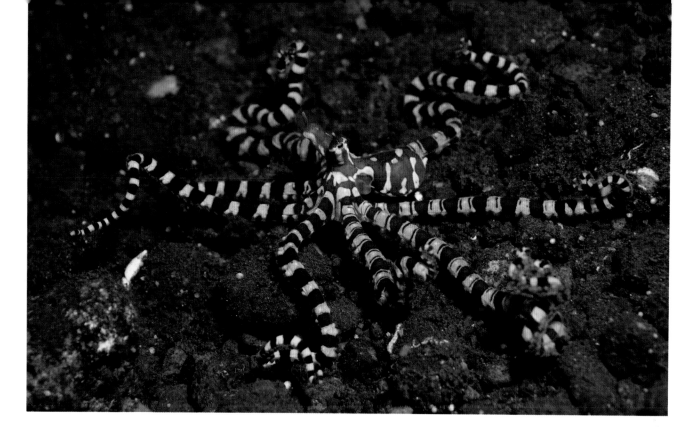

◀ MATING STRIPES

One of the rarer octopus found in South-East Asia is the Mototi Octopus (*Octopus mototi*). Thought to be a close relative of the blue-ringed octopus, the Mototi Octopus is possibly venomous. It took me many years to finally encounter one of these elusive molluscs, and that first encounter was very brief. So I was very surprised to dive a site off Dumaguete, Philippines, and find four very sociable Mototi Octopus. I found that I could get very close to them without them disappearing into the rubble, as they were too busy getting romantic. This male, displaying his nice striped suit, was courting a nearby female. Unfortunately this was no speed dating, as he didn't appear to be in any hurry while I was watching. A week later I heard that his mate could be seen guarding a clutch of eggs.

▲ WANDERING ARMS

The wandering arms of octopus literally have a mind of their own. Octopus arms are mainly used for movement and to capture meals, and are often sent into dangerous areas in search of prey. While the octopus has a brain and controls where its arms are going, recent research has found that the arms also have a say in what they are doing. Researchers found that two-thirds of the neurons that make up the octopus' nervous system are actually found in the arms. This means that the arms think for themselves and react to situations to avoid danger or identify prey. It is always fascinating to watch octopus arms probing for prey, like those of this Wonderpus (*Wunderpus photogenicus*) encountered off Bali, Indonesia. You can understand why each arm has to think for itself, with eight of them searching in eight different directions.

SEA SPIDERS

They may look like a spider, but sea spiders are a different class of arthropod with some different features. These strange creatures are found in all oceans, with more than 1,300 known species, but are easily missed due to their cryptic nature. Sea spiders have a tiny body and a head so small it is often difficult to tell the front from the back.

▼ EGG BEARER

Sea spiders feed on corals, sea anemones, sponges and bryozoans using a proboscis to suck out nutrients. Being slow walkers, they never stray far from their food source, so this is the best place to find them. I encountered this Orange Sea Spider (*Pseudopallene* sp.) at South West Rocks, Australia. This one is a male, and the only reason I can tell is by the yellow eggs under its belly. Much like seahorses, sea spider males look after the eggs after mating.

COMMENSAL SHRIMPS

Commensal shrimps are always found living on other creatures. These small and colourful shrimps are most commonly found on sea anemones, but will also reside on sea pens, soft corals, sea whips, echinoderms and molluscs. Some members of this family are very easy to find and observe, but others are much more cryptic.

NUDI RIDER ▶

One of the most striking members of the commensal shrimp family is the Imperial Shrimp (*Periclimenes imperator*). Growing to only 3cm (1.2in) in length, these small shrimps are most commonly found clinging to sea cucumbers. They generally feed on plankton and algae, but will also eat the faecal matter of their host. The ones on sea cucumbers are sometimes hard to find, as they often hide on the underside of the animal. Occasionally Imperial Shrimps are also found riding nudibranchs, and these are much more conspicuous. I encountered this Imperial Shrimp riding the tail of a Purple-dotted Chromodoris (*Chromodoris aureopurpurea*) off Bali, Indonesia. Also known as Emperor Shrimps, you can see how they got this name as they look like a member of the royal family regally riding their mount.

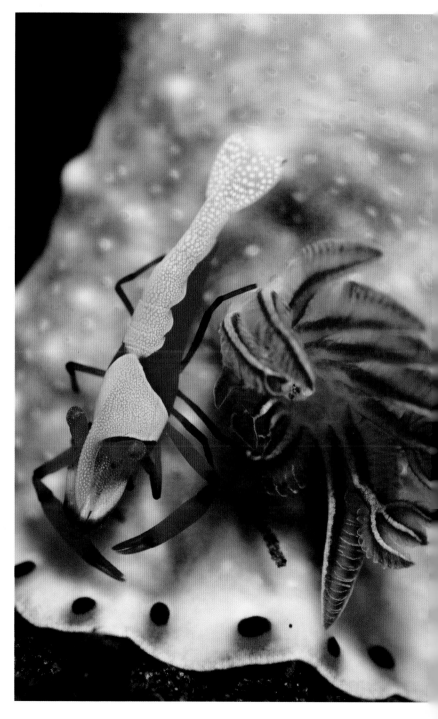

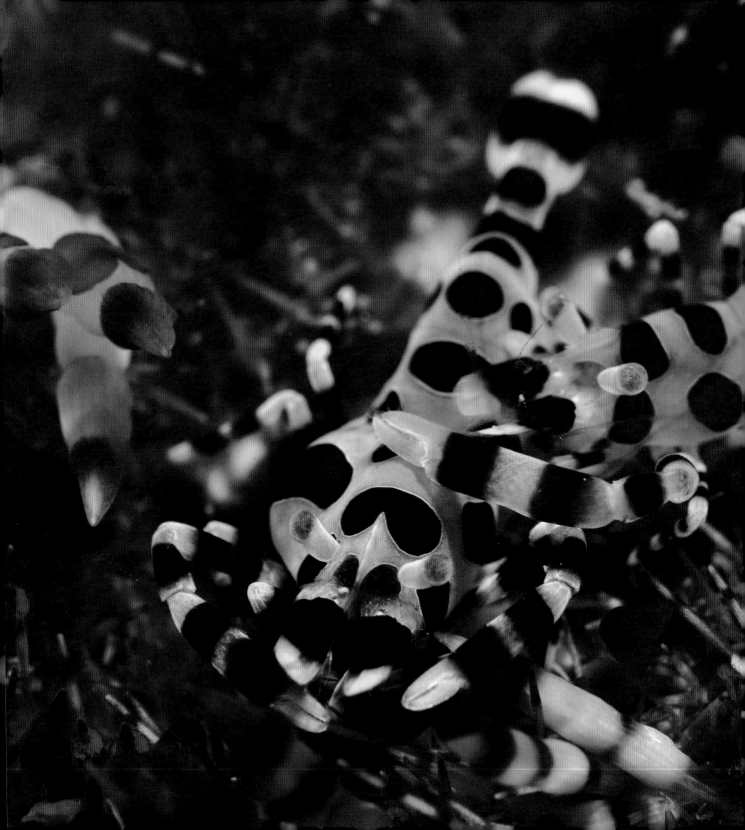

◀ *HOME IN THE SPINES*

The most colourful member of the commensal shrimp family has chosen a strange place to reside, with Coleman's Shrimps (*Periclimenes colemani*) only found on Variable Fire Urchins (*Asthenosoma varium*). Why these pretty shrimps decided to live on sea urchins is a mystery, but the strategy does keep them safe from predators. As seen in this image taken at Malapascua, Philippines, Coleman's Shrimps are always found in pairs, with a large female and smaller male. The shrimps clear a small patch on the urchin, by snipping off a few spines, and live their entire life in this spiny home.

SQUAT LOBSTERS

Squat lobsters may look like miniature lobsters, but they are more closely related to crabs. This family of crustaceans contains more than 900 members, and most are found living on other animals or corals. Very small and cryptic, squat lobsters are not easy to locate, but with most being very beautiful they are always worth looking for.

LIVING IN THE CRACKS ▶

Large barrel sponges are common on reefs throughout South-East Asia, and living in the cracks and folds of these sponges is a gorgeous little creature called the Hairy Squat Lobster (*Lauriea siagiani*). Covered in spiky hairs, these tiny squat lobsters are a lovely pink and purple colour that matches that of the barrel sponge. Wedged deep into cracks, Hairy Squat Lobsters are often difficult to see and even harder to photograph, but I was lucky to find this one peering from its sponge home while diving off Bali, Indonesia.

CRABS

Although crabs have a tough exoskeleton, they seem to spend most of their life hidden away from predators. These cryptic critters hide under rocks, in the sand, and some even live their whole life in a coral cage. More than 7,000 species of crabs are known, with a wealth of fascinating species for divers to encounter.

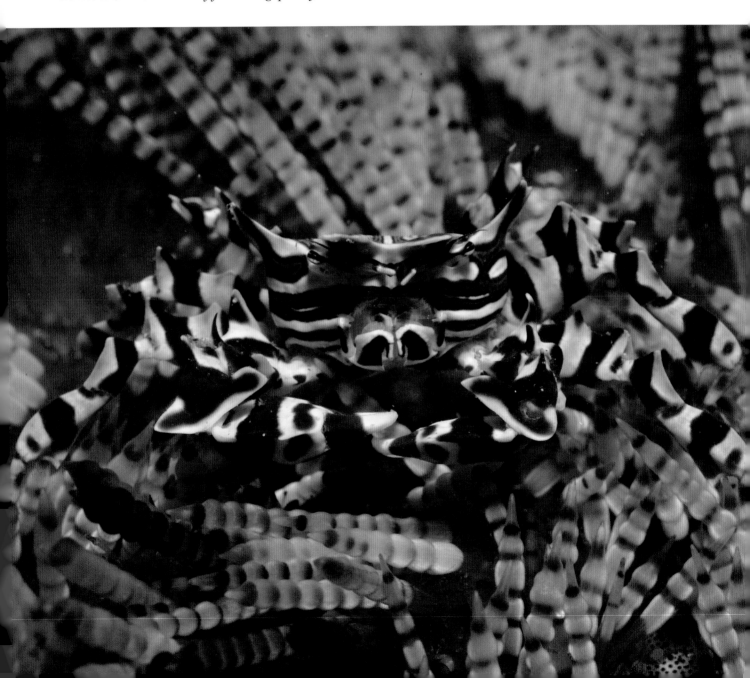

◀ A GARDEN OF SPINES

Some animals pick very strange places to live, but living on a spiny sea urchin would have to be the weirdest. However, this is the only place you will find pretty little Zebra Crabs (*Zebrida adamsii*). Even though they have a tough exoskeleton that acts as protective plating, it must still be a strange existence for a Zebra Crab to live its entire life on a small sea urchin. These little crabs are not too difficult to find, once you find the right sea urchin. I photographed this one at Komodo, Indonesia, and had fun getting close with my camera while avoiding the sea urchin spines.

▲ ON THE WHIP

Xeno Crabs (*Xenocarcinus tuberculatus*) have such good camouflage that they can hide in plain sight. These small crabs live on sea whips and have a colour, pattern and even growths to match their host. Only growing to 1.5cm (0.6cm) in length, Xeno Crabs are often hard to find without expert assistance. Fortunately I had an excellent guide to point out this one at Sekotong, Indonesia.

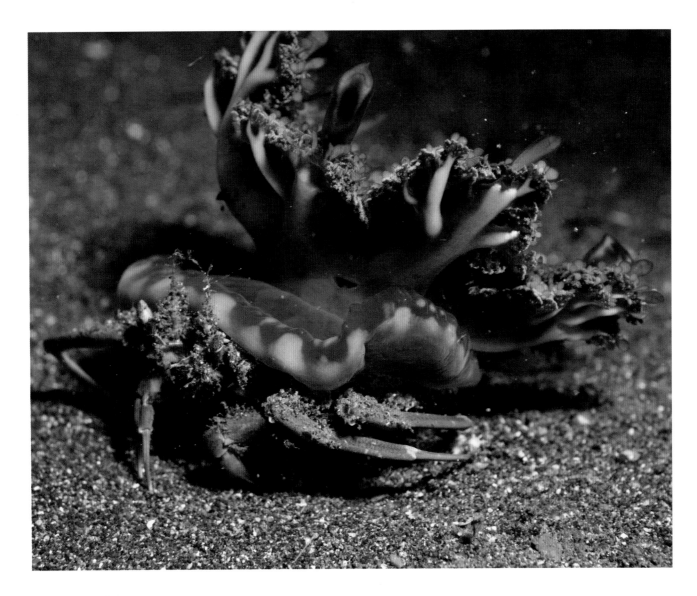

▲ CARRY ON

The Carrying Crab (*Dorippe frascone*) is a very strange creature that is only found in the Indo-Pacific region. To hide their location, and also for protection, they carry items on their backs. These items vary greatly and can be a leaf, stick, shell, sea cucumber, sea urchin or sea jelly. I encountered this peculiar Carrying Crab lugging around an Upside Down Sea Jelly (*Cassiopea* sp.) at Lembeh, Indonesia. The crab holds onto its preferred item with its back legs, and will even keep a hold of it when buried in the sand.

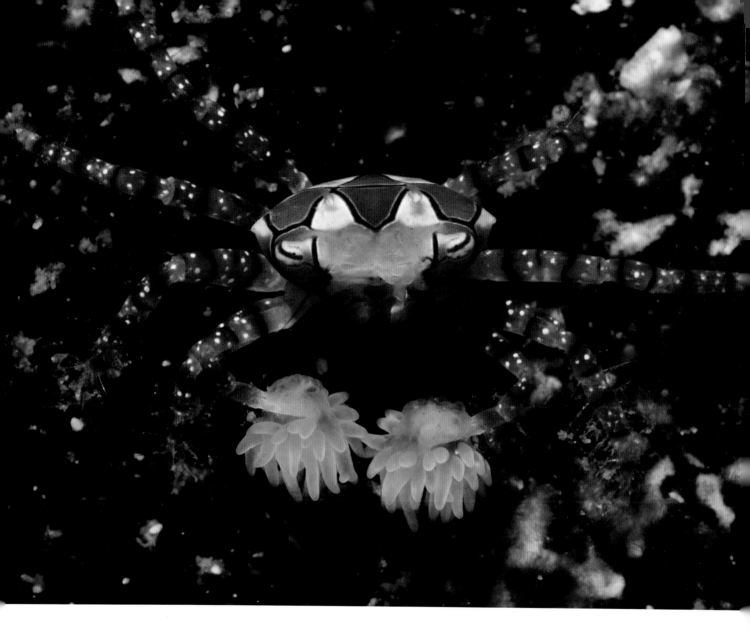

▲ KID GLOVES

One of the weirdest crabs divers can encounter in South-East Asia is the wonderful Boxer Crab (*Lybia tessellata*). These tiny crustaceans have a striking pattern and also have a very strange defensive behaviour as they stick sea anemones on their claws. Waving these sea anemones about looks like the crab is wearing boxing gloves. These tiny crabs are rarely more than 1cm (0.4in) long and like to hide under rocks, making them extremely difficult to find. A brilliant dive guide found this one for me at Lembeh, Indonesia, after searching under many rocks for half an hour.

93

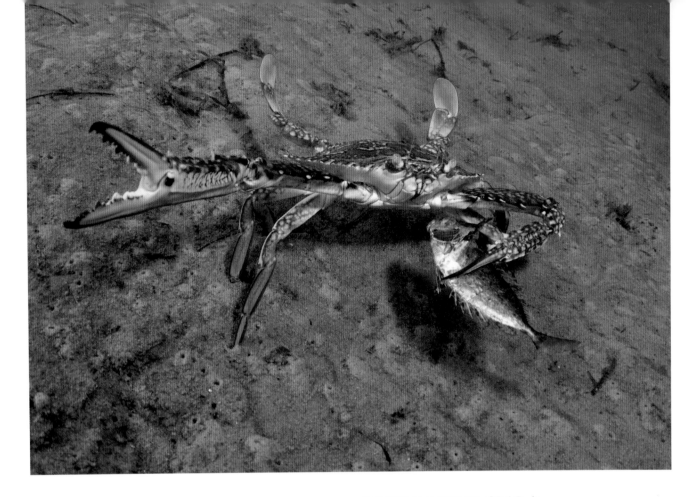

▲ FAST FOOD

Crabs eat a variety of food and are very keen scavengers, ready to munch on anything they find. I encountered this Blue Swimmer Crab (*Portunus pelagicus*) hanging onto a dead Pearly-spotted Rabbitfish (*Siganus margaritiferus*) off the Gold Coast, Australia. The crab was very protective of its prize and wasn't too happy with me getting close with my camera, snapping at me with its free claw. A good swimmer, eventually the crab got sick of the attention and swam off to enjoy its meal.

DOUBLE-DECKER CRAB ▶

It is very common to see female crabs with eggs, which they carry on their abdomen, but it is much rarer to witness crabs copulating. Over the years I have a seen a few crabs mating, but the most interesting were these double-decker Blue Swimmer Crabs. I first spotted the male waving his claws about, while diving off Dumaguete, Philippines. It wasn't until I got closer that I noticed something strange under him, another crab, his female partner. I am not sure how long they stayed locked together like this, as we had to move on, but I hoped it wasn't for too long as there were numerous octopus at this dive site and they love to snack on crabs.

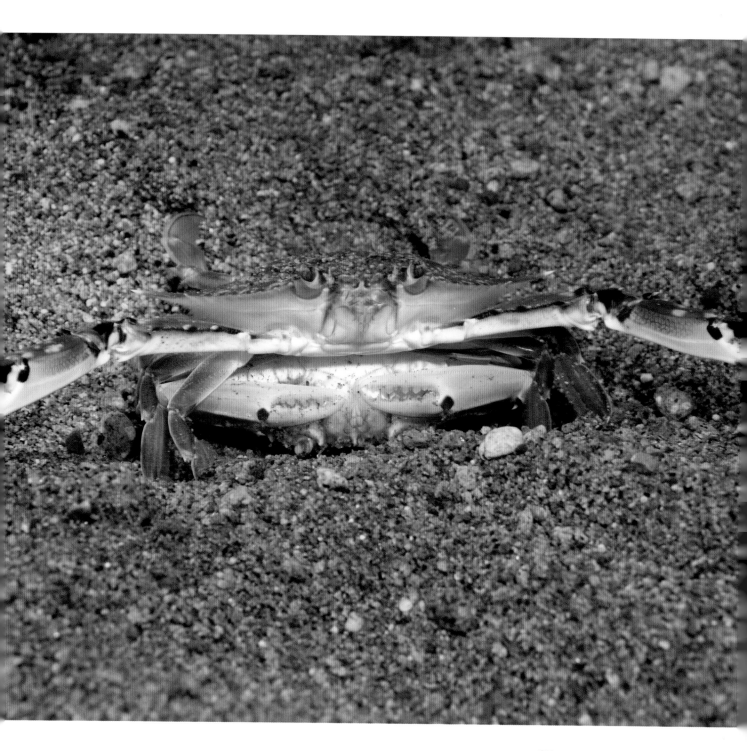

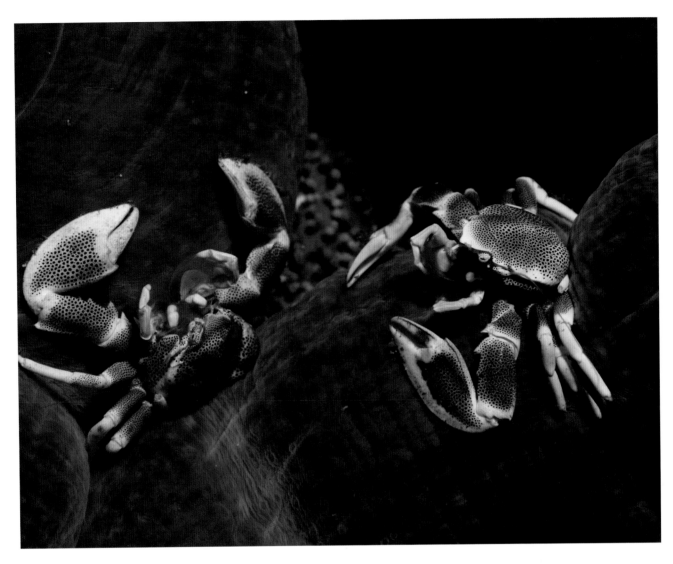

▲ APARTMENT LIVING

Porcelain crabs are not true crabs, but more closely related to squat lobsters. About 277 species of porcelain crabs are known, and many live on sea pens, soft corals and sea anemones. I encountered these Spotted Porcelain Crabs (*Neopetrolisthes maculatus*) sharing a sea anemone in Lembeh, Indonesia. Porcelain crabs are always entertaining to watch, as they share their sea anemone home with anemonefish, commensal shrimps and a number of other species. But they just seem to ignore the other occupants and spend most of their time feeding. Filter-feeders, porcelain crabs have modified jaw legs covered in fine brushes and wave them about to capture plankton.

SCORPIONFISH

Scorpionfish are very cryptic creatures with venomous spines, so best not found by accident. Using camouflage as a way to capture prey, scorpionfish hide among corals, rocks and seaweeds, waiting for small fish to blunder into them. This large family contains more than 350 species and all are easily approached by divers.

▼ THE WAITING GAME

A small and pretty member of the scorpionfish family is the lovely Leaf Scorpionfish (*Taenianotus triacanthus*). Growing to a length of 10cm (4in), the Leaf Scorpionfish comes in a wide variety of colours – white, yellow, pink, brown, red and green. Moulting their skin every two weeks, they can also change their colour to match their environment. Leaf Scorpionfish obtained their name not only because they look like a leaf, but because they move like a leaf. These fish move across the bottom by rocking from side-to-side, rather like a fallen leaf would. I encountered the one in this image off Timor-Leste in hunting mode. It was trying to capture small cardinalfish swimming above its head – a waiting game that can take hours.

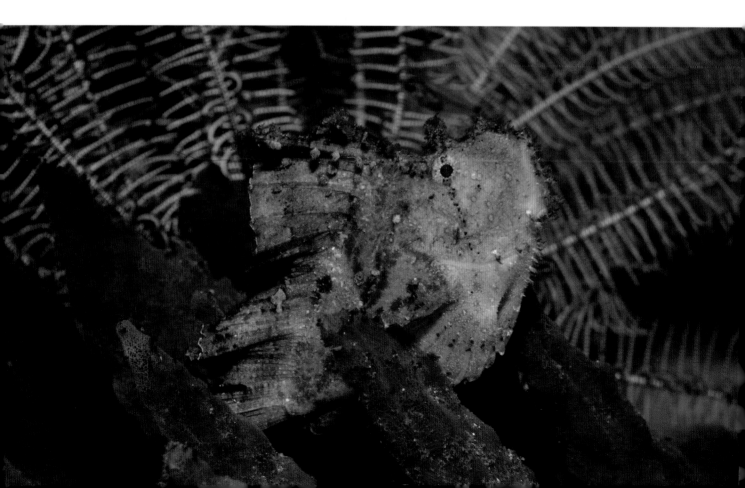

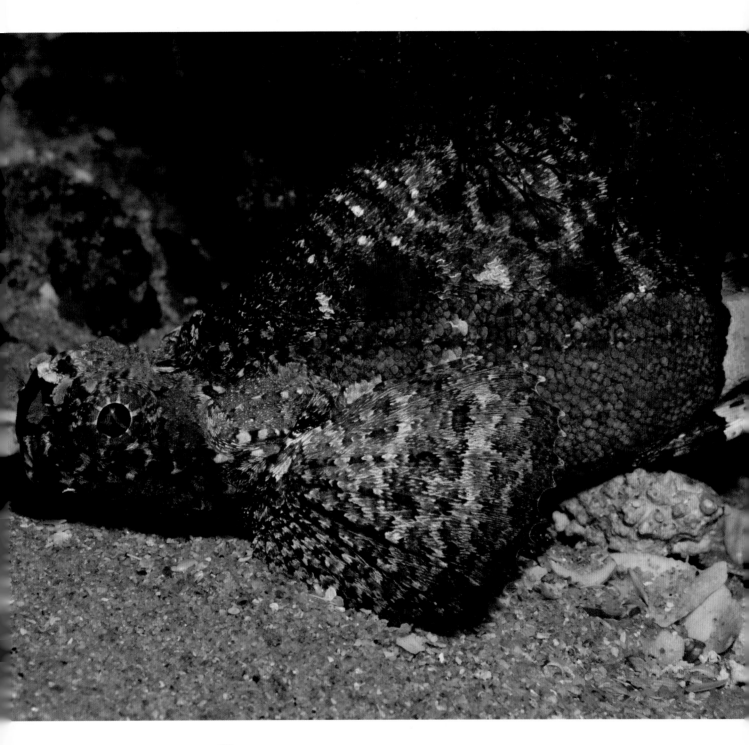

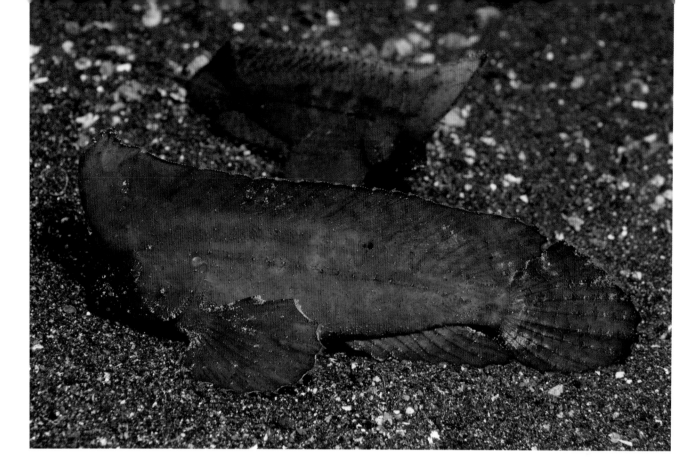

◀ CHICKEN LITTLE

There are many strange-looking scorpionfish, with one of the weirdest being the Goblinfish (*Glyptauchen panduratus*). This bizarre species is only found in southern Australia and being nocturnal, and well camouflaged, it is rarely seen by divers. The one in this image was encountered off Melbourne and shows some of the creature's strange features – a bright red ring around its pupil and the odd square head. But I found the most interesting thing about this fish was that when I got close it fanned out its pectoral fins and flattened its body to warn me to back off. This posture may work against some animals, but it made me laugh as it made the Goblinfish look like a chicken.

▲ A COUPLE OF LEAVES

A very cute family of scorpionfish are the waspfish. Found throughout the Indo-Pacific region, these attractive fish have a prominent dorsal fin that runs the full length of the body. Waspfish are often difficult to find as they like to hide among rocks, coral and seaweed by day, emerging at night to feed. However, some waspfish are more active by day, like this pair of Spiny Waspfish (*Ablabys macracanthus*) I encountered at Lembeh, Indonesia. This couple were slowly moving across the bottom pretending to be a pair of fallen leaves.

▼ A LACY YAWN

One of the most elusive and cryptic members of the scorpionfish family is the spectacular Lacy Scorpionfish (*Rhinopias aphanes*). Highly sought by underwater photographers, this wonderful fish is only found in the Indo-West Pacific. Papua New Guinea is one of the best places to find it, and I was fortunate to encounter this one off Port Moresby. Hiding among a cluster of feather stars, this fish was so well camouflaged that it took an experienced local guide half the dive to find it. While I was photographing the Lacy Scorpionfish it did a big yawn. All fish yawn; some do long drawn out yawns, others do very quick yawns. Capturing a yawn is often a case of being in the right spot at the right time.

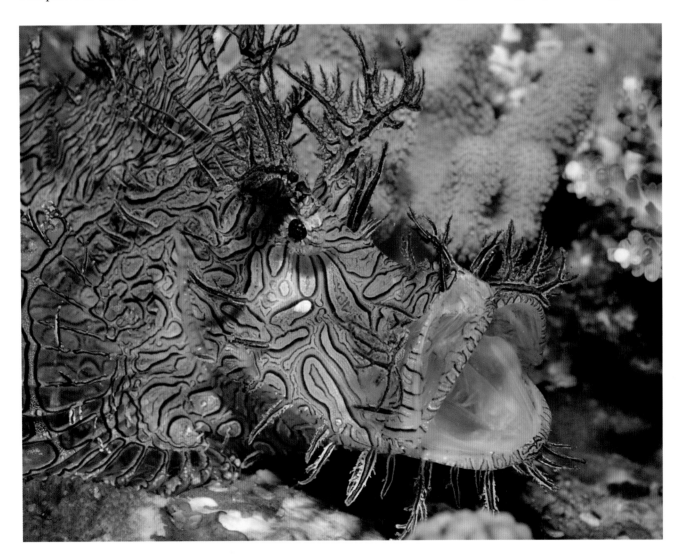

PROWFISH

Only found in southern Australia, prowfish are very strange fish with leather-like skin which they regularly moult. Bottom-dwellers, the three members of this family look like sponges, which makes them very hard to find as they like to live in sponge gardens.

▼ *SPONGE BOB*

The most common member of the prowfish family encountered by divers is the bizarre Red Indian Fish (*Pataecus fronto*). This very cryptic fish sits beside similar-coloured sponges, so a sharp eye is needed to find it. It not only looks like a sponge, but acts like a piece of broken sponge when moving, slowly rocking back and forth to move across the bottom. This strange fish is most commonly found in New South Wales, especially south of Sydney where thick sponge gardens are common. However, I encountered this one much further north at Byron Bay. With no red sponges in the area this Red Indian Fish's camouflage technique left a lot to be desired.

FLATHEADS

Flatheads are bottom-dwelling fish that often hide in the sand. This family contains about 60 species which are mainly found in the Indo-Pacific region. Many species of flathead are small and very cryptic, often only seen at night, but larger members of the family are much bolder and easier for divers to observe.

◀ THE FRIENDLY CROCODILE

Flatheads have decorative skin patterns to assist with camouflage. Most have a sandy coloration, as they live on the sand, but one member of the family likes to live on reefs and has elaborate decorative patterns – the wonderful Crocodilefish (*Cymbacephalus beauforti*). Even though the Crocodilefish grows to 50cm (20in) in length, many divers swim right past them as their camouflage is so effective. I have even seen divers accidently kneel or sit on Crocodilefish. This one, encountered at Mabul, Malaysia, was easily spotted resting on the sand. Ambush predators, Crocodilefish spend most of their time waiting for prey, allowing divers to get very close to inspect them.

▼ COURTING COUPLE

The largest member of the flathead family is only found off the east coast of Australia – the impressive Dusky Flathead (*Platycephalus fuscus*). Most commonly found in bays and estuaries, the Dusky Flathead can grow to a length of 1.5m (4.9ft). A shy species, they are often easier to approach in the mating season, as I found at Port Stephens when I encountered this courting couple. The male, the smaller of the pair, was affectionately keeping in touch with the larger female, and each time she moved he would re-establish contact. I later discovered that males will closely follow a gravid female until she is ready to spawn. So he was just biding his time with a few tender moments.

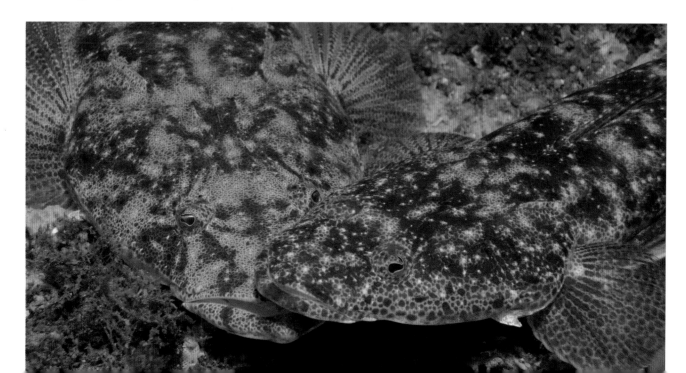

WOBBEGONGS

Although wobbegong sharks are found in many parts of the Indo-West Pacific they are mostly seen off Australia and are an icon species Down Under. Twelve species of these well camouflaged bottom-dwelling sharks have been identified, with ten of them found in Australia. Being ambush predators, wobbegongs spend most of their lives resting on the bottom, waiting for prey to come close enough to be grabbed.

▼ THE MASTER OF CAMOUFLAGE

Of all the wobbegong species the Tasselled Wobbegong (*Eucrossorhinus dasypogon*) would have to have the most cryptic of camouflages. This species inhabits the tropical waters of Australia, Papua New Guinea and eastern Indonesia, but I have always found them to be most common at the southern end of the Great Barrier Reef. Lady Elliot Island is generally a reliable place to find this species, and this was where I encountered this one. Hidden under ledges or sheltering in caves, many times I have come face-to-face with one of these camouflaged sharks while exploring the dive sites around the island. I have even accidently rested on a Tasselled Wobbegong when exploring a cave. Fortunately the shark just ignored me, unlike many other divers that have been bitten by an angry wobby.

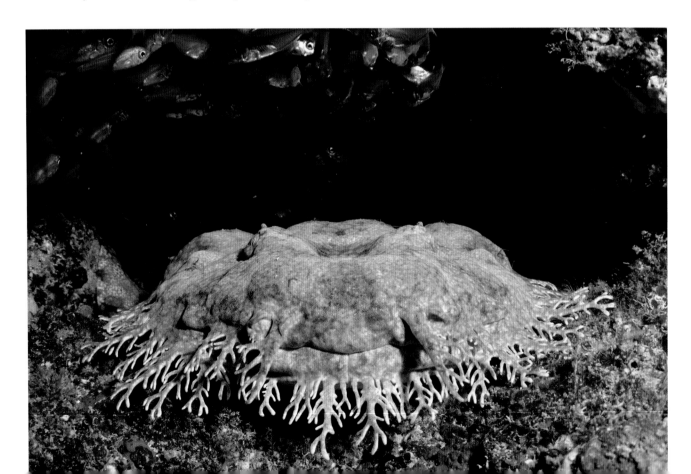

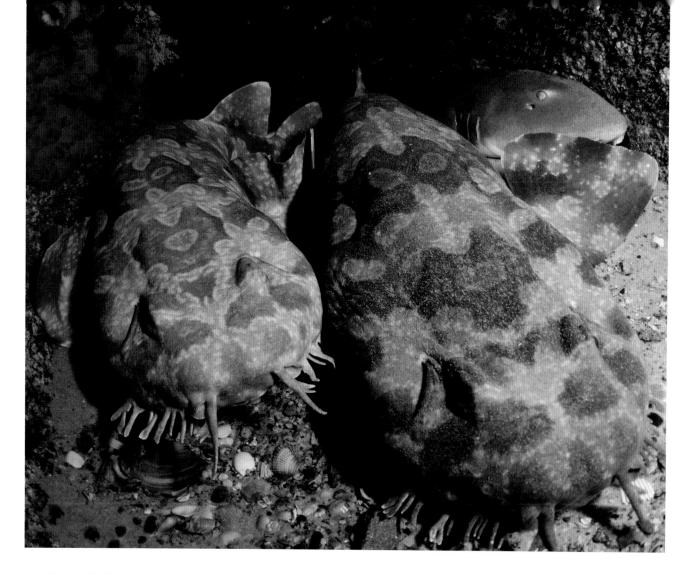

▲ COMMUNAL ACCOMMODATION

Most wobbegong species are solitary animals that only meet members of their own species to breed. However, Spotted Wobbegongs (*Orectolobus maculatus*) are much more social and are often found together sheltering in caves or resting in gutters. As can be seen from this image taken off the Gold Coast, Australia, they are also happy sharing accommodation with other shark species, in this case a Brown-banded Bamboo Shark (*Chiloscyllium punctatum*). Spotted Wobbegongs are happy resting alongside several other shark species, including Port Jackson Shark (*Heterodontus portusjacksoni*), Blind Shark (*Brachaelurus waddi*) and Ornate Wobbegong (*Orectolobus ornatus*). Sometimes their flatmates come off second best from this arrangement, as Spotted Wobbegongs have been recorded eating these other shark species.

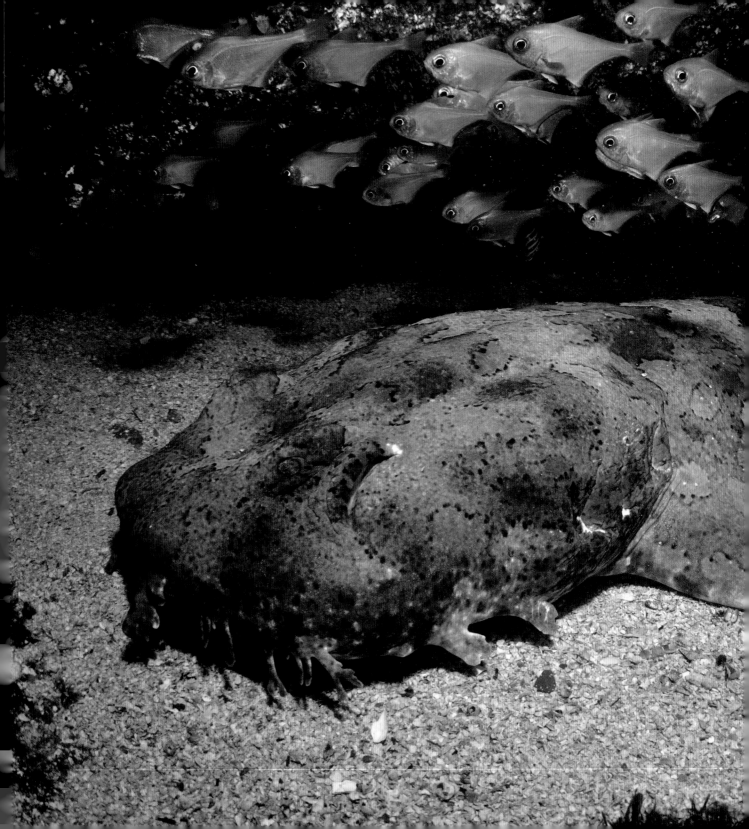

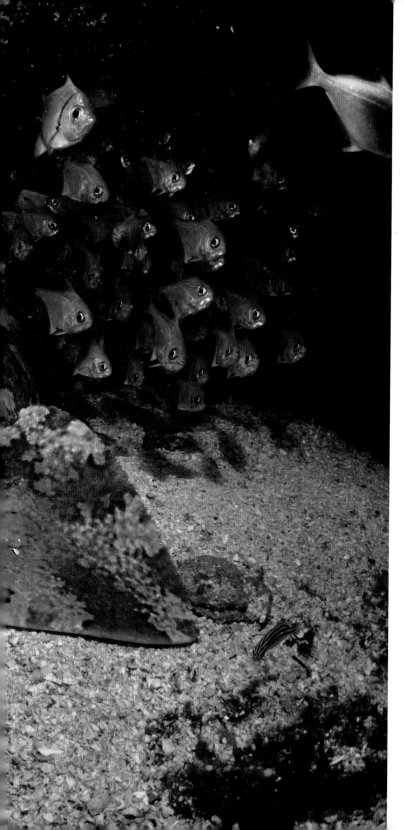

◄ SNAP HAPPY

While wobbies can be seen all around Australia, there is one spot where they are so abundant that they litter the bottom in their hundreds. I call the site 'Wobby World' but it is more commonly known as Julian Rocks off Byron Bay. This wonderful dive site is home to three species of wobbegongs, including the Banded Wobbegong (*Orectolobus halei*). Though most are generally docile like this one, I have found some Banded Wobbegongs to be snap happy, snapping at divers that get to close. On one dive at Julian Rocks I was following a dive guide around the site. Swimming into a gutter we stumbled across the largest Banded Wobbegong I have ever seen, at least the maximum 2.9m (9.5ft) in length that they are reported to reach. My guide decided to pat the huge wobby. Not a very wise idea I thought, and the wobby agreed. It suddenly turned and snapped at the diver. Its large mouth could have engulfed his whole head, but instead its teeth snapped shut just millimetres in front of his face. The diver got the message and quickly backed off, and turning towards me I could see his face had turned a ghostly white.

▲ THE FEISTY BABY

Divers rarely see baby or juvenile sharks, as they usually hide to avoid being eaten by their larger relatives. However, juvenile Ornate Wobbegongs (*Orectolobus ornatus*) are often encountered off the east coast of Australia, especially off Byron Bay where this image was taken. One of the smaller members of the wobbegong family, this species only grows to 1.2m (3.9ft) in length, but it is no less feisty than its relatives. Over the years I have encountered many of these small wobbies off Byron Bay. I

had one unforgettable encounter at this location when attempting to photograph a juvenile Ornate Wobbegong. Using a Nikonos camera and macro lens, which had a metal frame to define the picture area, I pushed the frame close to the face of a small wobby. It didn't like this intrusion and let me know by biting the metal frame, giving it a shake and then swimming off. Later inspecting the metal frame I was very surprised to see tiny puncture marks left by the wobby – the bite force of that small jaw is remarkable.

▲ AUSSIE CRAWL

Western Australia is home to world's largest variety of wobbegong sharks, with nine species found in different parts of this large state. Unfortunately, wobbegongs are hard to find in many parts of Western Australia as they are far more cryptic than they are off the east coast. One species that can occasionally be encountered in tropical waters is the Northern Wobbegong (*Orectolobus wardi*).

I encountered this Northern Wobbegong at the Mackerel Islands, doing something that wobbies are rarely seen doing – walking. While wobbies are mostly seen lazing on the bottom, they do regularly swim when disturbed or looking for a new resting place. Occasionally divers encounter one on the move, slowly walking across the bottom using its pectoral fins like hands.

THE UGLY

I don't really consider any marine animal to be ugly, but the following creatures are a little more unattractive than most. They may have missed out on the good looks, but they are all fascinating animals for divers to encounter.

● ● ● ● ●

STARGAZERS

Stargazers could easily be called crankyfish, as they always have a very cranky look on their face, fixed with a permanent frown. Stargazers are ambush predators and spend most of their lives buried in the sand. They mainly feed at night, with only their eyes and mouth exposed ready to snatch prey. About 50 species of stargazers have been described, and while easy to get close to, they are often difficult to find.

▼ STARGAZER MINEFIELD

One of the most common stargazers seen at muck diving sites throughout South-East Asia is the Reticulated Stargazer (*Uranoscopus* sp.). This species is mostly seen at night, and it is rare to see more than one at a dive site. But there is one dive site in the Philippines where this species is found in plague proportions – Padre Burgos Pier at Sogod Bay. This amazing pier is one of the best night dives in Asia and home to an incredible variety of marine life. Those seeking stargazers need to venture beyond the pier and explore the sandy plain around it. In this zone I stumbled across a minefield of stargazers, including the one illustrated here. Every few metres I found a Reticulated Stargazer with its beady eyes staring up at me. During an hour-long dive I encountered more than a dozen of these cranky fish.

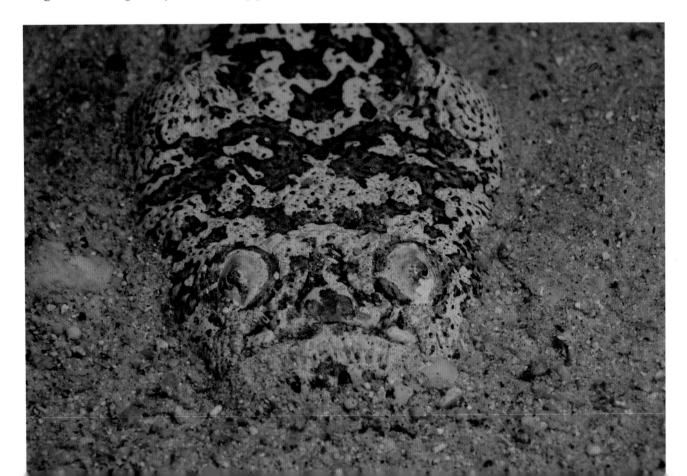

GHOULS

With a name like ghoul, you would expect this family of fish to be very ugly and horrid. They are members of the scorpionfish family and possess some very nasty venomous spines. Found throughout the Indo-West Pacific, the ghoul family contains nine members that have all been hit by the ugly stick. Getting close to ghouls is never a problem, just be cautious of those spines.

▼ GARBAGE GUTS

Ghouls are common at muck diving sites throughout South-East Asia, but one of the uglier members of the family is best found off Australia – the Caledonian Ghoul (*Inimicus caledonicus*). These unattractive fish are regularly encountered off the Gold Coast, which is where this one was photographed munching on a dead fish. I watched it for several minutes to see if it would swallow the fish, but it made no attempt to finish the meal. I suspected the fish was caught in its throat, either from being too big or because of the fishing tackle. I did consider trying to remove it, but looking at those lethal spines I stayed well away and hoped this ghoul was just a slow eater.

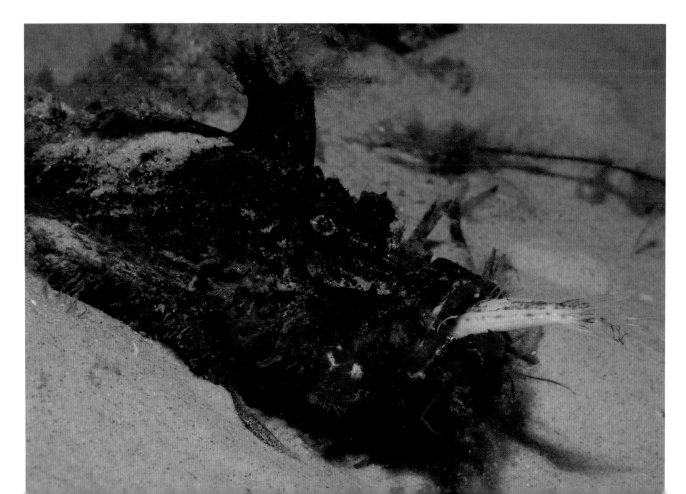

STONEFISH

Top prize in the ugly stakes would have to go to the stonefish. Also part of the scorpionfish family, there are five species of stonefish recognised and all resemble an algae-covered stone. These highly venomous fish have caused a number of human fatalities when accidently stepped on or touched. Stonefish use their extreme camouflage as a way to ambush prey, but it does make them very difficult to find at times.

STONEFISH TEMPLE ▶

The most common stonefish divers encounter in the Indo-Pacific region is the Reef Stonefish (*Synanceia verrucosa*). It is not an easy fish to find as it buries itself into the sand or hides among rocks, and most encounters are purely by chance. There is one place where it is very easy to see – a pinnacle of coral on Australia's Great Barrier Reef called Steve's Bommie. Located on the Ribbon Reefs, Steve's Bommie is a magnet for marine life both big and small, but it could easily be renamed Stonefish Temple, as the top of this pinnacle is home to a large population of Reef Stonefish. Two of these stonefish are shown in this image, with the second hidden away on the right, and in this general area I encountered four of these very ugly fish.

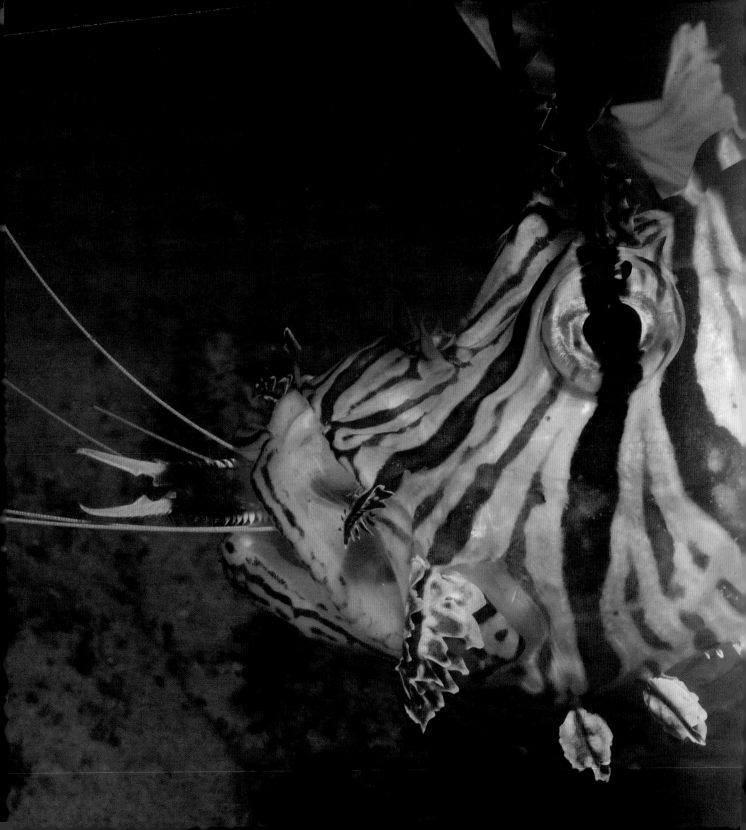

THE NASTY

The following group of marine animals are all quite pretty and innocent to look at, but their looks are very misleading as all of them have some nasty habits. Some are sneaky, some are cranky, some are deceptive, and some are downright horrible.

• • • • •

WORMS

Marine worms are very different from the terrestrial worms that most people are familiar with. They are much more colourful than earthworms and come in a wide variety of sizes and shapes. The most common marine worms are the multi-coloured flatworms and tubeworms. However, the most interesting marine worms are the nasty varieties – the fireworms and the wicked Bobbit Worm.

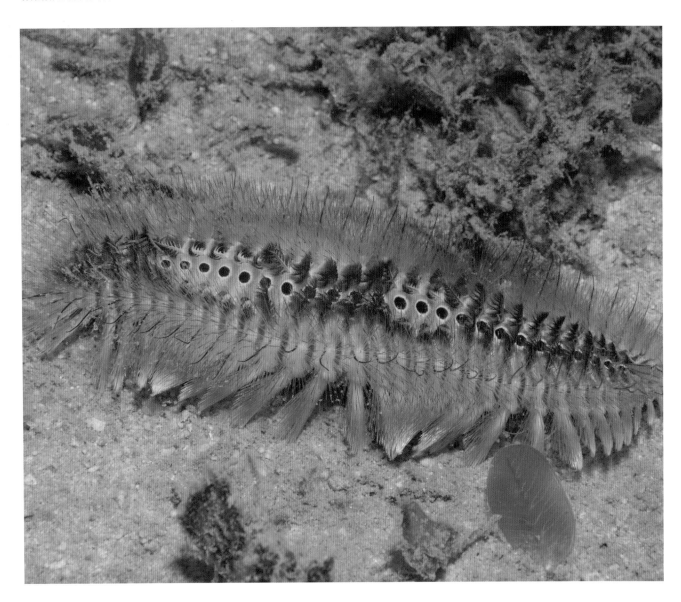

◀ A PRICKLY ENCOUNTER

Fireworms are one of the most interesting and flamboyant families of worms that divers can encounter. Also known as bristleworms, as their bodies are covered in fine bristles, this family contains about 120 species. Fireworms are often difficult to find, as many are nocturnal and hide under rocks or in the sand. I was fortunate to find this spectacular Golden Fireworm (*Chloeia flava*) out for a stroll at the Perhentian Islands off Malaysia.

I encountered my first fireworm on the reef flats at Heron Island, Australia, as a teenager after turning over a rock. Enchanted by the pretty worm I let it crawl over my hand. After returning the critter to its home I suddenly realised that I had dozens of its very fine bristles stuck in my skin. I managed to pull some out, but many broke off and then irritated my skin for several days. I have never touched a fireworm since.

UNDERWATER RABBIT TRAP ▶

Most tubeworms have very colourful feather-duster-like heads that quickly retract when a diver gets close. One tubeworm with much nastier headgear is the Bobbit Worm (*Eunice aphroditois*). Growing to a length of 3m (9.8ft), these worms live in the sand and feed at night. When feeding, the head emerges from the sand and the jaws open wide, like an underwater rabbit trap. Spring loaded, the jaws snap closed when they make contact with anything that swims by, be it a fish, crab or octopus. The worm then pulls the victim into the sand to be consumed. I photographed the Bobbit Worm in this image at Lembeh, Indonesia, waiting for prey.

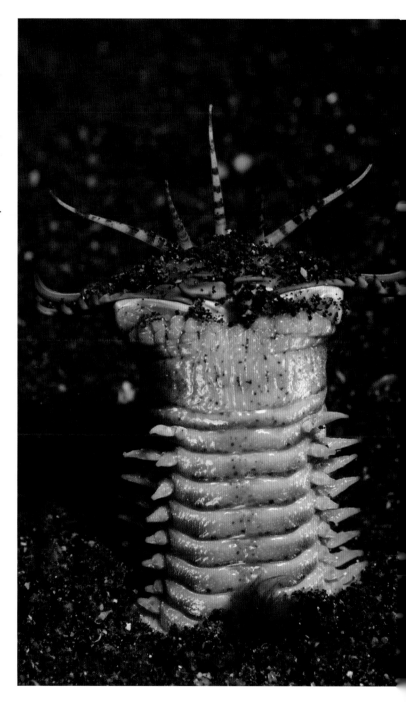

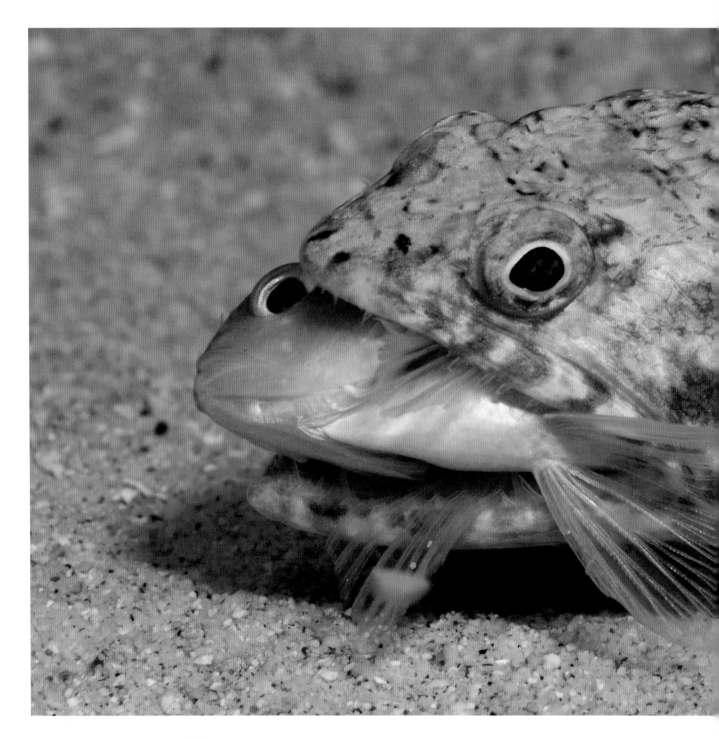

LIZARDFISH

..

Generally seen sitting on the bottom and doing nothing, lizardfish are not the most exciting family of fish that divers encounter in the marine realm. This family contains about 35 species, and all have a mouthful of very sharp small teeth. It is very easy to get close to lizardfish, and sometimes they are worth watching.

◀ QUICK-AS-A-FLASH

Lizardfish are nice to photograph. They sit motionless on the bottom and will generally allow a diver to get very close with a camera. However, these sweet, innocent-looking fish have a dark side that is rarely seen. I always watch lizardfish in the hope of seeing this particular behaviour, but it took more than 30 years of diving before I finally witnessed it in Sogod Bay, Philippines. The dive had been pleasant but uneventful until I stopped to look at a Variegated Lizardfish (*Synodus variegatus*). It was simply sitting on the sand, but looked like it was ready for action. Suddenly it launched off the bottom, and quick-as-a-flash shot straight over to a nearby coral patch and grabbed a Scalefin Basslet (*Pseudanthias squamipinnis*) with its needle-like teeth. It then just as quickly settled on the sand, with its meal hanging out of its mouth. This whole attack took about one second, not enough time to even raise my camera. But I rapidly got my camera into action, managing a few quick images before the poor basslet disappeared down the lizardfish's throat.

LIONFISH

Members of the scorpionfish family, lionfish are very pretty creatures with their feather-like fins and exotic colours. Found throughout the Indo-Pacific region, 18 species of lionfish are recognised, and all are superb hunters. Lionfish feed on fish, crustaceans and molluscs, and will even eat other lionfish. They are very easy to get close to, as being highly venomous they are unconcerned by the presence of divers.

▼ A PAINFUL JAB

One of the smaller members of the lionfish family is the lovely Dwarf Lionfish (*Dendrochirus brachypterus*). This species has beautiful fan-like pectoral fins, as can be seen in this image taken off Tufi, Papua New Guinea. While it may be small, the Dwarf Lionfish is one species you don't want to mess around with, as I discovered on a dive off Sekotong, Indonesia.

I have a great respect for lionfish, but on this dive I let my guard down for a second. I found the Dwarf Lionfish at the start of the dive, sitting next to a nudibranch I hadn't seen before. To photograph the nudibranch I had to get the lionfish to move, so I waved my hand in front of it. Big mistake, as the lionfish moved quicker than expected, shooting forward and jabbing me in the finger. At first there was no pain, but by the end of the dive my finger was throbbing, and continued to do so for six hours!

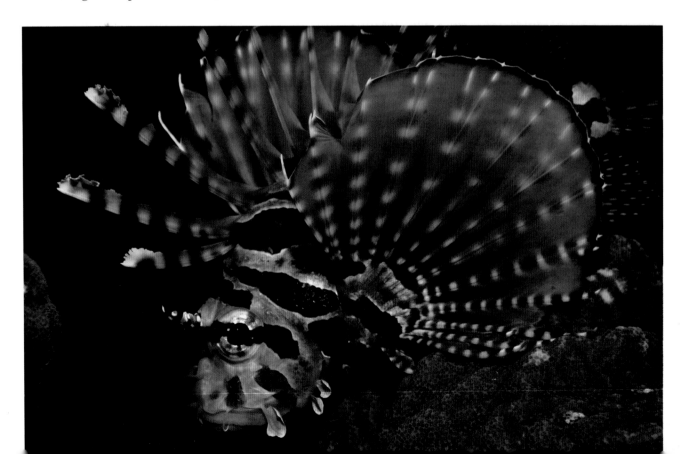

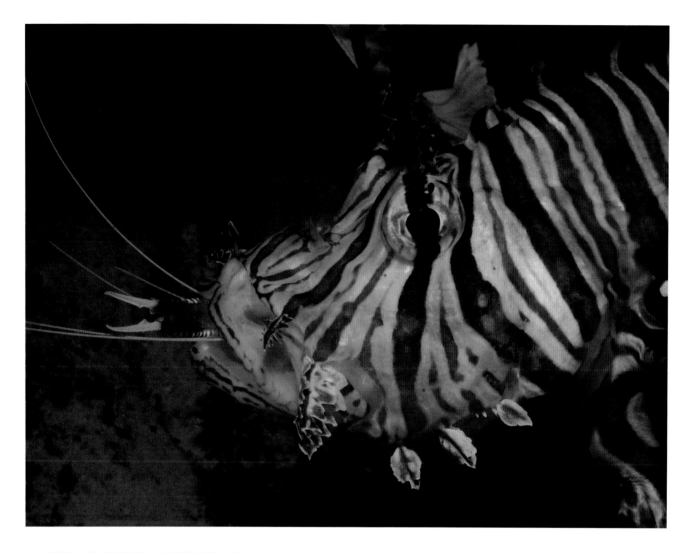

▲ THE INDISCRIMINATE KILLER

A number of boxer shrimp provide cleaning services to fish, so the general rule of the sea is that you don't eat these helpers. Unfortunately, lionfish don't always follow the rules, as I discovered diving off Brisbane, Australia. While exploring Curtin Artificial Reef, my buddy suddenly made a cry. I turned around to see her pointing at a Common Lionfish (*Pterois volitans*).

Nothing to get excited about as they are pretty common, until I saw it had a Banded Boxer Shrimp (*Stenopus hispidus*) in its mouth. I was very surprised, as I knew that boxer shrimps clean fish, but I had never seen one actually cleaning a lionfish. However, upon closer inspection I suddenly realised that the shrimp wasn't doing any cleaning; it was struggling as the lionfish was swallowing it!

123

TRUMPETFISH

Trumpetfish are closely related to seahorses and are common on coral reefs around the world. Trumpetfish may look charming with their elongated bodies and long snouts, but these nasty fish feed on other fish and sneak around the reef in order to do it. They are not too difficult to get close to, and they will sometimes use a diver as a wingman.

▼ TRUMPET BLOWING

The most common trumpetfish encountered throughout the Indo-Pacific region is the Pacific Trumpetfish (*Aulostomus chinensis*). They are always interesting to observe when hunting as they will stick close to another fish in order to hide their presence. When they get within range of small fish they will lunge forward and grab them. Often found in pairs, I encountered the two in this image off Brisbane, Australia. These two followed me around for the entire dive, using me as cover to get close to prey. They managed to snatch a few small fish, but I could never get a photo as they were just too fast. I did manage to capture this image of one yawning.

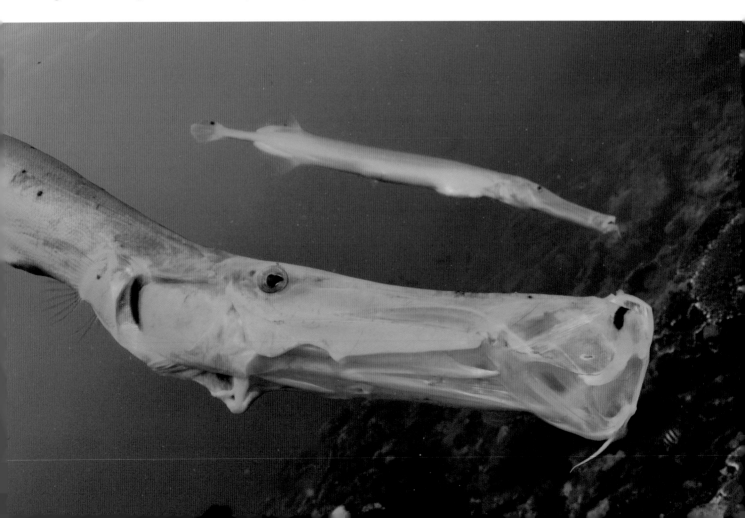

HAWKFISH

Generally seen perched on rocks and corals, hawkfish are pretty small reef fish that are easy to approach. With a curious nature, they are often seen peering at divers, and some even follow humans around, hoping to capture a tasty morsel displaced by a diver's fin. About 35 species of hawkfish are known, and a few are particularly nasty in their choice of food.

▼ PYGMY PLUNDERER

Found living in black coral trees and gorgonians, the Longnose Hawkfish (*Oxycirrhites typus*) is one of the most attractive members of its family. These sweet- and innocent-looking fish have a long snout and a gorgeous red and white criss-cross pattern. They typically feed on small crustaceans, but also eat other critters. I encountered this one off Port Moresby, Papua New Guinea, sitting in a gorgonian fan that typically hosts Bargibant's Pygmy Seahorses (*Hippocampus bargibanti*). It seems the hawkfish like this species of gorgonian to perch in as they also like to snack on pygmy seahorses. I used to love encountering Longnose Hawkfish, but once I discovered that they feed on pygmy seahorses I lost all respect for them.

GRUBFISH

Grubfish, also known as sand perch, are bottom-dwelling fish found on tropical reefs. The grubfish family contains about 60 members that typically feed on small crustaceans and fish. They are commonly observed sitting on the bottom, watching the world go by, and are usually very easy to get close to. With pretty skin patterns grubfish are quite attractive, but some of their dietary habits are a little nasty.

▼ UNEXPECTED MEAL

Grubfish are one species of fish I always enjoy encountering. Very curious and friendly towards divers, you can often interact with them by digging in the sand. They are hoping you will uncover a small crustacean they can dine on. But my whole opinion of grubfish changed after a dive off Brisbane, Australia.

Exploring a collection of scuttled ships at Curtin Artificial Reef, I spotted a Speckled Grubfish (*Parapercis*

hexophtalma) sitting on the bottom with something protruding from its mouth. Getting closer I suddenly realised that the item in question was an Ornate Ghostpipefish (*Solenostomus paradoxus*). I was mortified, but managed to capture one image before the grubfish swallowed the evidence. I was also a little disappointed as I had been diving around Brisbane for 25 years and had never seen a ghostpipefish in the area, so didn't expect to see my first protruding from the mouth of a grubfish!

DAMSELFISH

The damselfish family is quite large, containing more than 300 species that are all quite small. Darting about the reef, most damselfish are shy and harmless, and often difficult to get close to. In contrast, a few members of this family are very territorial and have a nasty temper, attacking other fish and divers.

▼ THE EGG GUARDIAN

Damselfish are very good parents and guard their eggs until they hatch. In this image a Narrow-banded Sergeant (*Abudefduf bengalensis*) is looking after a clutch of eggs off Brisbane, Australia. These fish guard their eggs with zeal and attack other fish, and divers, that get too close to their precious offspring. This one didn't attack me, but I have found myself being bombarded by numerous damselfish over the years. The worst was a frenzied attack at another Brisbane dive site, Flinders Reef. The crazed fish bit my hands, arms and legs, which wasn't a problem with my neoprene protection, but then it went for my head and found some exposed skin. It delivered a savage bite on my forehead that really stung. I finally got away from the fish and upon returning to the boat discovered that I had blood running down my face. When asked by non-divers about shark troubles, I tell them I have more fear of a 5cm (2in) long damselfish!

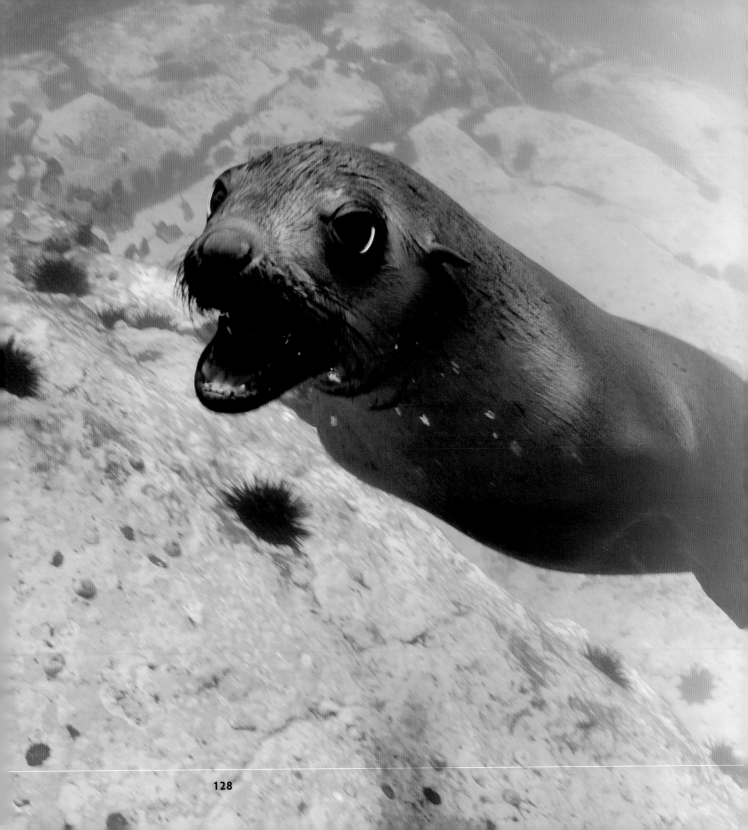

THE PLAYFUL

Playful may not be the right term for all these marine animals, but they are all curious of divers and easy to interact with. Some of these creatures take great delight in swimming around humans, others follow divers hoping for a meal, while some just seem to tolerate bubble-blowing aliens invading their realm.

• • • • •

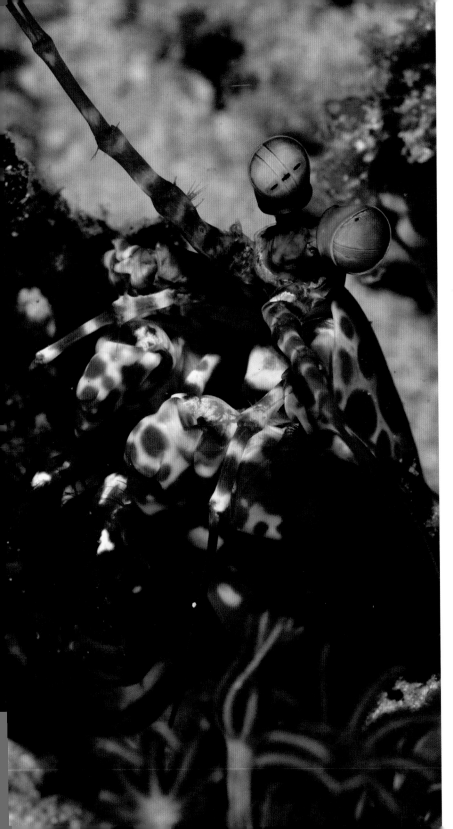

MANTIS SHRIMPS

With a praying mantis–like stance and claws, mantis shrimps are just as lethal hunters as their terrestrial namesakes. This family of crustaceans contains more than 400 species, with these elongated creatures very different to their shrimp cousins. Mantis shrimps have excellent eyesight, basic intelligence, good memory, and can learn simple tasks. They are also very curious creatures, which makes them fun to encounter.

◀ HIDE AND SEEK

There are two types of mantis shrimps, which can be distinguished on the basis of their claws, the smashers and spearers. The smashers have club-like claws to crush the shells of prey, while the spearers have claws with sharp spines, to impale prey. The most common member of the smasher family is the Peacock Mantis Shrimp (*Odontodactylus scyllarus*). This is a very curious critter and likes to know what is happening around its patch of reef. They live in burrows, which have multiple exits, so can disappear down one hole and reappear on another part of the reef. This allows them to play hide and seek with divers, like I did with this one that I encountered at Komodo, Indonesia. It was very curious of my activities and followed me across the reef to see what I was doing.

▲ TUNNEL OF TERROR

Swimming over sand or rubble, divers often find tunnel-like holes which are the homes of spearing mantis shrimps. These ambush predators rarely leave their burrow, and wait for prey to come within striking distance of their deadly claws. While most mantis shrimps are less than 10cm (4in) long, the Zebra Mantis Shrimp (*Lysiosquillina maculata*) grows to a massive 40cm (16in) in length.

I have seen some very big Zebra Mantis Shrimps, but the largest was this giant encountered at Komodo, Indonesia. First I found its huge hole, which at 10cm (4in) across was twice the normal size, but there was no sign of the occupant. My guide showed me a trick to lure the mantis shrimp to the surface – he started to tap next to the hole. It only took a few seconds for the curious crustacean to rise to the surface to see who was knocking on its door, its eyes rotating back and forth to investigate the intruders. Satisfied that we were not a threat, it then slowly sank back down into its tunnel.

SCHOOLING FISH

Numerous species of fish form into large schools. They do this for a number of reasons, including safety in numbers, social bonding, and ease of communication, while it also makes it easier to find food. Schooling fish are also more confident and ready to play, and are more likely to swarm around divers.

▼ TREVALLY WHIRLPOOL

Diving with immense schools of trevally is always unforgettable. My favourites are the Bigeye Trevally (*Caranx sexfasciatus*), which are common throughout the Indo-Pacific region. These wonderful fish can grow to more than 1m (3.3ft) in length and gather in vast numbers on reefs and pinnacles. This school was encountered at Sipadan, Malaysia, which is always a reliable location for experiencing this spectacle. These fish like to swirl around divers, and being surrounded by thousands of them is like being in a trevally whirlpool.

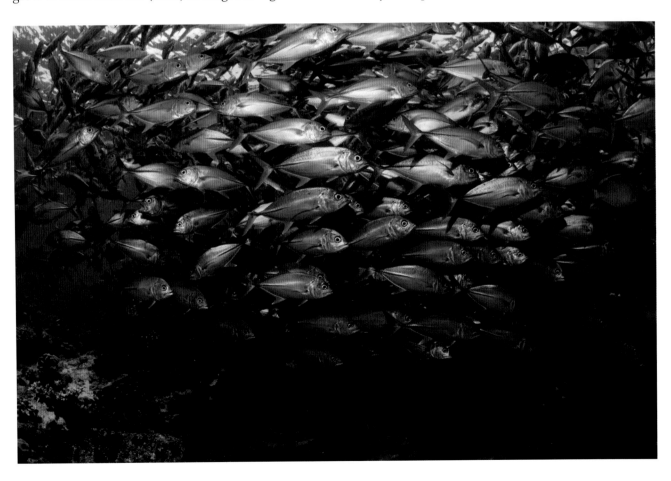

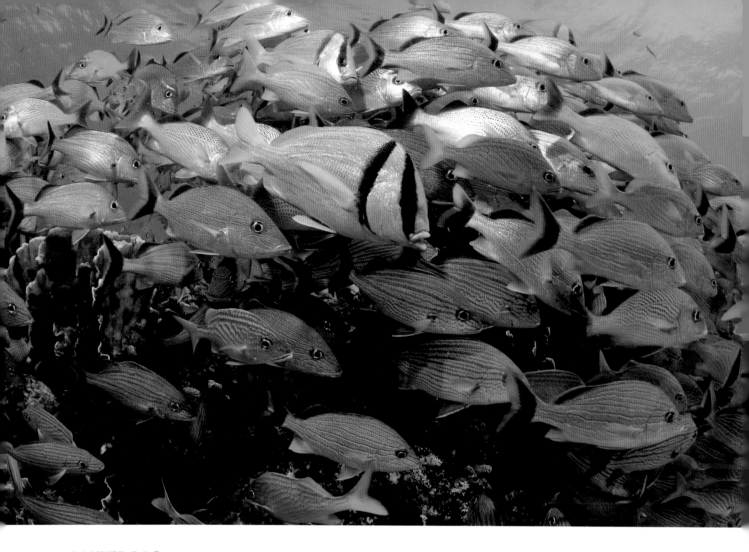

▲ A MIXED BAG

It is always interesting to encounter mixed schools of fish. Sometimes these mixed schools are by accident, with the fish mingling together as they hunt or swim in the same direction. These schools generally separate quickly and regroup by species. By contrast other fish species seem to be very happy schooling together with closely related species. I encountered this mixed bag of grunters off Isla Mujeres, Mexico. The reefs in the area were swarming with many species of grunters, and almost every school I encountered was a mix of species. In this school are at least four species, including Blue-striped Grunt (*Haemulon sciurus*), French Grunt (*Haemulon flavolineatum*), Sailor's Grunt (*Haemulon parra*), and the odd one out in the middle, a Porkfish (*Anisotremus virginicus*). These mixed schools of fish probably group together for the same reason that fish school in the first place, but it must cause a few headaches during the breeding season.

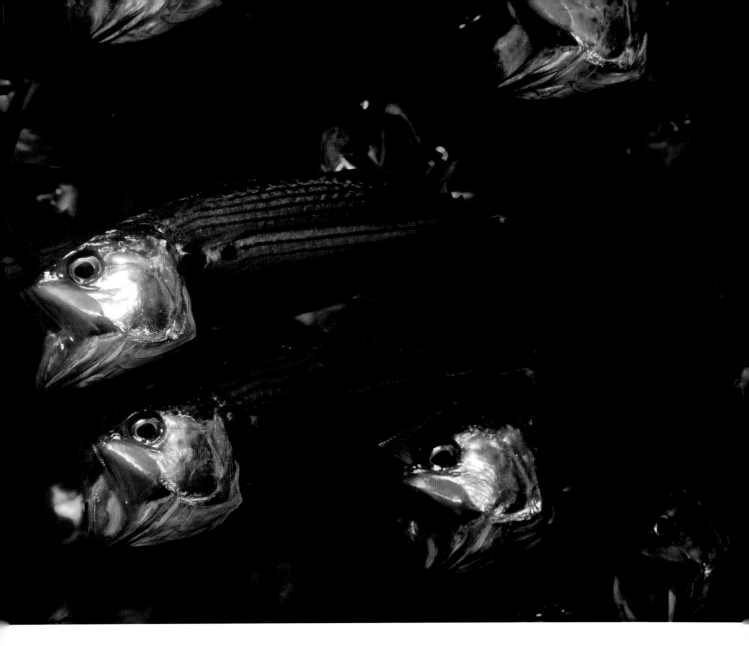

▲ EAT AND RUN

Drifting along a wall at Mabul, Malaysia, I encountered one of the most interesting schooling fish that divers can see, Long-jawed Mackerel (*Rastrelliger kanagurta*). Also known as Mouth Mackerel, these fish are almost always seen swimming with their jaws open wide. Feeding on plankton, Long-jawed Mackerel are very entertaining to watch as they sweep up and down the reef trying to capture small prey in their enormous mouths.

WRASSES

The wrasse family is large and varied with more than 460 recognised species. Wrasses are typically very colourful fish and all start life as female. Living in groups ruled by one dominant male, the rest are his harem of females. If the male dies the most dominant female changes sex and takes his place. Small wrasses are often shy, but many species are very cheeky and playful.

▼ *THE CHEEKY BLUE*

Anyone who has dived off Australia's New South Wales coast would have come into contact with the world's friendliest wrasse, the Eastern Blue Groper Wrasse (*Achoerodus viridis*). Known locally as the Blue Groper, every dive site in New South Wales is home to a family of these cheeky fish.

Accustomed to being hand-fed by divers, these fish are very playful and hard to avoid at times. I have had them follow me on countless dives, but some very cheeky ones have nudged me to remind me that they are hungry. If you want to win a friend for life, then feed a Blue Groper. Their favourite food is sea urchin, and with their super thick lips they have the right gear to handle such a spiky meal, as can be seen in this image taken at Port Stephens.

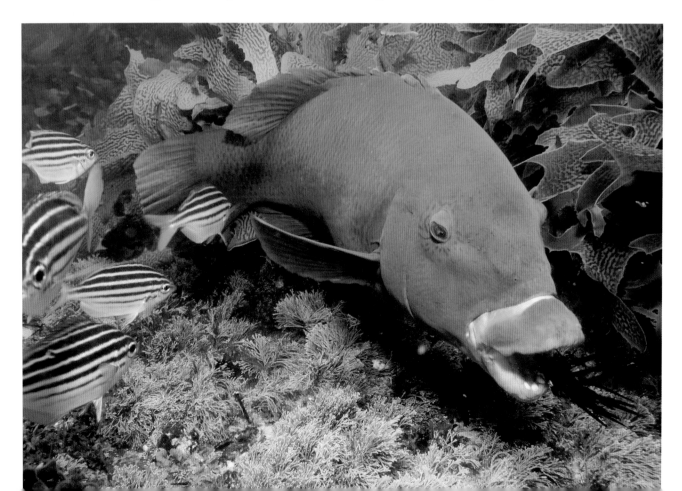

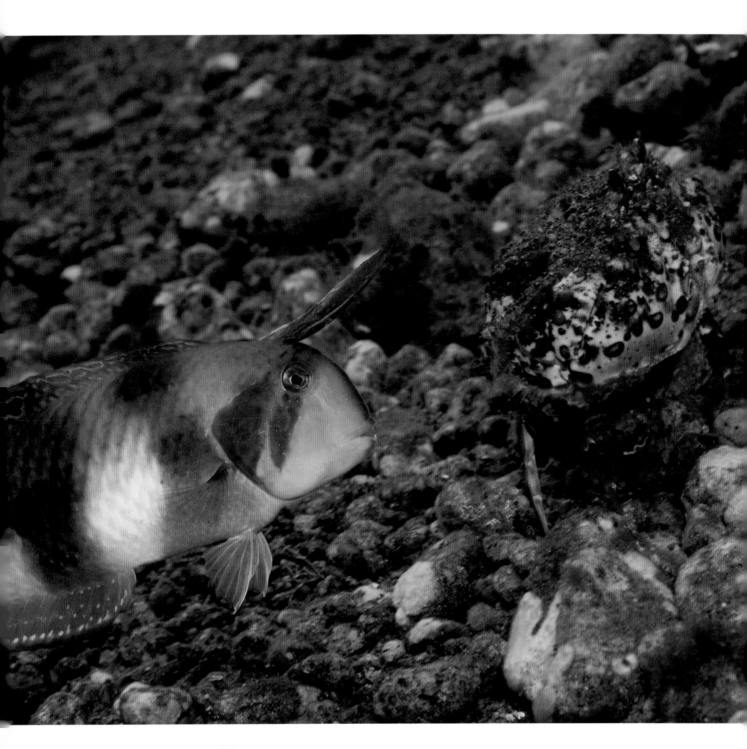

◄ FOLLOW THAT CRAB

One shy but interesting family of wrasses are the razorfish. These very thin-bodied fish generally live on sandy bottoms, and when threatened they dive into the sand and disappear. Razorfish are often hard to get close to, so are best observed from a distance. Occasionally you will find one so preoccupied that you can get very close. A good example is this Peacock Razorfish (*Iniistius pavo*) encountered at Dumaguete, Philippines. I found it chasing this box crab across the bottom. It looked like it was playing follow-the-leader with the crab, but it was just waiting for the crab to disturb tiny invertebrate species amongst the rocks, which it could eat.

▼ FISH FIGHT

If you find a pair of fish fighting, nine times out of ten it will be a pair of wrasse. They seem to fight over territory, food and females, but it is often hard to discern the reason for the conflict. I encountered this pair of Little Maori Wrasse (*Oxycheilinus bimaculatus*) having quite an argument at Dumaguete, Philippines. I found them in this position locked jaw-to-jaw, and as I watched they would push, pull and twist each other around. These feisty fish finally parted, but a few seconds later they were biting each other again. This went on for several minutes, the whole time the wrasse were unconcerned by my presence.

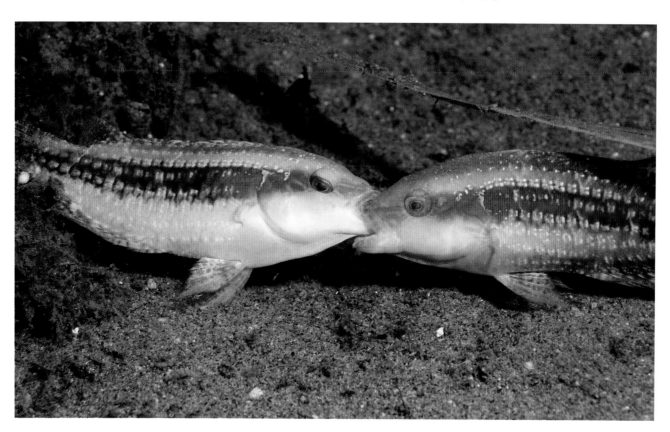

TURTLES

Having roamed the oceans for 150 million years, turtles are very ancient marine reptiles. They live their whole life at sea, the females only coming ashore to lay their eggs. All seven species of marine turtle are threatened by pollution and fishing activities, but fortunately there are still plenty of places where divers can encounter abundant numbers of these playful animals.

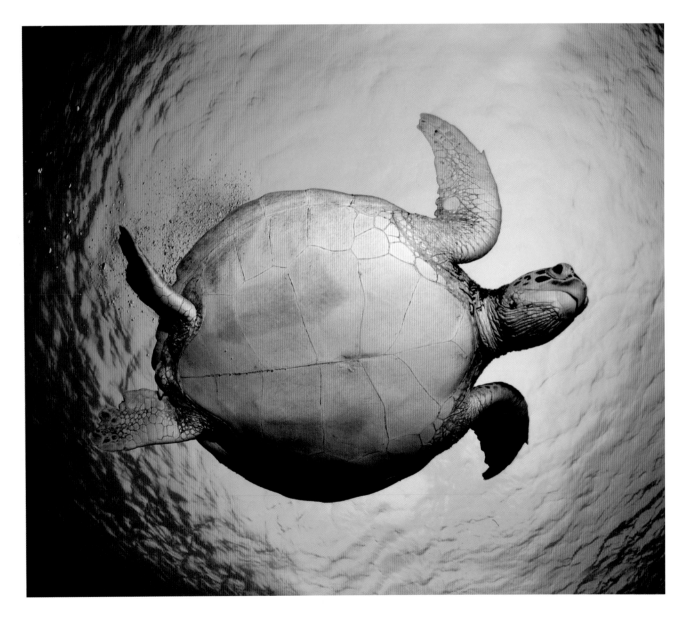

◀ DREAM DRIFTER

The most abundant and widespread sea turtle species is the lovely Green Turtle (*Chelonia mydas*). They can grow to 1.5m (4.9ft) in length, but animals that big are only occasionally seen. While most common on Australia's Great Barrier Reef and in the Caribbean, some of my best encounters with Green Turtles have been in South-East Asia.

Sipadan in Malaysia is a great spot to see numerous Green Turtles, as they nest on the island. It is common to see them resting on ledges and on the corals, exhausted after a night of egg-laying. I encountered this one slowly drifting along the reef wall in a dream-like state.

▼ CORAL ARMCHAIR

Another hot-spot for turtles is Apo Island, Philippines, where I encountered this resting Green Turtle. When sleeping, turtles either wedge under a ledge or snuggle on a coral, and stay in this position for several hours. However, I have found turtles sleeping in some very strange spots, such as one in a black coral tree, another in a barrel sponge, and one inside an airplane on an artificial reef. But even these odd spots looked more comfortable that this fellow slung awkwardly between the hard corals.

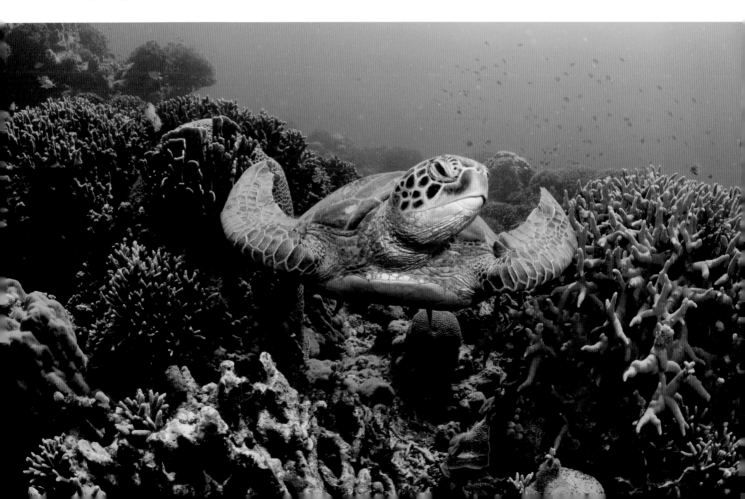

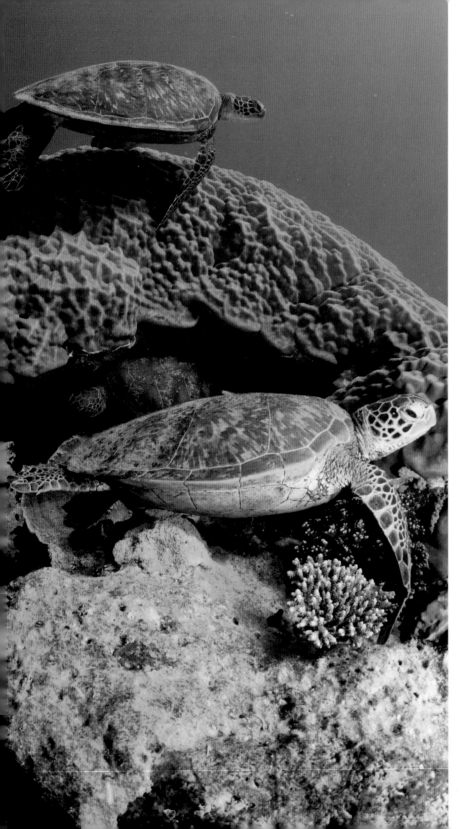

◀ APARTMENT-BLOCK LIVING

Heron Island, on Australia's Great Barrier Reef, is home to countless turtles. Once the site of a turtle soup factory, the island is now more famous for its resort, wonderful diving and over-friendly turtles. I encountered this group of Green Turtles at the island's most famous dive site, Heron Bommie. The coral heads here are a popular resting place for Green Turtles and there is often competition for prime spots, which can lead to pushing and shoving. The turtle in the middle got the best spot on this bommie, while the other two were waiting for it to head to the surface for a breath of air so that they could steal the spot.

▼ *A PESTY NEIGHBOUR*

With its over-sized head, the Loggerhead Turtle (*Caretta caretta*) is easy to identify. Feasting on sea jellies, many Loggerheads die from eating plastic bags that they mistakenly think are their prey. Although found in the tropics around the world, these turtles are more commonly seen in subtropical waters, with Brisbane, Australia, a good place to see them. I have often encountered Loggerhead Turtles on the reefs off Brisbane, generally sleeping in caves and ledges. This one was trying to sleep under one of the scuttled ships at Curtin Artificial Reef. Unfortunately it had selected a spot next to a nesting Narrow-banded Sergeant (*Abudefduf bengalensis*), a very territorial damselfish. Constantly pecking at the turtle's thin skin at the shoulder was enough to move the reptile onto another sleeping spot.

▲ CORAL CRUSHER

Hawksbill Turtles (*Eretmochelys imbricata*) are often confused with Green Turtles, but are easily identified by their pronounced beak and jagged shell edge. These small turtles feed on sponges, sea anemones, sea jellies and corals, and are often so busy munching that they ignore divers. This image was taken at Manado, Indonesia, and it illustrates a common pose for a Hawksbill Turtle – head down, bum up and eating coral.

142

FUR SEALS

The friendliest mammals in the ocean would have to be fur seals. Eight of the nine species of these playful pinnipeds reside in the Southern Hemisphere. They differ from true seals in having external ears and muscular flippers which they can use for walking. Fur seals may look a little clumsy on land, but underwater these animals are acrobats and always enjoy playing around divers.

▼ THE HANGOUT

Fur seals live in colonies that can number in the hundreds, and often thousands. Most colonies are used for breeding, with a dominant male, or beach master, controlling a group of females. However, there are also smaller non-breeding colonies, where the juveniles and subadults hang out. The fur seals at these non-breeding colonies, like these Long-nosed

Fur Seals (*Arctocephalus forsteri*) at Eaglehawk Neck, Tasmania, are much more entertaining, as without parental supervision these kids just want to have fun. Jumping in the water I soon had a dozen fur seals zooming around me, but it soon wears you out trying to keep up with these fast-paced performers. I took this image when the group had settled down, after the initial fun and games.

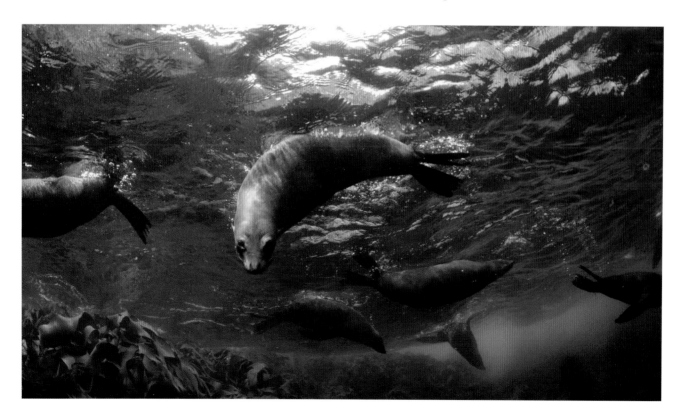

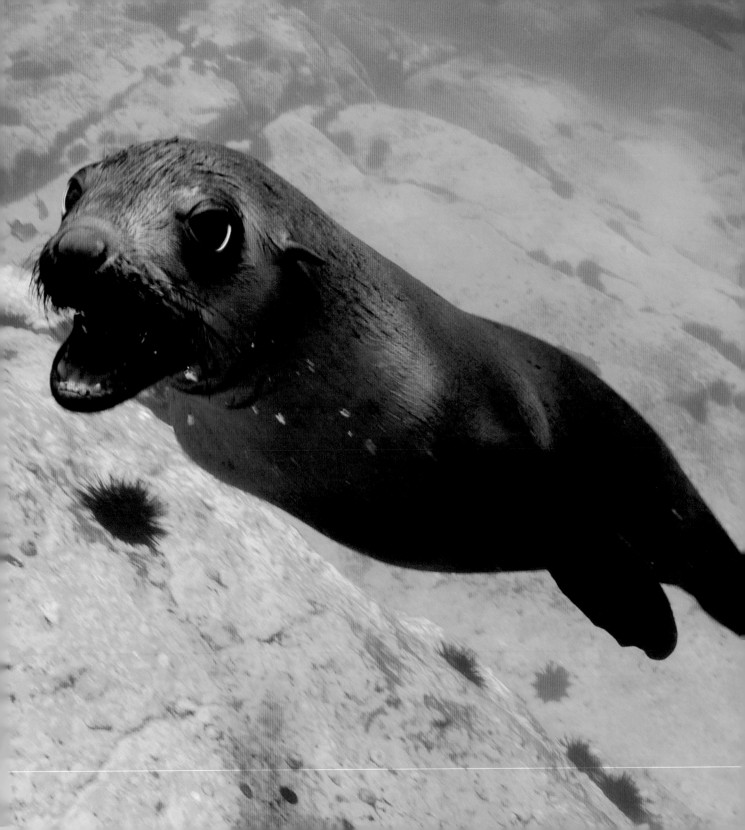

◄ SHOUT

The cheekiest animal that divers will encounter in southern Australia is the Australian Fur Seal (*Arctocephalus pusillus doriferus*). Most common off Victoria and Tasmania, where large breeding colonies are found, these animals are sometimes so comfortable with divers that they nibble on fins, hands and even heads! I have had some of my most memorable encounters with Australian Fur Seals at Montague Island, New South Wales. This colony is full of larrikin juveniles that like nothing better than zipping around divers. Photographing these fast-moving animals is never easy, but being with them is always a delight. They are particularly endearing when they swim past barking, like the one in this image.

▼ FRIENDLY FELLOW

I had another unforgettable encounter with a juvenile Australian Fur Seal in Melbourne's Port Phillip Bay. Diving under Rye Pier we were joined by this friendly little individual. The fur seal had been residing on the pier for weeks, and seemed to enjoy checking out divers. It was probably the most sedate fur seal encounter I have had. No fast-paced zipping about, as this little fellow was happy to wallow on the surface and slowly swim around us. I had a more heart-stopping fur seal encounter at the same location on a night dive several years later, when a large fur seal zoomed between the pylons right in front of me. I like to think it was the same animal back for a visit with an old friend.

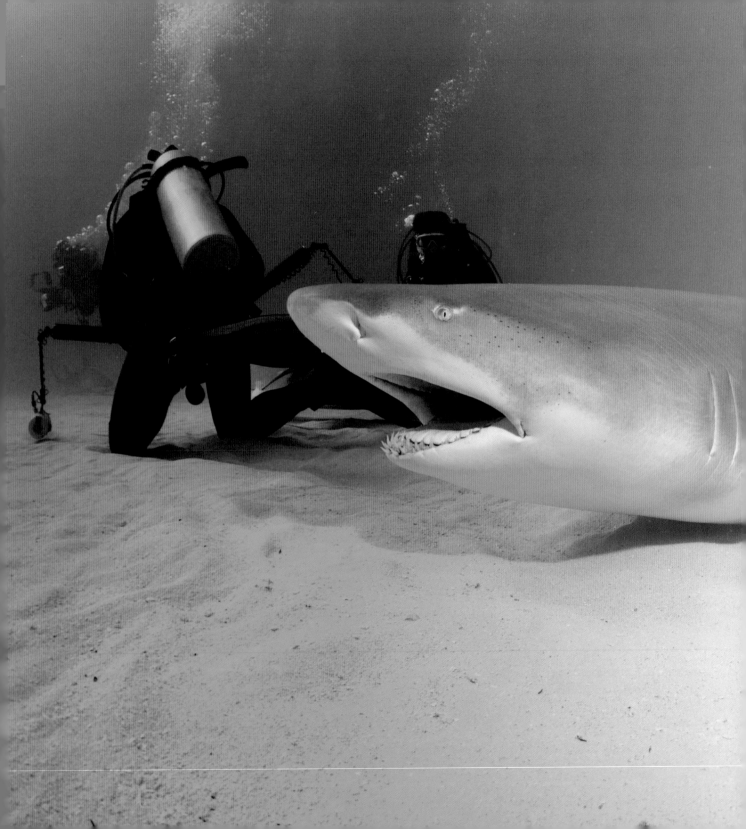

THE DANGEROUS

The oceans are full of creatures that could possibly bite, sting or attack you. Fortunately these potentially dangerous animals rarely kill or seriously injure people, and most incidents occur due to humans harassing the animal, feeding the animal, or being mistaken for the animal's prey. Although you have to take care when encountering these creatures, the rewards for doing so are wonderful.

• • • • •

BLUE-RINGED OCTOPUS

Few things are more deadly than the venomous bite of a blue-ringed octopus. These tiny octopus – most are no bigger than 10cm (4in) long – are beautiful to look at and fortunately very docile. The blue-ringed octopus family contains four known members and a few undescribed species, and is only found in the Indo-West Pacific region. Easy to observe and photograph, just don't touch or annoy these deadly critters.

▼ SHELL SHELTER

Australia is home to several species of blue-ringed octopus, which reside in both tropical and temperate waters. Australian children are warned not to touch or handle any small octopus, but encounters do happen by accident, including my first one as a teenager. Snorkelling in a bay south of Sydney, I was looking for abalone. Spotting an abalone I dived down, only to find it was an empty shell. Turning the shell over something suddenly shot out – a tiny Blue-lined Octopus (*Hapalochlaena fasciata*). At first I was fascinated, as this was the first time I had seen one of these small octopus. When it suddenly swam towards me I quickly backed off, but it kept on coming so I decided to exit the water, not wanting to tangle with this deadly little creature.

Years later, after encountering dozens of Blue-lined Octopus, including the one in this image at South West Rocks, I realised that I had been very naive. I had thought that this tiny octopus was trying to attack me, when all it was doing was looking for shelter, having been dislodged from its shell home.

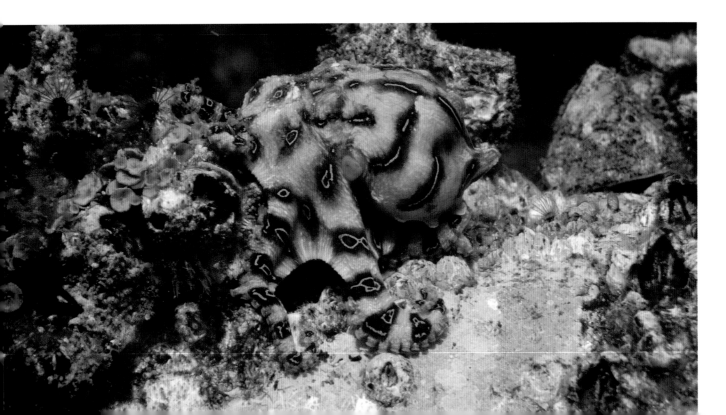

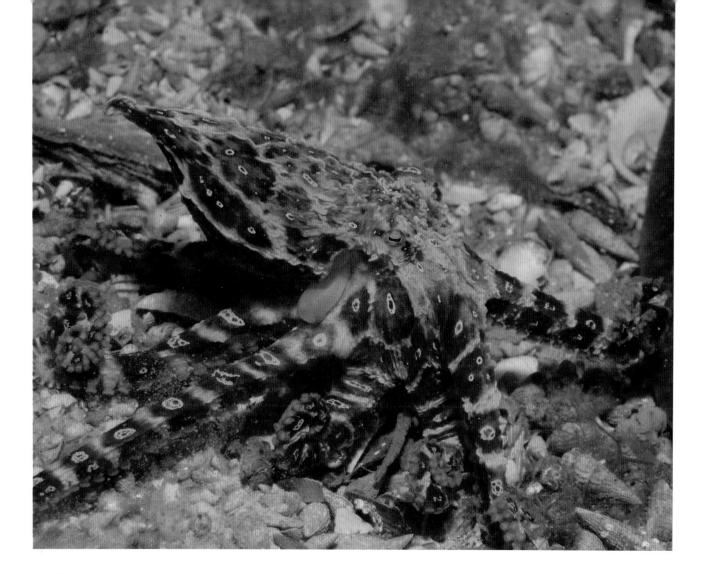

▲ *THE STROLL*

Most people think of blue-ringed octopus as tropical, however one of the most abundant species is only found in the temperate waters of southern Australia – the Southern Blue-ringed Octopus (*Hapalochlaena maculosa*). It is especially common under the many piers in Melbourne's Port Phillip Bay, which was where I encountered this one. They are more commonly seen at night, when they emerge to feed, but occasionally make daytime appearances. I encountered this one by day, while it was out for a stroll, looking for another place to slumber. I followed it for several minutes, and in this image it can be seen about to walk across a Spotted Stingaree (*Urolophus gigas*). The small ray instantly reacted to the touch, quickly swimming away. Meanwhile the octopus wisely disappeared between some shells, before some of the resident fish decided that it would make a tasty meal.

▲ HEAD HUGGERS

The most common tropical member of this family is the Greater Blue-ringed Octopus (*Hapalochlaena lunulata*). Like other members of this family they are most commonly observed at night feeding, but I had a rare daytime encounter with a mating pair at Lembeh, Indonesia. When my dive guide first showed me this spectacle I was confused, thinking I was witnessing a strange octopus fight. But after a couple of suggestive hand signals from my guide I worked out what was going on. Other pairs of mating octopus I have observed barely come into contact with each other, with the male sending out a wandering arm to inseminate the female. Blue-ringed octopus have short arms so the male has to get much closer, hanging onto the female's head. In this encounter the only one in imminent danger was the male, as the females have been known to eat them after mating!

GREAT WHITE SHARK

Before the film Jaws came out the Great White Shark (Carcharodon carcharias) was just another dangerous shark, now it is one of the most feared creatures on the planet. Growing to a length of 6.5m (21.3ft), it is a highly efficient predator that feeds on marine mammals, sharks and rays, and sometimes accidentally bites people. But they are not mindless killers as depicted in films, rather an important part of a healthy marine ecosystem.

▼ *CAGED VIEW*

I would one day love to encounter a Great White Shark in the wild and observe it behaving naturally, without the stimulation of baits. Until that day comes I will make do with the views of these incredible beasts that I've enjoyed from the safety of a shark cage. However, I find cage diving a frustrating and very artificial experience, as the sharks have to be lured close with baits and most of the time they are completely uninterested in the divers. Photographing Great White Sharks from a cage is also challenging, as the cage is constantly moving and you miss half of the action if you are not looking the right way. This is easily my favourite Great White Shark image, taken from the cage at the Neptune Islands, Australia. I have plenty of pictures that show the grace and beauty of the Great White Shark, but this image shows the raw power of this awesome creature.

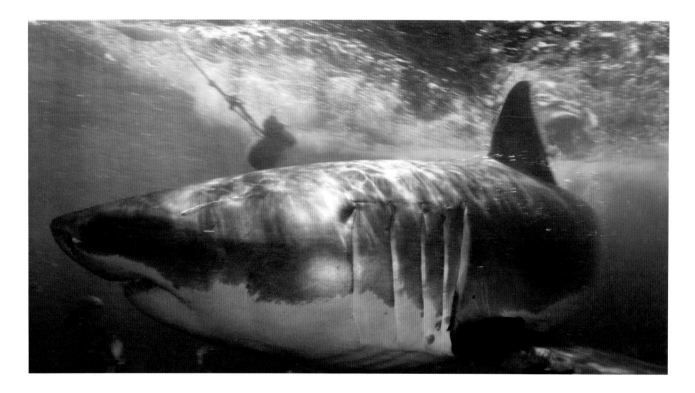

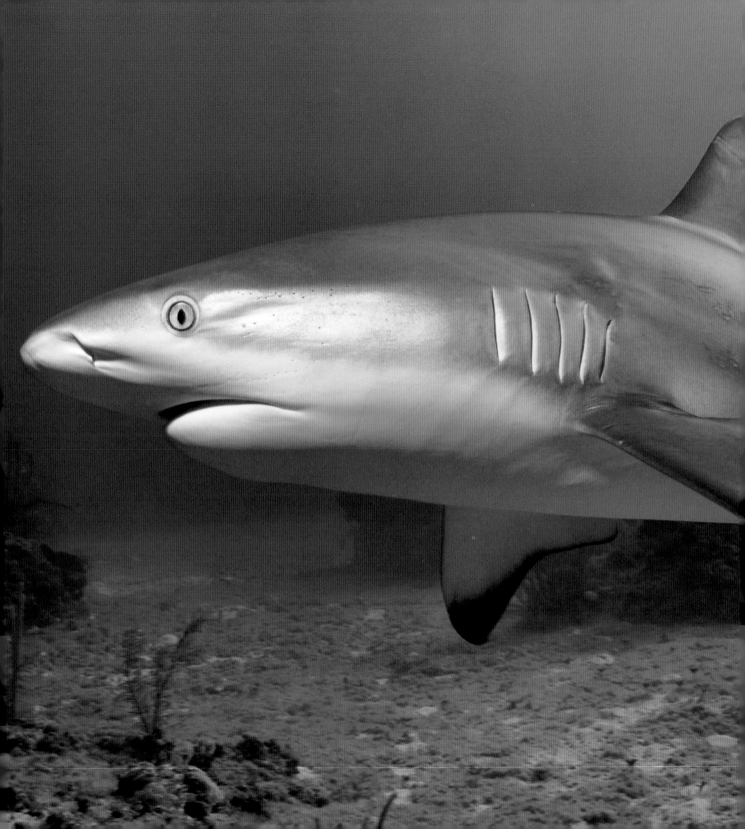

WHALER SHARKS

The whaler shark family contains more than 60 members and many are considered potentially dangerous. The sharks of this family are all sleek streamlined creatures with teeth designed to catch, cut and tear apart prey. Most members of this family are shy and wary of divers, and baits are required to bring them in close. A few members of the whaler shark family are very curious and have been known to nudge and even bite divers.

◀ *EYE-TO-EYE*

Getting eye-to-eye with any member of the whaler family is quite difficult, as these sharks are extremely cautious around divers. I managed to have a very close encounter with this Caribbean Reef Shark (*Carcharhinus perezii*) on a shark feed off Grand Bahama, Bahamas. Shark diving is big business in the Bahamas, with millions of dollars generated from the industry each year. As such, all sharks are protected in this progressive country. With baits in the water the sharks were very excited, zipping around the divers, but mainly concentrating on the food. While watching them snatching the baits was fun, I got the most enjoyment from seeing the curious nature of these sharks. Normally they wouldn't have come within 10m (33ft) of me, but with the smell of food in the water the sharks overcame their natural fear to curiously inspect me.

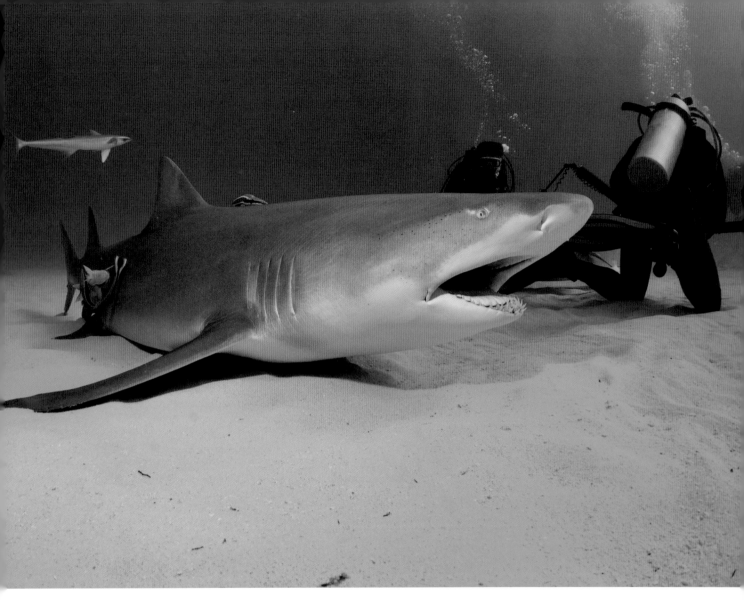

▲ ON A BREAK

Most whaler sharks have to constantly keep swimming to push water through their gills to breathe, and if they stopped swimming they would drown. A few members of the whaler family are able to rest on the bottom and suck in water to breathe. One such species is the Lemon Shark (*Negaprion brevirostris*). Usually a shy species, it is attracted to a few shark feeding locations off Grand Bahama, Bahamas, where I encountered this one. At shark feeds the Lemon Sharks take the odd baits, but appear to enjoy just swimming around the boat and divers. They are so accustomed to humans that when they want to take a break they will drop on the sand right beside you, allowing for a very close encounter.

▼ FOLLOW YOUR NOSE

Sharks are rarely alone and always have an entourage of interlopers and groupies. The most common of these followers are the suckerfish, but sharks are also accompanied by numerous species of trevally, the most famous being the Pilot Fish (*Naucrates ductor*). In this image, taken at Beqa Lagoon, Fiji, I encountered this Sicklefin Lemon Shark (*Negaprion acutidens*) being piloted by a gang of juvenile Golden Trevally (*Gnathanodon speciosus*). The trevally gain a number benefits from this association, including a share in the shark's meals through grabbing titbits, protection from predators, and using less energy by riding the bow-wave created by the shark.

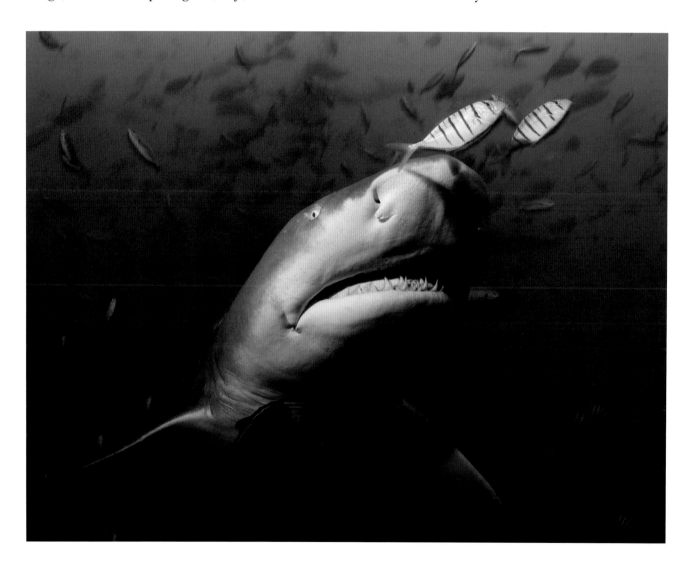

▼ SPEED DEMON

Whaler sharks can turn on impressive bursts of speed when feeding, with one of the fastest members of the family being the Silvertip Shark (*Carcharhinus albimarginatus*). I encountered this one at a shark feed at Beqa Lagoon, Fiji. It was one of three zooming around the site, spending more time checking out the divers than the baits. My most memorable encounter with this species was at Lady Elliot Island, Australia. Exploring a coral head I looked up to see my buddy staring wide-eyed at something behind me. I turned around to see a Silvertip Shark shoot past only centimetres away. Later my buddy told me he had watched the shark speed out of nowhere, aiming straight for my head. It wasn't attacking me, but was definitely checking me out.

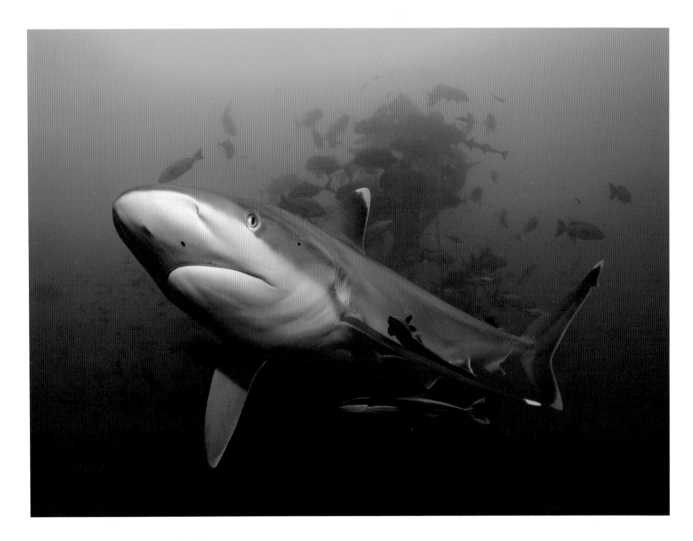

▼ *LUMBERING TIGER*

Growing to a length of 5.5m (18ft), the Tiger Shark (*Galeocerdo cuvier*) is a giant among whaler sharks, and responsible for a number of attacks on people. I always enjoy encountering Tiger Sharks, whether at a shark feed or just patrolling a reef. They are never in a hurry and slowly lumber around like they have all the time in the world. I encountered this one, which is known as 'Hook', at a shark feed off Grand Bahama, Bahamas. She was great fun to watch as she slowly swam around the divers, occasionally taking some food. Sometimes she would get very curious of a diver and bump them with her snout. I was very excited that she bumped me several times, but as I gently pushed her away I was acutely aware that she had a mouthful of very sharp teeth just below that blunt snout.

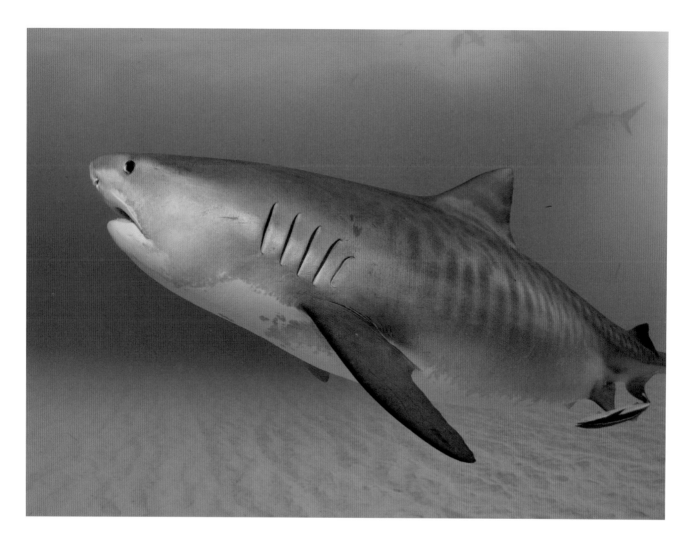

▼ LOVE BITES

The most common member of the whaler shark family encountered by divers in the Indo-Pacific region is the Whitetip Reef Shark (*Triaenodon obesus*). These very social sharks are often found in groups patrolling the reef, resting on the bottom, or sleeping in caves. I encountered this one in a cave at the Rowley Shoals, Australia. She was being a little antisocial and not mixing with the other Whitetip Reef Sharks in the area and I could understand why. If you look closely you will see fresh bite marks around her gills and pectoral fins – evidence that she has recently mated. Male sharks, lacking hands, have to bite the female when mating in order to insert a clasper. Unfortunately these 'love bites' can inflict some nasty wounds, so this one was wisely staying hidden to avoid any frisky males.

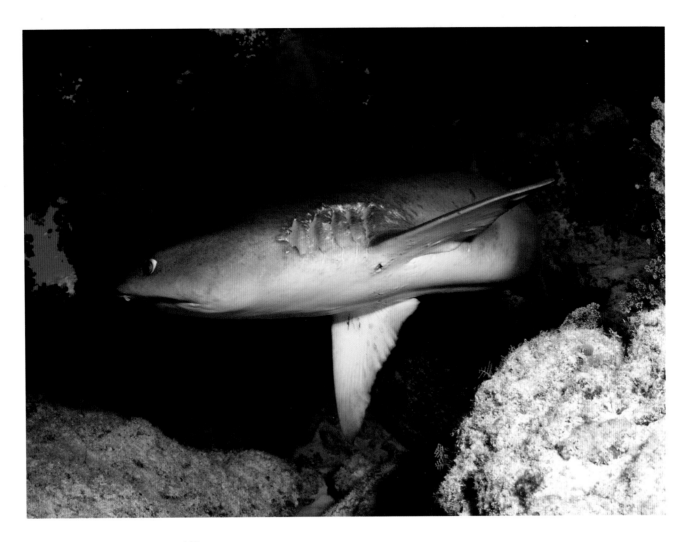

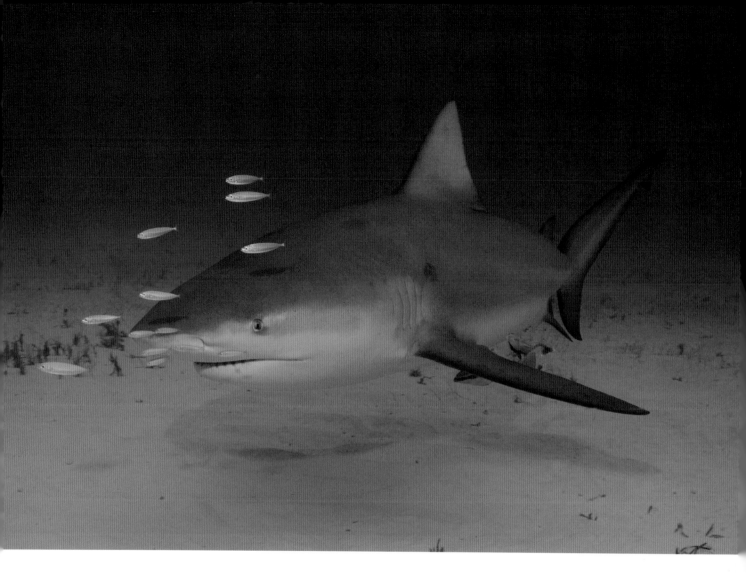

▲ TIMID ASSASSIN

The most notorious of all the whaler sharks is the much-maligned Bull Shark (*Carcharhinus leucas*). Responsible for many bites on swimmers, these bulky sharks should always be treated with respect. Often found in shallow murky water, and also freshwater rivers, most bites from this species are likely due to the shark investigating the person to see if they are prey. I have always found Bull Sharks to be wary of divers, including this one encountered off Bimini, Bahamas. At this site we were watching Great Hammerhead Sharks (*Sphyrna mokarran*) being hand-fed, and while the Bull Sharks were offered food, they were far too timid to take it. They would instead sneak around behind us and dart away when we turned around to photograph them. It was unnerving at times to have a dozen Bull Sharks milling around behind you.

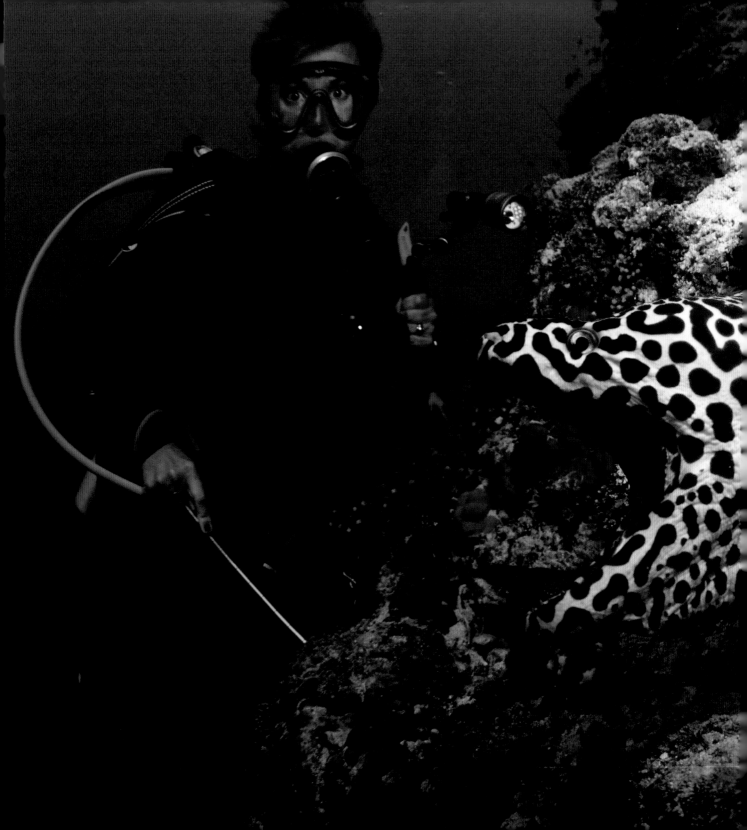

THE MISUNDERSTOOD

The following marine animals are misunderstood, and often mistreated, due to misleading tales of their dangerous nature. Some of them are potentially dangerous, but they are not the evil killers as they have been depicted in books, films and other media. Getting close to many of these animals is not a problem, but a bit of common sense can help to stop you, or the animal, getting injured.

MORAY EELS

Moray eels have always featured in books and films as vicious killers ready to tear apart any human they encounter. In fact these creatures are quite docile and are only interested in divers when offered baits. The moray eel family contains more than 200 species, and while they have razor-sharp teeth, they generally reserve their use for grabbing prey. Getting close to moray eels is easy, as most are curious or indifferent of divers.

▼ DAY BREAK

One of the largest members of the moray family is the impressive Giant Moray (*Gymnothorax javanicus*). By day divers encounter them resting in a lair, which can be a cave, ledge or even a shipwreck, which is where this one was residing at Mabul, Malaysia. Very placid by day, divers can often get very close to study Giant Morays, but once the sun sets they leave their lair to search for food. Moray eels prey on fish, crustaceans and cephalopods, and watching them hunt at night is an extraordinary experience. I have encountered morays looking for prey numerous times, but will never forget one Giant Moray at Lady Musgrave Island, Australia. Investigating every nook and cranny for sleeping fish, the moray found several fish as I watched. Once discovered the fish would try to flee, but with a quick snap of the jaw the fish was grabbed and consumed. The power of those jaws was impressive to watch, and one snap was so potent it cut a fusilier in two.

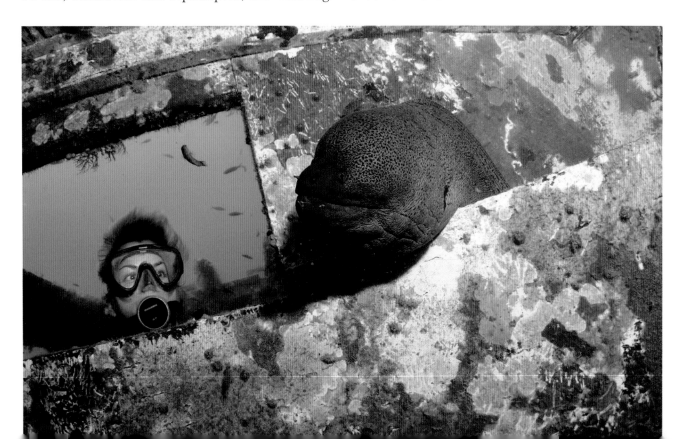

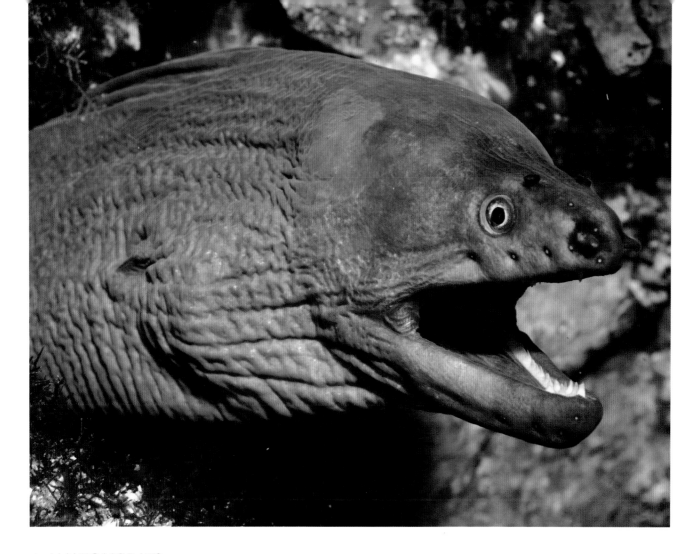

▲ MANIC MORAYS

The most common moray species encountered in southern Australia is the Green Moray (*Gymnothorax prasinus*). Morays look threatening as they constantly open and close their mouths, as seen in this image taken at South West Rocks. But this is merely the way the moray breathes. The Green Moray is generally not too interested in divers, but I did have an unnerving experience with this species at Coffs Harbour. Exploring a dive site called Moray Mooring should have been the first clue that this location was home to more than its fair share of moray eels. Once on the bottom I could see that every available hole was occupied by a Green Moray. I quickly discovered why when my guide produced a bag of pilchards to feed them. The morays, expecting a feed, were out of their holes and slithering all over the guide. It was quite a spectacle, with morays tearing apart the fish, swimming in midwater and also climbing all over my guide. I quickly gave up on photos, not only because of poor visibility, but because I had morays all over me.

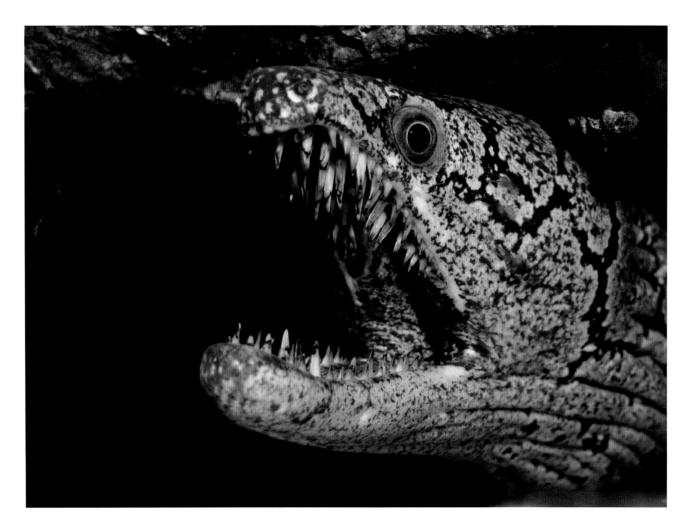

▲ ALIEN JAWS

Moray eels sport some pretty impressive dentures, but few can match the lethal weapons of the Mosaic Moray (*Enchelycore ramosa*). Only found off the east coast of Australia and the north of New Zealand, I encountered this elusive Mosaic Moray at South West Rocks. This image always reminds me that those needle-sharp teeth are not the only set of jaws that moray eels have, as recently it was discovered they have a second set of jaws in their throat. Moray eels swallow their prey whole, and with no hands to help guide food down their throat they have a second set of jaws to assist in this process. Their hidden set of jaws extend forward to grab the food and pull it into the stomach. It has been likened to the inner jaws of the creature in the *Alien* movies. Fortunately moray eels don't have acid blood, although they do have toxic flesh, but that is another story.

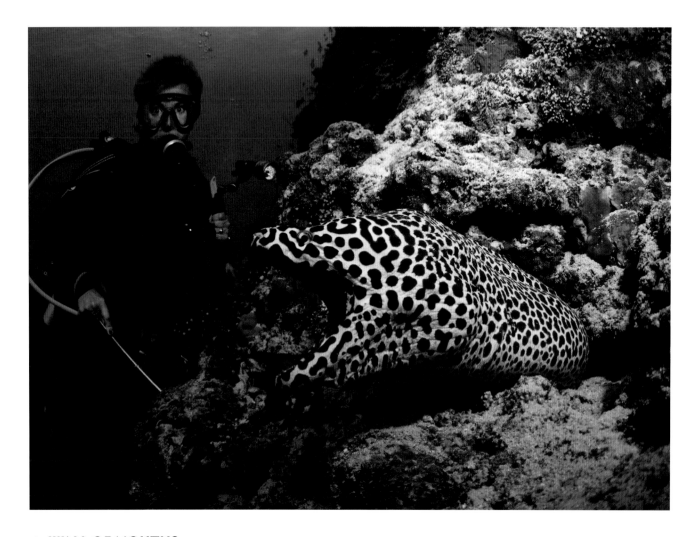

▲ WALL OF MOUTHS

Checkout dives on liveaboard dive boats are generally done at a pretty average dive site so divers can check their gear and buoyancy. However, a checkout dive I did in the Maldives introduced me to the greatest collection of moray eels I have ever encountered. This dive site on North Male Atoll is called Kanduohgiri and the dive brief mentioned moray eels, but not hundreds. Within a minute of descending I had encountered several Giant Morays and this lovely Honeycomb Moray (*Gymnothorax favagineus*). As the dive progressed I couldn't believe the number of moray eels, as every hole had one, two, five, and in some cases a dozen morays. I counted seven species of moray eel, but there may have been more. I later learnt the reason for this abundance of morays – the site is right next to a fish processing plant.

▼ RIBBON WITH FLARES

The most flamboyant member of the moray family is the pretty Ribbon Eel (*Rhinomuraena quaesita*). These lovely eels have a thin ribbon-like body, strange flared nostrils and chin whiskers. Always entertaining to watch, Ribbon Eels have a habit of hanging out of a hole and snapping at passing fish, as can be seen in this image taken at Anilao, Philippines. Ribbon Eels not only look very different to other morays but are the only moray that goes through a bizarre sex- and colour-change cycle. Juveniles start off black and then, as they develop into adults, change into blue males and yellow females, although adult males have also been observed changing into females.

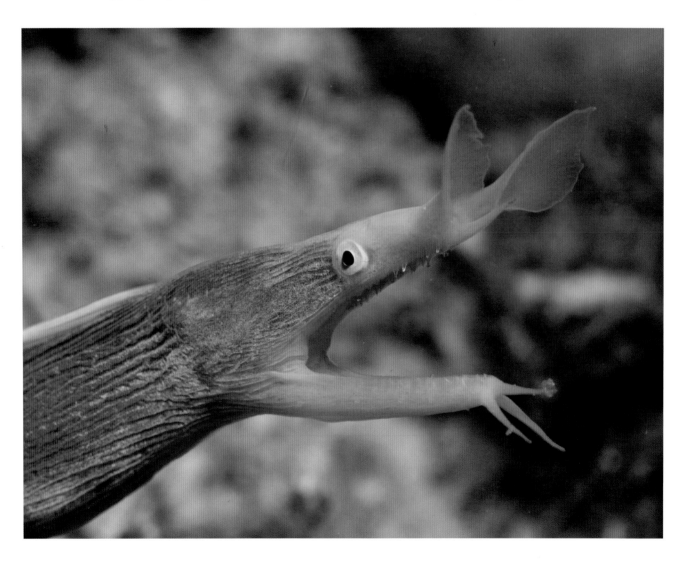

BARRACUDA

With large sharp teeth and a vicious snarl, barracuda have a reputation as malicious killers. While potentially dangerous, especially if spearing fish, barracuda generally pose no threat to divers and are quite placid creatures. The barracuda family contains 28 species and most species are shy, although they are often more bold when found in large schools.

▼ NIGHT SHIFT

Found on reefs around the world, the Great Barracuda (*Sphyraena barracuda*) is the largest member of this family, reaching a length of 1.7m (5.6ft). Usually found singly, it is an ambush predator that uses short bursts of speed to grab prey. Divers generally encounter Great Barracuda hovering over coral heads, waiting for prey to come within striking distance. They can often be far more active at night. I encountered this one at night off Mabul, Malaysia. It hadn't commenced feeding activities, unlike a very active Great Barracuda I once encountered on the Ribbon Reefs, Australia. This creature started to follow us around, and it quickly became obvious why, as each time our torches lit up a fish the Great Barracuda would strike. It was spectacular to see this powerful fish in action, but we soon felt sorry for the small fish and turned off our torches to avoid a bloodbath.

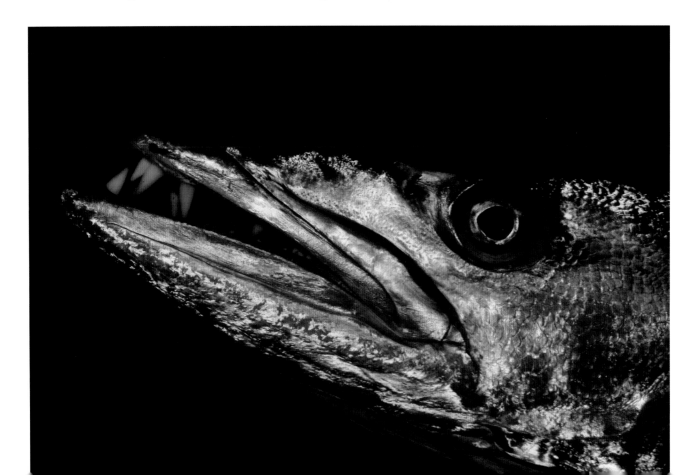

GREY NURSE SHARK

One of the most impressive sharks that divers can encounter is the wonderful Grey Nurse Shark (Carcharias taurus). Known by many common names in different countries – including Sand Tiger Shark and Spotted Ragged-tooth Shark – these harmless but fierce-looking sharks are seen at many dive sites off Australia, South Africa and the USA. Usually found in aggregations, they are one of the largest free-swimming sharks that divers can easily get close to.

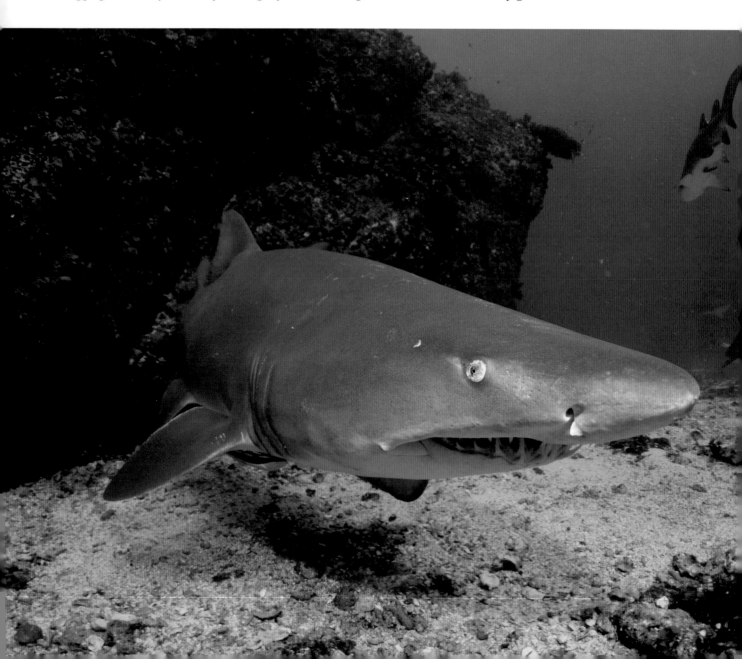

◀ TOOTHY SMILE

Once labelled a man-eater and almost hunted to extinction off the east coast of Australia, the Grey Nurse Shark is slowly making a comeback since being protected. These poor sharks were once killed by spearfishers, and even today suffer at the hands of fishers. Once you have encountered one of these graceful, slow-swimming sharks you will wonder why anyone would want to kill one. They are very curious and will often check you out with their beady little eyes, like this one was doing off Brisbane, Australia.

PLAYING CHICKEN ▶

Over the years I have encountered thousands of Grey Nurse Sharks and found that each one is quite different in terms of how it behaves and reacts to divers, depending on the situation. Generally sharks that are solitary or in a small group are nervous and difficult to approach, but sharks in a group of six or more are bold and often curious of divers. Some can even get a little cocky. I have had Grey Nurse Sharks following me and have even had a few brush up against me. However, the most interesting behaviour is when a very bold one decides to play chicken, such as in this image taken at South West Rocks. If the cheeky shark decides you are fair game it will swim straight at your head. Generally the shark will swim overhead, but a few times I have had to duck to avoid a collision.

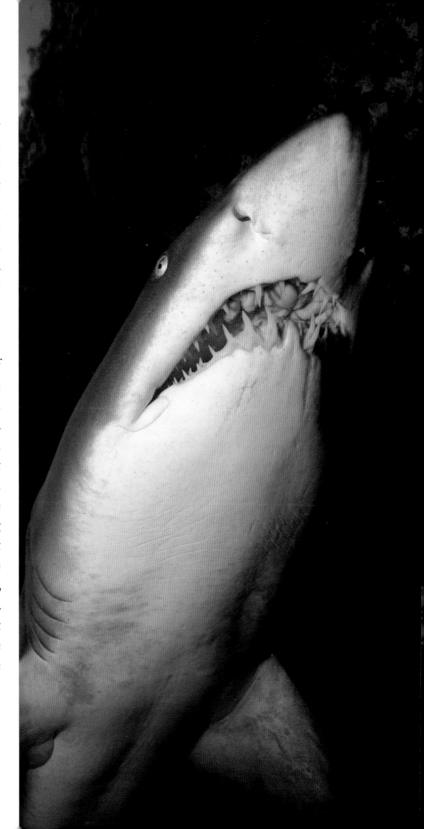

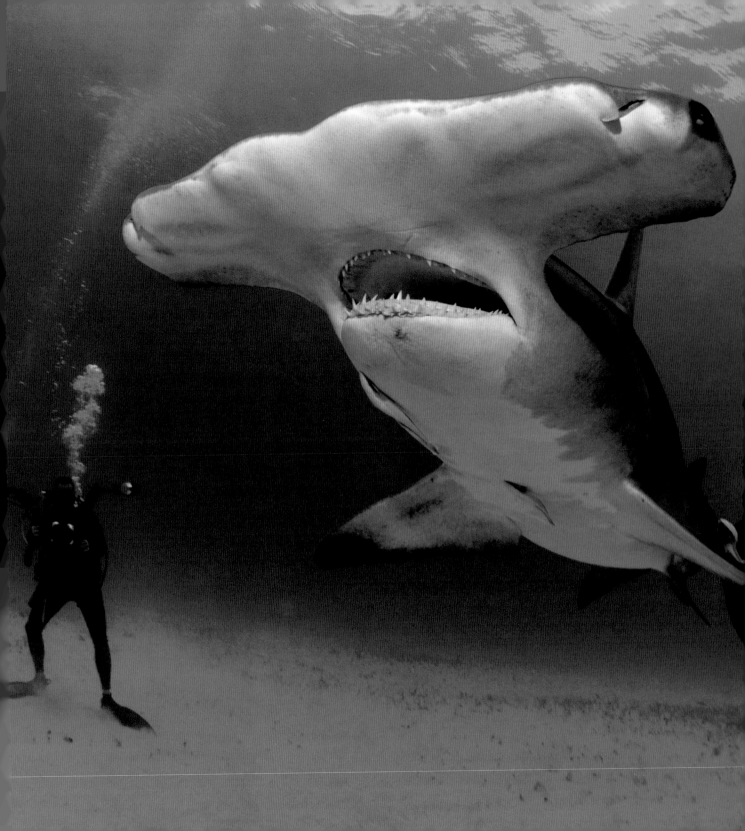

HAMMERHEAD SHARKS

They may look bizarre with their hammer-shaped heads, but hammerhead sharks are the most recently evolved of all shark species and also the most high-tech. That weird head has evolved to enhance their sense of sight, smell and taste, with their electro-receptors spread over a wide area. Once considered dangerous, we now know hammerhead sharks are shy and wary by nature, so encounters are often very brief.

◀ A LUCKY ENCOUNTER

My first experience with a Great Hammerhead (*Sphyrna mokarran*) was a dive I will never forget. It was 1986 and I was diving the Great Barrier Reef off Townsville on a week-long liveaboard trip. Several days into the trip the crew decided they would try a shark feed at a reef they had never visited before. I gave them almost no chance of attracting a shark, so got in the water 30 minutes after everyone else and sure enough, no sharks. Rather than spend the entire dive sitting on the bottom, my buddy and I decided to explore the reef.

After 40 minutes we returned to where the others had set up the baits, but had since returned to the boat. We were just about to ascend when I noticed a dark shape coming up the reef from deep water. Within seconds it materialised from the gloom – a huge Great Hammerhead. It continued up the reef and was heading straight for me. It came in low, and I was wide-eyed with amazement as this large shark skimmed over my head. Within seconds it turned and was coming in for another pass. It was then that I realised that I was lying on the only remaining bait. Before I could move the shark came back for another pass. I looked at my buddy, and we both decided to head up, quickly.

Climbing back onto the boat was the first time I realised that I had my camera in my hand. I was so excited at seeing this impressive shark that I completely forgot to take any photos. I didn't get to see another Great Hammerhead until 30 years later on a trip to Bimini in the Bahamas, when this image was taken. This time I took plenty of photos.

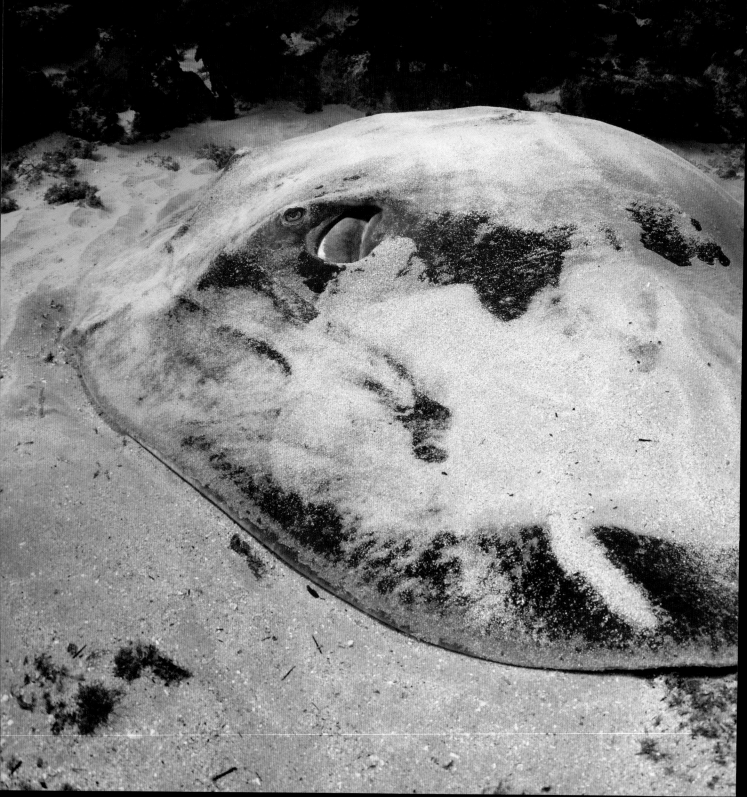

STINGRAYS

Stingrays have an undeserved reputation and are feared by many people, who are worried that they will be jabbed by their dagger-like tail barbs. Those tail barbs are purely for self-defence against sharks and other predators, including foolish divers who grab them. In reality stingrays are very calm and placid creatures that will allow divers to get very close. With more than 70 species, the stingray family includes many interesting and varied species.

◀ NOT QUITE UNDERCOVER

Stingrays may have tail barbs for defence, but they also like to deploy a little cloak and dagger to make them more difficult to find. Some hide under ledges or in caves, but most like to hide under a layer of sand. Being covered in sand works very well for small species, but doesn't quite have the same effect when the ray is more than 2m (6.6ft) wide, such as this Smooth Stingray (*Dasyatis brevicaudata*) encountered at Jervis Bay, Australia. The second-largest stingray species in the world, it is common in southern Australia and always fun to encounter.

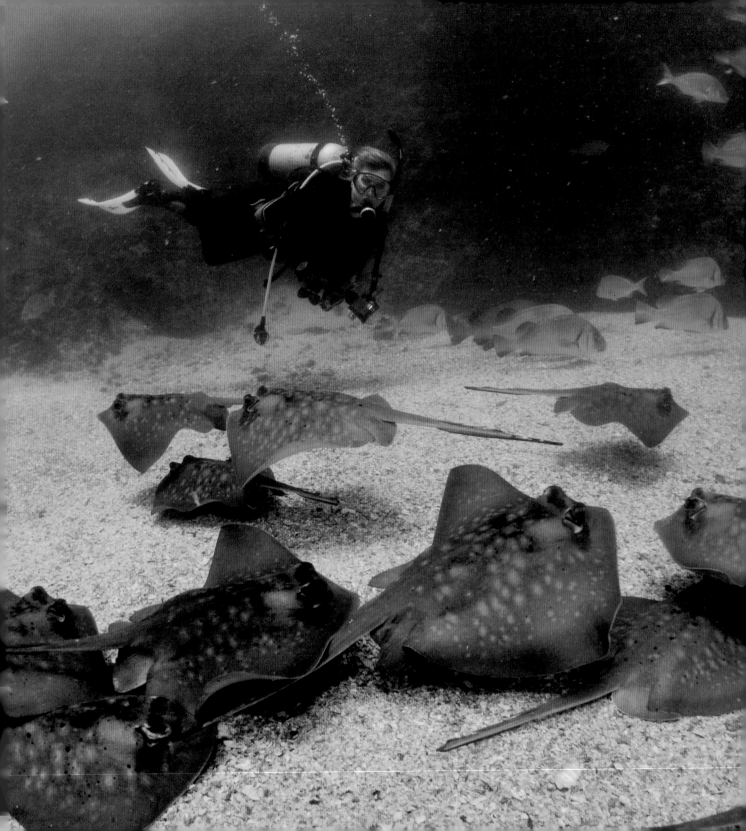

◀ BIZARRE GATHERING

The Blue-spotted Maskray (*Neotrygon kuhlii*) is a very common stingray on reefs throughout the Indo-Pacific region. Usually found singly, it is rare to see more than a few around any reef. However, a strange gathering of this species occurs at Byron Bay, Australia, each summer. Julian Rocks is the premier dive site here and it is home to a good variety of rays, including a small number of Blue-spotted Maskrays. But as can be seen in this image, thousands of these rays aggregate at this site in the month of January. I couldn't believe the number of rays when I first witnessed this event, with them piled on top of each other and swimming around the site. Why they gather is not understood – it is possibly for mating or feeding, but whatever the case it is a spectacle not to be missed.

SPINELESS STINGRAY ▼

The most unique member of the stingray family is the strange Porcupine Ray (*Urogymnus asperrimus*). This rarely seen species has no tail barb, and instead has a body and tail covered in short sharp thorns. One of the most reliable places to encounter Porcupine Rays is at Heron Island, Australia. The one in this image was photographed in the harbour, and was one of two hiding in the powdery sand under the jetty. This species has been fished by humans for thousands of years, with its skin used as sandpaper, to cover shields and as sword-handle grips. Very tolerant of divers, Porcupine Rays are wonderful stingrays to observe and photograph.

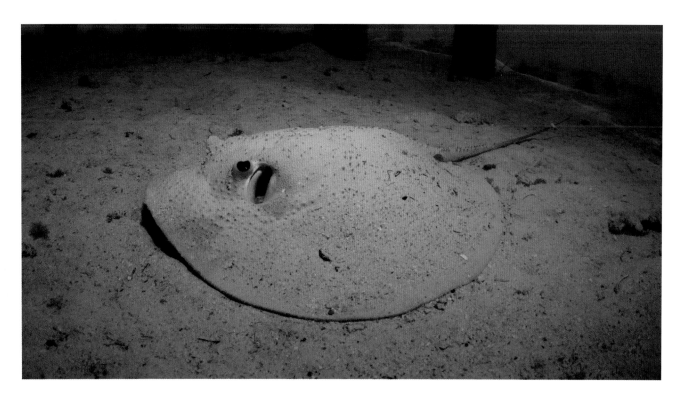

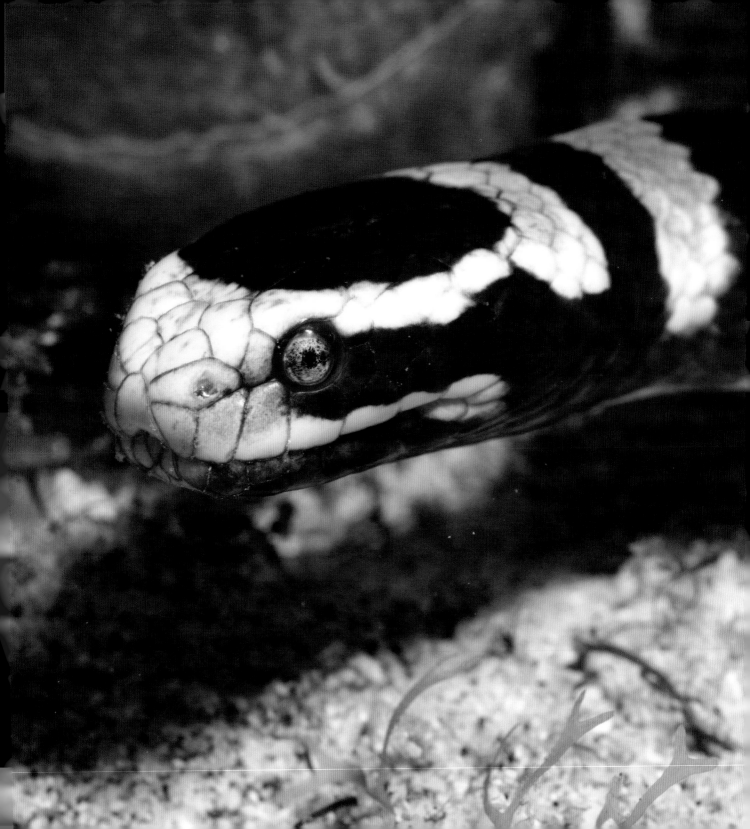

SEA SNAKES

Sea snakes are some of the most venomous creatures on the planet and have been responsible for a number of human fatalities. However, these docile creatures pose little threat to divers as long as they are not handled or harassed. The sea snake family contains more than 70 species, and not all of them are venomous. They are fascinating creatures to encounter.

◄ DISCO DISTURBER

The most common sea snake divers encounter throughout South-East Asia is the Yellow-lipped Sea Krait (*Laticauda colubrina*), which is often simply called the Banded Sea Snake. I encountered the one in this image at Sogod Bay, Philippines, as it searched the reef for small fish. Like all sea kraits, this species regularly comes ashore at night to rest, and this is when I have had some very unusual encounters. Loloata Island in Papua New Guinea is home to many Yellow-lipped Sea Kraits, and walking around the island at night they can be observed in the gardens and on the footpaths. One evening we had one slinking under our dinner table, while another caused havoc in the disco when it slithered onto the dance floor.

▼ EGG THIEF

The cutest and strangest member of the sea snake family is the Turtle-headed Sea Snake (*Emydocephalus annulatus*), which is non-venomous and only eats fish eggs. I encountered the one in this image at Marion Reef, Australia, and found it slowly patrolling the reef. Researchers have discovered that these sea snakes have a very small home range, and regularly tour their home turf as they know where the resident reef fish lay their eggs. This species, along with many other sea snake species, has dramatically declined in numbers during the past few decades. Why sea snakes are disappearing is still not understood, but it could be linked to human development, pollution or just a general decline in coral reef communities.

▲ TASTE TESTING

The most common sea snake on Australia's Great Barrier Reef is the lovely Olive Sea Snake (*Aipysurus laevis*), which grows to 2m (6.6ft) in length and is common on inshore reefs and shipwrecks. The one in this image was encountered on a shallow coral reef at Bundaberg, Australia. It was exploring the reef for resting fish, flicking its forked tongue to taste the water for their scent.

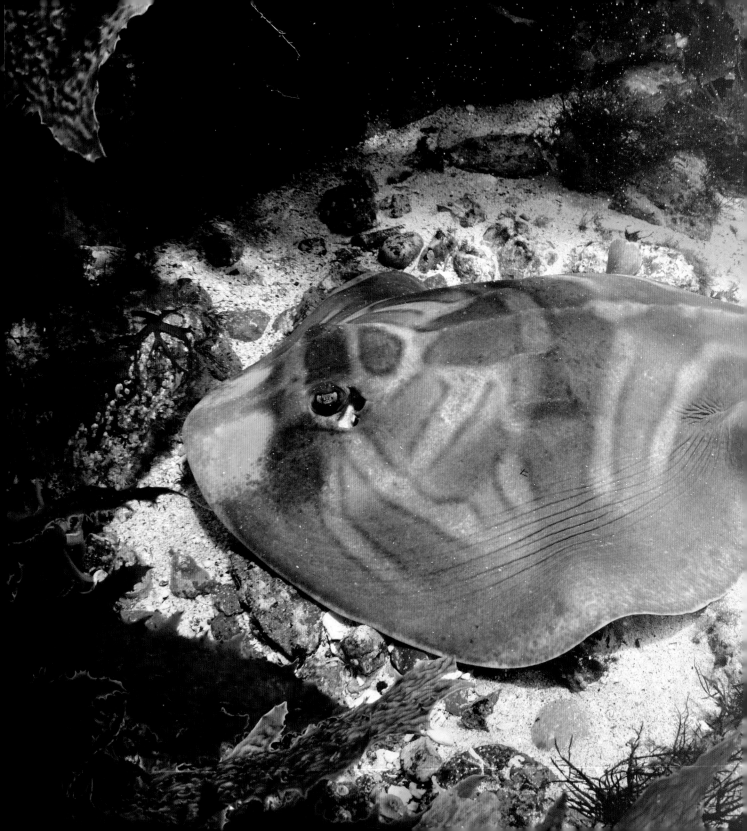

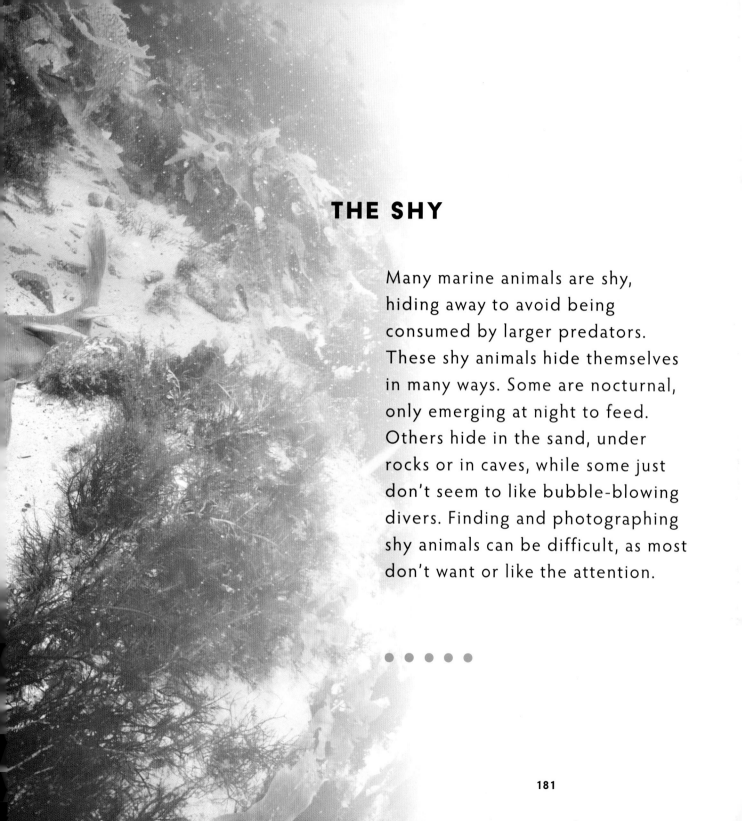

THE SHY

Many marine animals are shy, hiding away to avoid being consumed by larger predators. These shy animals hide themselves in many ways. Some are nocturnal, only emerging at night to feed. Others hide in the sand, under rocks or in caves, while some just don't seem to like bubble-blowing divers. Finding and photographing shy animals can be difficult, as most don't want or like the attention.

• • • • •

HERMIT CRABS

What came first, the hermit crab or the shell? I have often wondered this, as these strange crustaceans have a soft abdomen and protect it by living in old mollusc shells. The hermit crab family contains more than 1,100 species that live in the sea and on land. Most hermit crabs are nocturnal and quick to withdraw into their shell when disturbed. Divers can often get very close to them when they are busy feeding or fighting over accommodation.

▼ HOME INVASION

Hermit crabs, like all crustaceans, regularly have to moult their exoskeleton in order to grow. And after moulting they often find that their current shell doesn't fit their new body. As such hermit crabs are constantly on the lookout for vacant shells, but sometimes they try to claim ones that are already occupied. I encountered this pair of Hairy Red Hermit Crabs (*Dardanus lagopodes*) off Mooloolaba, Australia. The one on the left was checking the other hermit crab's shell for size. For several minutes I watched this naughty crab first checking the shell then trying to pull the other crab out of its home. Fortunately the existing occupant was well anchored and survived the attempted eviction.

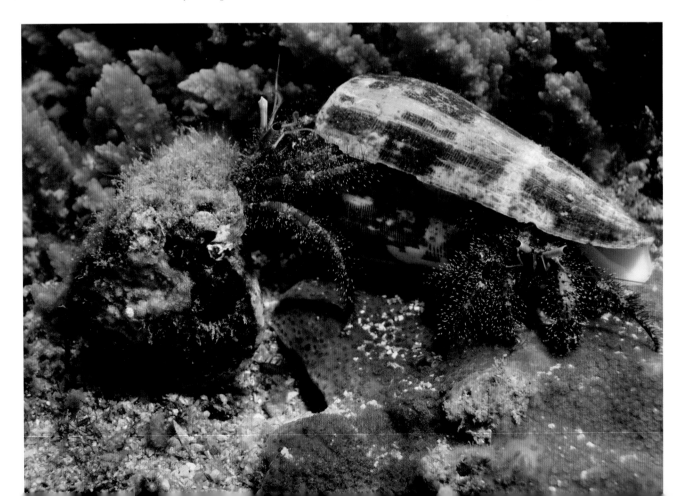

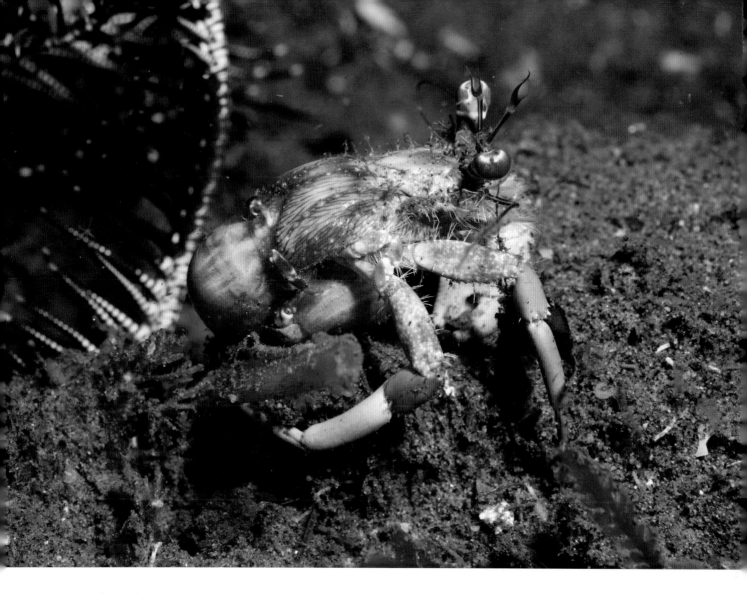

▲ THE STREAKER

Diving off Dumaguete, Philippines, I once came across an unexpected sight – an Anemone Hermit Crab (*Dardanus pedunculatus*) strolling around without a shell. These hermit crabs usually attach sea anemones to their shell for extra defence against predators, so I was quite surprised to see this one naked. I have a number of theories as to how this poor hermit crab got separated from its shell. Stolen by another hermit crab is a possibility, but then the crab would have claimed the other shell. A more likely scenario is that the hermit crab was ambushed by an octopus and escaped from its shell to avoid getting eaten. Feeling sorry for the hermit crab, I spent the next ten minutes looking unsuccessfully for a vacant shell, so only hope it found one before being consumed.

SQUID

Squid are the bashful cousins of the octopus and cuttlefish. Free-swimming and roaming the oceans, the squid family contains more than 300 members that vary in size from a few centimetres to giants over 15m (50ft) long. Often found in schools, squid are generally wary of divers and difficult to approach, but are often more curious and friendly at night.

◀ FROM ANOTHER WORLD

Squid are found around the world, in both the shallows and the deep ocean. These alien-like creatures often look very bland and dull by day, with their fabulous colours only evident at night. I encountered this spectacular Bigfin Reef Squid (*Sepioteuthis lessoniana*) on a night dive at Lembeh, Indonesia. This species is often seen by divers in South-East Asia, usually in small groups of a dozen or less. On this dive I found a group of five, but I really think they found me. Attracted by my torchlight, the squid would dart around me, coming in close to inspect me and then zooming off again. At first I thought they were using my torchlight to hunt, but they seemed to be far more interested in me. The encounter was all too brief, but was like being visited by aliens from another world.

GHOSTPIPEFISH

Closely related to seahorses, ghostpipefish are delicate little fish that like to hide in corals and feather stars. Often camera shy, these camouflaged creatures are not difficult to find, but tend to turn away from the camera or the observer. Only six species of ghostpipefish have been identified, but several undescribed species may soon be added to that list.

▼ MORE THAN A YAWN

Sometimes you capture behaviour images without even knowing it, which is what happened to me off Port Moresby, Papua New Guinea. Diving at Lion Island, I found a group of Ornate Ghostpipefish (*Solenostomus paradoxus*) hiding in a black coral tree. I proceeded to shoot numerous images of these delicate fish. When changing camera positions I noticed one suddenly yawn. I was annoyed at missing the photo opportunity and continued to shoot several more images of these lovely creatures before moving on to other subjects.

Later that day I downloaded the images and while reviewing the ghostpipefish shots I noticed that one appeared to grow extra chin whiskers from one image to the next. I then arrived at this close-up and realised that what I had thought was a yawn was actually the ghostpipefish capturing a tiny shrimp – that was hanging out of its mouth.

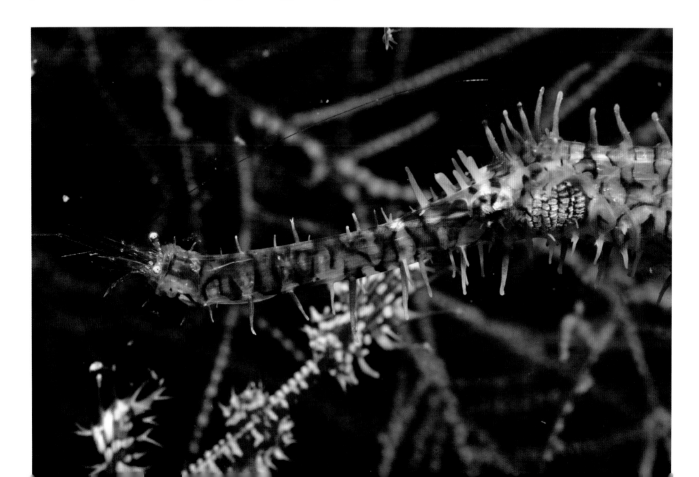

▲ *LEAF LITTER*

Numerous fish species pretend to be dead leaves so that they are ignored by predators, but none pull off this deception better than the Robust Ghostpipefish (*Solenostomus cyanopterus*). These lovely little fish can be yellow, green, orange or red, but in areas close to shore where fallen leaves litter the seafloor they generally tend to be a mottled brown. The Robust Ghostpipefish in this image was encountered off Bali, Indonesia, and was doing a great job of impersonating a dead leaf.

PIPEHORSES

Pipehorses can best be described as a cross between a seahorse and a pipefish. Elongated like a pipefish, these strange small fish also have a prehensile tail like a seahorse, which allows them to anchor to the bottom. This family contains about 12 species, and most have body filaments that help to camouflage them. Shy and elusive, pipehorses are often very difficult to find.

▼ HIDING IN PLAIN SIGHT

One of the prettiest members of the pipehorse family is only found on a small stretch of coast around Sydney, Australia. The Sydney Pygmy Pipehorse (*Idiotropiscis lumnitzeri*) was only discovered in 1997 by a very observant local diver. I have spent many dives looking for this elusive little fish, and was finally rewarded on a dive at Bare Island. It took almost an hour to find the well camouflaged pipehorse, as its body colour and filaments closely matched the surrounding algae.

I photographed it for several minutes before I noticed that it had a friend – another pipehorse hanging off the same piece of algae. Later, while reviewing the images, I suddenly noticed that another pipehorse was also present, hiding in plain sight. See if you can find all three pipehorses in this photo.

PIPEFISH

Pipefish are an elongated version of a seahorse, with many of the same features and a similar breeding strategy, with the male looking after the eggs. These wonderful little fish are mostly bottom-dwellers, living on the sand, in corals and under ledges. The pipefish family contains more than 200 species, and most are a little shy, relying on camouflage to keep them hidden from predators.

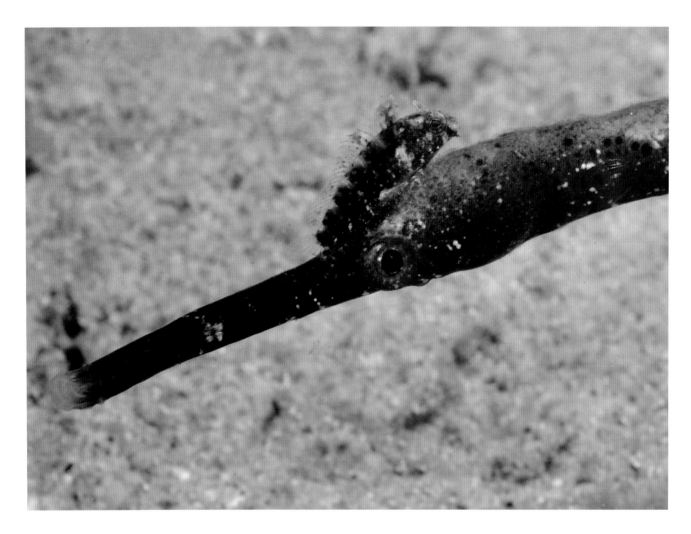

◀ CORAL CREEPER

I always enjoy encounters with pipefish, and while they generally don't do much, these lovely creatures are a delight to observe. One of my favourites from this family is the Scribbled Pipefish (*Corythoichthys intestinalis*). Common throughout the Indo-Pacific region, it can be found slowly snaking over corals, sand or rubble. I encountered this one at Moalboal, Philippines, slowly moving across the corals looking for small shrimps to eat.

▲ NICE HAT

Blennies often like to find a good lookout spot to search for food and keep an eye out for predators. This Bearded Sabretooth Blenny (*Petroscirtes xestus*) picked a strange lookout when it landed on the head of a Bendstick Pipefish (*Trachyrhamphus bicoarctatus*). I encountered this odd pair at Sekotong, Indonesia, and can only assume that the pipefish's camouflage was so good that the blenny thought it was a stick.

189

JAWFISH

Jawfish look very cute, with their giant eyes and oversized mouths. They live in burrows in the sand and rubble, and feed on plankton. About 80 species of jawfish have been identified, and all are oral brooders, holding their eggs in their mouth until they hatch. Always entertaining to watch, jawfish are quite timid and quick to disappear into their burrow if threatened.

◄ *THE BIG SPIT*

Jawfish seem to spend most of their time feeding, fighting and maintaining their burrow. The Yellow-barred Jawfish (*Opistognathus randalli*) in this image, encountered off Timor-Leste, was busy cleaning its burrow, allowing me to get very close. Ducking in and out of its hole, the jawfish would spit out mouthfuls of sand each time it emerged at the entrance. With a constantly crumbling home, maintenance is a never-ending battle for the jawfish.

▼ DAZED AND CONFUSED

Jawfish only exit their burrows to feed and fight. Very territorial, they can often be observed berating intruders that venture onto their turf. Very rarely do you see a jawfish sitting out in the open, like this Indonesian Jawfish (*Opistognathus* sp.) I encountered off Bali. It was neither feeding nor fighting, but simply sitting on the bottom several metres from its burrow. After a couple of photos the dazed and confused fellow seemed to wake up and quickly swam back to its home in the rubble. When it reappeared at the entrance to its burrow I could see it had a mouthful of eggs. The whole episode possibly brought on by the stress of parenthood.

PUFFERFISH

Even though pufferfish have poisonous skin, they are still very shy. They typically have prickly skin and can swallow water to inflate their stomach to appear larger. This family contains more than 120 species, and most are only about 10cm (4in) long, although larger members of the family can reach 1m (3.3ft) in length. Many pufferfish are quite pretty, with decorative skin patterns, and are always enjoyable to encounter.

◄ *THE AWKWARD FLATMATE*

It is not uncommon to find pufferfish resting on the bottom. They don't seem to be very picky about where they rest, as I have found them sleeping in coral, sponges, rusty cans and even old tyres. They also don't mind sharing a bedroom, but sometimes their flatmates are not too happy with the arrangement. I encountered this odd couple when diving in Lembeh, Indonesia. I don't think the Palechin Moray (*Gymnothorax herrei*) was very happy sharing its home with this large Starry Pufferfish (*Arothron stellatus*). The pufferfish seemed to be very content, allowing me to get very close, but the poor moray was squashed to the side in its own home.

GROPERS

Most people think of gropers as very large fish, but in reality most members of this family are less than 50cm (20in) in length. Also known as rockcods, the groper family contains more than 160 species. Ambush predators, gropers spend much of their time hidden in caves and coral. Most are shy and wary of divers, but ones that are familiar with humans are often very bold.

▼ DOUBLE CLEAN

Getting close to large gropers is often difficult as these shy fish don't seem to like the attention. However, they are often more relaxed when visiting cleaning stations. I encountered this Flowery Rockcod (*Epinephelus fuscoguttatus*) enjoying a clean at Mabul, Malaysia. This species can reach a length of 1m (3.3ft), and is often hard to spot as its skin pattern helps to camouflage it against corals. This one was easy to see, though, resting on a tyre at an artificial reef and getting the full cleaning services from not only a Common Cleaner Wrasse, but also a pair of Rock Shrimps.

▲ HOT LIPS

The most famous gang of gropers on the planet is found at a site called Cod Hole on Australia's Ribbon Reefs, and these fish are anything but shy. First discovered in 1973, this astonishing site is home to a large population of friendly Potato Cod (*Epinephelus tukula*). Normally a very shy species, the individuals at Cod Hole have been hand-fed by divers for decades and are now so accustomed to humans that they completely ignore you, unless you have food. Sadly the number of Potato Cod at Cod Hole has declined since it was first discovered. While once there were more than 25 present, today divers are lucky to see five. The reason for the decline is not clear, but fishing, pollution and too many divers touching them are all possible causes.

WRECK RESIDENT ▶

The largest member of the groper family is a very shy fish known as the Giant Groper (*Epinephelus lanceolatus*). This huge creature is found throughout the Indo-Pacific region and is reported to reach a length of 2.7m (8.9ft), although divers often see ones that are much larger. Giant Groper generally live in caves, but will also shelter inside shipwrecks. I encountered the one in this image inside a shipwreck off Brisbane, Australia, at a site called Curtin Artificial Reef. Numerous Giant Gropers are found in the wrecks at this dive site and most are more than 2m (6.6ft) long, but I once encountered a monster groper deep inside a wreck. Shining my torch about in the darkness, I suddenly saw the head of a Giant Groper which was enormous, being twice the size of any I had previously seen. Unfortunately most of its body was hidden behind a bulkhead, but shining the torch I picked up the end of its tail, more than 3m (9.8ft) from the head. Before I had a chance to get a photo, the massive fish disappeared into the dark recesses of the wreck.

PARROTFISH

Parrotfish are closely related to the wrasses and are one of the most important species on a healthy coral reef. These fish have strong parrot beak-like teeth that they use to eat algae, coral polyps and sponges by scraping them off rocks and coral. This feeding process keeps the reef in check, allowing for healthy coral production, while a by-product of this feeding is sand – lots of sand. The parrotfish family contains 95 species, most of which are shy.

◄ SMILEY

Photographing parrotfish by day is a tricky proposition as they never stop moving, either busily feeding or swimming about the reef. At night they are far easier to approach when they find a hiding spot in which to sleep. I found this pretty Bicolour Parrotfish (*Cetoscarus ocellatus*) in a cave on the Rowley Shoals, Australia. This parrotfish had only just settled down and hadn't had time to slip into its sleeping bag. To avoid being eaten by sharks and moray eels while they sleep, many parrotfish excrete mucus from their mouth that forms a cocoon around their body. This mucus makes it harder for predators to detect the parrotfish and also gives them an early warning system if attacked.

STAMPEDE ►

The largest member of the parrotfish family is the wonderful Bumphead Parrotfish (*Bolbometopon muricatum*). Generally found in large schools, it can grow to 1.3m (4.3ft) in length. The best time to observe this species is early in the morning when they gather to feed, and one of the best places to see them is Sipadan, Malaysia. A large population of Bumphead Parrotfish call this coral island home and sleep in the many caves that riddle its walls. In the early morning the fish wake and form into large feeding herds. I encountered this stampede of them rising from the depths on their way to breakfast.

◀ BATTLING BEAKS

Identifying parrotfish is a complicated business as these multifaceted fish have different appearances for male, female and juvenile forms within the same species. They also change sex and colour, starting out as females and developing into males as required. Considering how complex their social structure must be, parrotfish are very social fish, with many species found in schools. However, fights occasionally break out between parrotfish, like this pair of battling Greenlip Parrotfish (*Scarus viridifucatus*) I encountered off Port Moresby, Papua New Guinea. These two fish had quite a fight for several minutes, snapping and pushing each other. It turned out to be a lot of bluff, as they didn't actually do any damage.

BLIND SHARKS

Members of this tiny family of sharks are only found off the east coast of Australia. The two small, shy bottom-dwelling species spend most of the day hidden away in ledges. They are often difficult to find and photograph, as generally all that divers see is a tail hanging out of a hole.

▼ GLOVE MUNCHER

The Blind Shark (*Brachaelurus waddi*) is the most common member of this family and is found off New South Wales and southern Queensland. Although common, they are often difficult to find as they spend the day hidden away in order to avoid being consumed by wobbegongs. However, the one in this image was quite content sitting amongst the sponges at Port Stephens.

Blind Sharks are very docile, but will bite when annoyed, as I discovered on a dive off Tweed Heads when one latched onto my finger. I was taking close-up pictures at the time and shark had finally had enough of all the attention. Fortunately for me I was wearing gloves and managed to extract my finger, but the glove caught on the shark's small teeth. No matter what I tried I couldn't get the shark to let go of the glove. Eventually I had to take the poor shark back to the boat and cut the finger section off the glove, which the shark promptly swallowed before I released it back into the water.

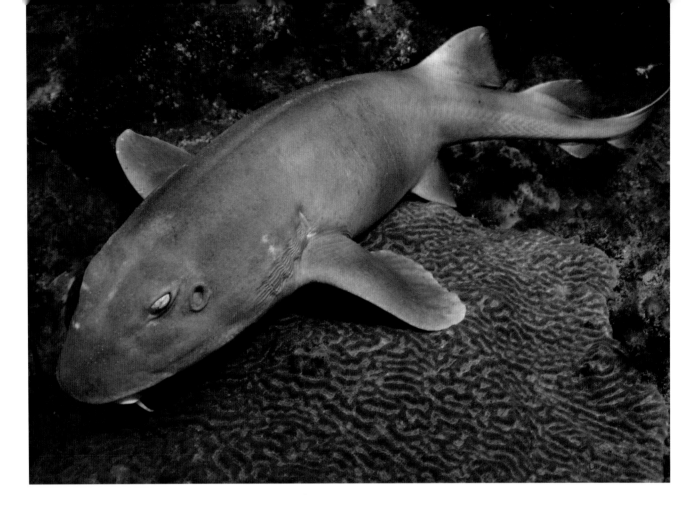

▲ A SPECIES MIX-UP

The only other member of the blind shark family is the very rare Colclough's Shark (*Brachaelurus colcloughi*). This small shark is only found off southern Queensland and northern New South Wales, with a very limited range between Gladstone and Ballina. I was fortunate to be the first to photograph a Colclough's Shark in the wild in 1992, and have only seen four more of these very rare sharks since then, including this one photographed off Tweed Heads. However, I first thought I photographed this species in 1991, due to a species mix-up in a shark book.

The problem was that the only good book on Australian shark species at the time was G.P. Whitley's *Sharks of Australia*, which was originally written in 1940 and illustrated with very poor line drawings. However, the problem wasn't the drawings, but the fact that they had the artworks for the Colclough's Shark and the similar-looking Brown-banded Bamboo Shark (*Chiloscyllium punctatum*) mixed up. I didn't discover the mistake until 1994, when the brilliant *Sharks and Rays of Australia* by P.R. Last and J.D. Stevens was released.

BAMBOO AND EPAULETTE SHARKS

The bamboo and epaulette sharks are shy and reclusive animals that spend much of their time hidden in caves and ledges. The 16 species in this family all have slender bodies, and are only found in the Indo-West Pacific region. The best time to see these sharks is at night, when they emerge to feed, but even then they are wary of divers.

▼ A RARE COUPLING

The most common member of this family found on the Great Barrier Reef is simply called the Epaulette Shark (*Hemiscyllium ocellatum*). These small sharks are most commonly found in shallow water, and the one in this image was in the shallows at Raine Island. However, I had a very special encounter with a pair of Epaulette Sharks at Heron Island when I was a teenager.

Snorkelling the waters around Heron Island I was very excited as I had my first underwater camera. On one memorable snorkel I stumbled across a pair of mating Epaulette Sharks. They were closely intertwined, the male grasping the female's pectoral fin and with a clasper inserted into her cloaca. I watched them for several minutes before they parted, and only snapped off two pictures, not realising what a rare incident I was observing. After finding out how rare (I have never seen mating sharks since), I was eager to see my photos. But excitement soon turned to disappointment when I discovered that my camera had been playing up, and the images were ruined.

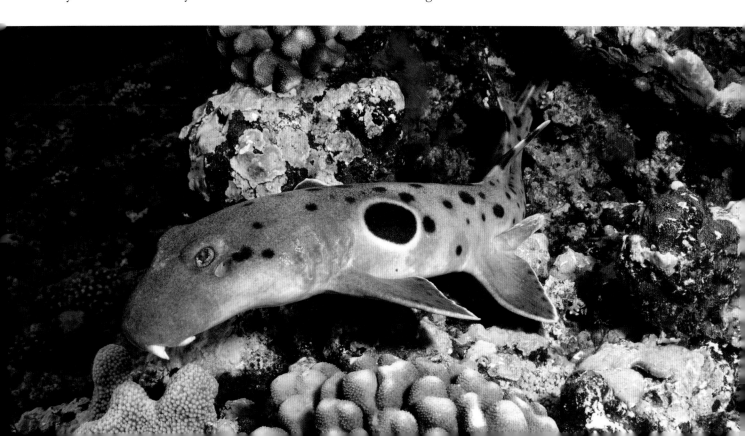

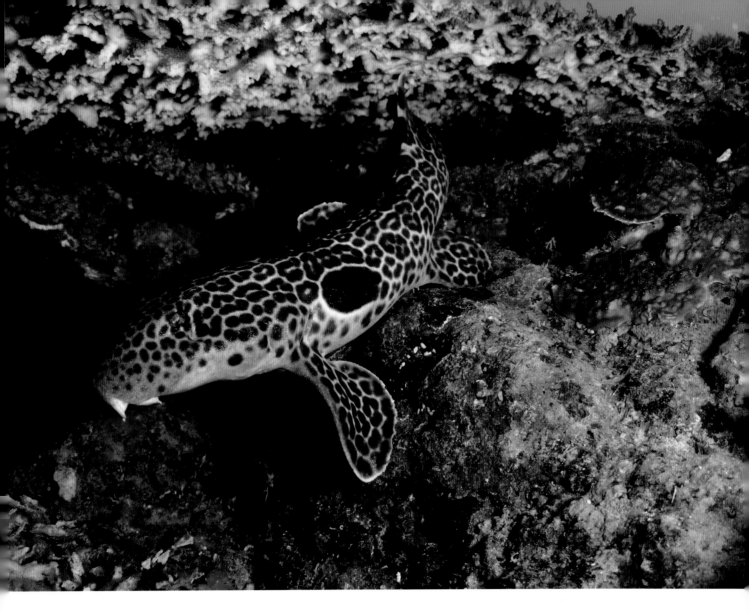

▲ UNDER THE PLATE CORAL

It took me many years and three trips to Papua New Guinea to get this image of a Leopard Epaulette Shark (*Hemiscyllium michaeli*). The greatest variety of epaulette sharks is found in the warm waters of Papua New Guinea, but these charming sharks are never easy to find or photograph. I had several near misses with this species at night off Port Moresby, but each time I got close, the shark would either swim off or crawl between the corals. This image was taken off Tufi and it was a very unexpected encounter to find one propped under a plate coral by day. It didn't stay in this position for long, and disappeared into a hole after only two images.

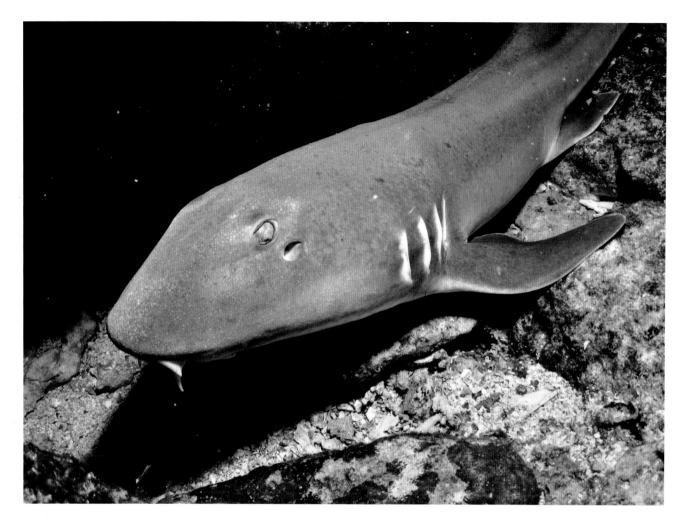

▲ A NEW BAMBOO?

The most common and widespread member of the bamboo shark family is the Brown-banded Bamboo Shark (*Chiloscyllium punctatum*). Found throughout the Indo-West Pacific, the name of this species is rather misleading, as only the young have brown bands, while the adults are just plain grey or pale brown. The only area where I have found this species to be common is off southern Queensland, Australia.

This one was photographed off Brisbane, where they are often found sheltering in caves. I have suspected for many years that the Brown-banded Bamboo Sharks in this area are a separate species or subspecies, as they are much longer than normal. This species is reported to grow to 1m (3.3ft), but the ones off southern Queensland can be 1.3m (4.3ft) and longer. A new species, or just a case of not enough being known about this bamboo shark?

NURSE SHARKS

Considering how large nurse sharks grow they are very shy animals that prefer to avoid divers if they can. These large reef sharks feed at night on a variety of critters and spend the day resting in caves and shipwrecks. The family contains four species and all have small teeth, so these lumbering giants pose no threat to divers, unless they run into you.

▼ CAVE COLLISION

The most common member of this family found in the Indo-Pacific region is the Tawny Nurse Shark (*Nebrius ferrugineus*), which grows to a length of 3.2m (10.5ft). I have encountered this species many times on Australia's Great Barrier Reef, including the one in this image at Lady Musgrave Island, but I will never forget my first encounter on the Swain Reefs.

Diving along a wall at Horseshoe Reef I found a dark small cave. Entering the cave and shining my torch about

I was surprised to see a large grey tail, and knew straight away that it was a Tawny Nurse Shark. I couldn't see the head, but figured the animal was almost 3m (9.8ft) long. Raising my camera to get a photo I suddenly stopped when I noticed that the shark was moving. It was backing out of the hole and turning around. Realising that I was blocking the only entrance to the cave, I quickly back-pedalled as the large shark turned around and rushed towards me. I managed to push clear of the entrance just as the shark emerged, narrowly avoiding a collision.

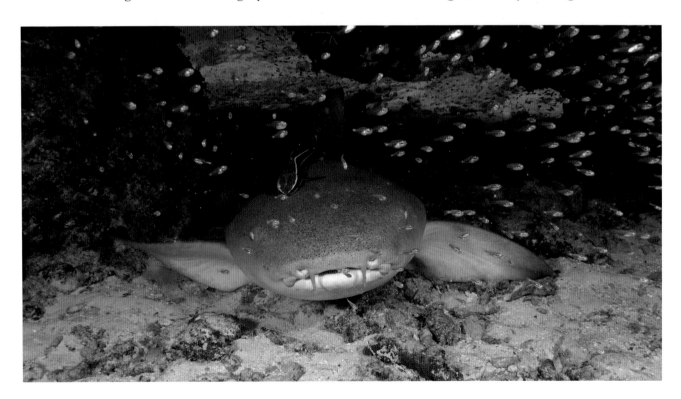

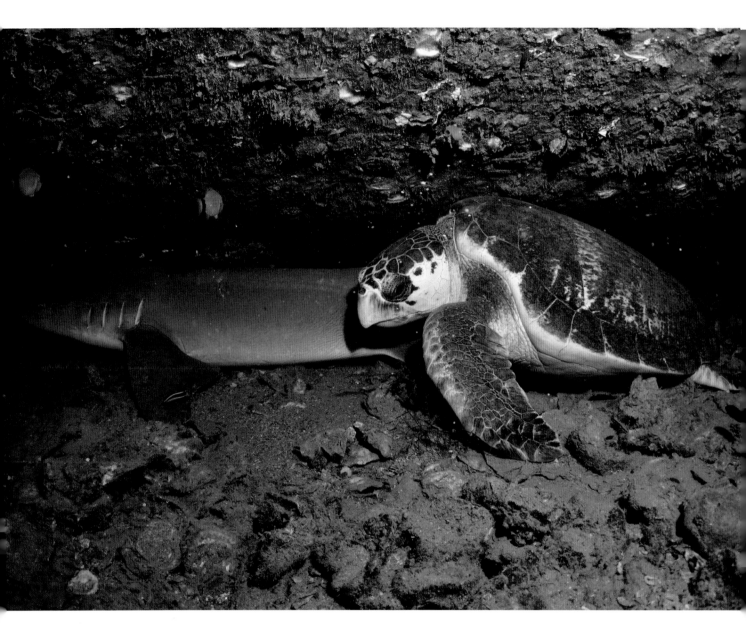

▲ STRANGE BEDFELLOWS

Tawny Nurse Sharks are sometimes social in their sleeping habits, with several often sharing a cave. I got a big surprise while diving the *SS Yongala* shipwreck off Townsville, Australia, finding this Tawny Nurse Shark and a Loggerhead Turtle snuggled up together. A very strange pair of bedfellows indeed.

▼ OFF WITH THE BAIT

Nurse sharks generally feed at night, but offer them free food and they will take it at any time of the day. Attracted to shark feeds throughout the Indo-Pacific region, Tawny Nurse Sharks appear on cue to claim a free handout. They can be a little pesky for the shark-feeders, as they often sit in front of the food box and hog the action. The feeders generally try to ignore them so that they can feed the more exciting species of sharks, but they are very persistent. This one grabbed some food at a shark feed at Beqa Lagoon, Fiji, and was quickly sneaking off with its prize before it was claimed by another shark.

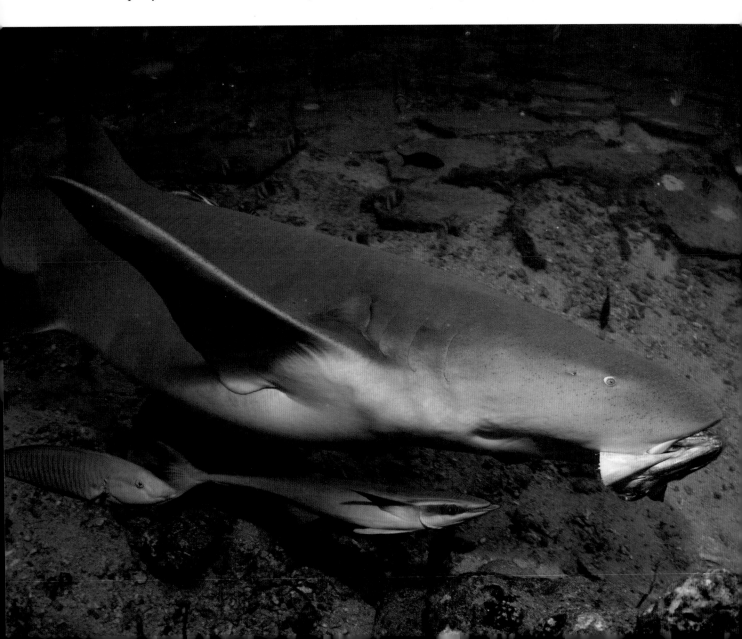

CATSHARKS

Catsharks are small bottom-dwelling sharks that are rarely seen by divers in most areas. While the family contains 160 species, most reside in deep water and the ones that live in the shallows spend the day hidden in caves and ledges. Catsharks may be difficult to find, but they are very interesting creatures.

▼ FLOP GUTS

A number of catshark species are found in the southern waters of Australia, with the most common and widespread being the Draughtboard Shark (*Cephaloscyllium laticeps*). Like many catshark species it can swell its body by swallowing water, in order to wedge itself into a ledge or make itself look bigger.

Both defensive tactics are designed to keep these sharks safe from predators, but have left them with a funny nickname – flop guts. I encountered this Draughtboard Shark while exploring the kelp beds off Eaglehawk Neck, Tasmania. Although they are more active by night, divers often find them resting amongst the kelp and algae, on their flop guts.

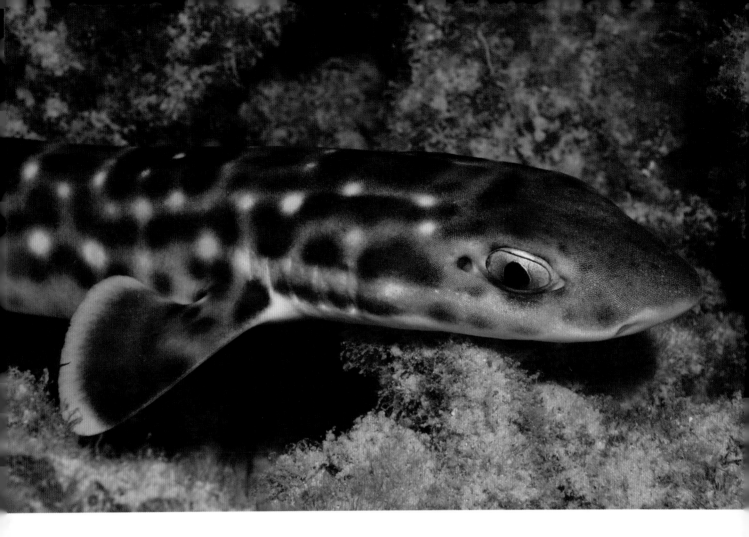

▲ ELUSIVE CAT

Very few catshark species are seen in tropical waters, as most prefer cooler temperate seas, but divers can see Coral Catsharks (*Atelomycterus marmoratus*) on reefs throughout the Indo-West Pacific. I have done a great many dives throughout South-East Asia and always hoped to see one of these elusive catsharks, but it took many years to finally encounter one at the Perhentian Islands off Malaysia.

I was very surprised to see this species by day, unfortunately wedged tightly into ledges where they were impossible to photograph. I knew that the best chance to capture an image of one was at night, so took the plunge on the reef in front of the resort. After an hour underwater I hadn't seen one. Swimming back into the shallows to exit the water, my light suddenly picked up several slender shapes swimming over the coral rubble. I couldn't believe it – four Coral Catsharks swimming around. They were lovely to watch, but impossible to photograph as they were busy looking for prey. Fortunately the shark in this image decided to take a break and dropped to the bottom in front of me.

SHOVELNOSE RAYS

Shovelnose rays look like a cross between a shark and ray, as they have a shark-like body and ray-like head. Also known as guitarfish, the shovelnose ray family contains 45 species that vary greatly in size and shape. They generally feed on sandy bottoms, and that is the best place to find them. Shovelnose rays could be called semi-shy, as some will tolerate the close presence of a diver, while others quickly take flight.

▼ FIDDLER ON THE BOTTOM

Australia is home to good variety of shovelnose rays, with the strangest being the fiddler rays. These rays have a round head, making them look like a fiddle or banjo. They are also one of the most colourful members of the clan, with the head decorated with banded patterns. Two species of fiddler ray are found in Australia's temperate waters, with the Eastern Fiddler Ray (*Trygonorrhina fasciata*) common off New South Wales. Found in bays and rocky reefs, I encountered this one at Montague Island. These rays hide in the sand or under kelp, as they are preyed upon by sharks. The ones at Montague Island also have to contend with the resident rambunctious Australian Fur Seals, as the seals seem to enjoy chasing and terrorising the ray population.

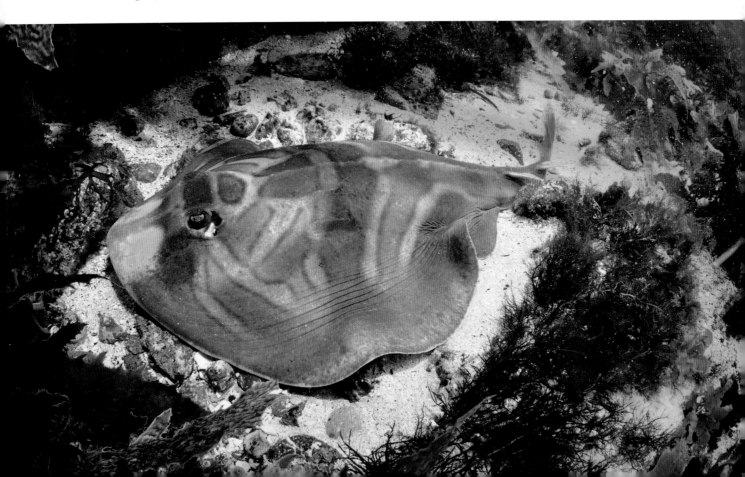

SAND SETTLING ▶

Another member of this family seen off eastern Australia is the Eastern Shovelnose Ray (*Aptychotrema rostrata*). This sandy-coloured ray is easily overlooked as they generally bury into the sand, but I encountered this one sitting above the sand off Brisbane. It didn't stay exposed for long, as with a quick shake of its body it raised a cloud of sand and disappeared from view.

▼ A PREHISTORIC ENCOUNTER

This image of a Shark Ray (*Rhina ancylostoma*) is not the best, but it is one that I treasure very much. This species, which is also known as the Bowmouth Guitarfish, is found throughout the Indo-West Pacific region, but is rarely seen by divers. I have always dreamt of encountering one of these rare rays and finally saw the one in this image off Port Moresby, Papua New Guinea. Drifting along a coral wall, my wife Helen was ahead of me and out of view. Suddenly she started to frantically shake her rattle, indicating that she had seen something. I quickly caught up to her and was amazed to see her pointing at this Shark Ray. It was slowly cruising along the wall and only a few metres away. It was then that I almost cried as I had a macro lens on my camera, but with this possibly being a once-in-a-lifetime encounter I framed two quick images and hoped for the best. Upon surfacing we workout out that our dive group had completed a combined total of about 10,000 dives and that this was the first time that any of us had seen one of these prehistoric-looking rays.

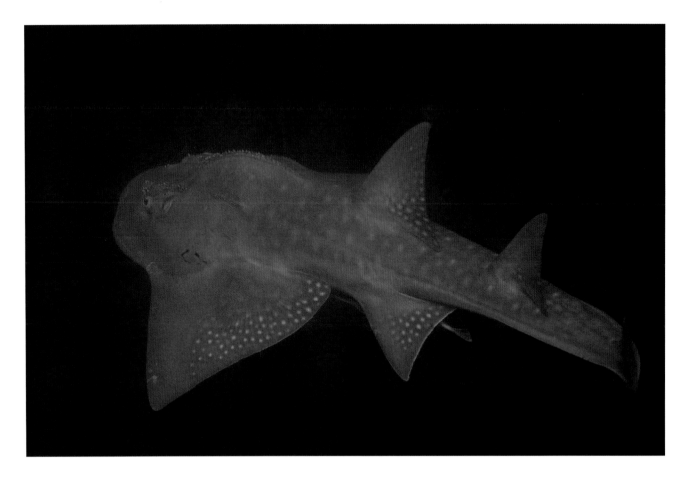

SKATES

The skates are the most interesting family of rays divers encounter in temperate seas. Considered to be the most primitive of all the rays, they have no tail barb and are the only rays that lay eggs. More than 200 species of skates are known, but most live in deep water, so only a small number of species are seen by divers.

▼ THE SKATE THAT WALKED

The temperate seas in Australia's southern states are home to the pretty but seldom-seen Thornback Skate (*Dentiraja lemprieri*). This small skate only grows to 30cm (12in) in width and is occasionally seen off Victoria and Tasmania. I photographed this one under Blairgowrie Pier, Melbourne, but I had my most memorable encounter with this species at another Melbourne site, Portsea Pier.

I was exploring the sand wide of the pier hoping to encounter my first skate. After an hour I was just about to return to shore when I finally found what I was looking for – a small Thornback Skate. I excitedly took a few pictures and then the ray moved, but it didn't swim as expected, instead walking across the bottom with its fins. This was a behaviour that hadn't been documented before. I suspect the skate was searching for food and was using this walking technique to move slowly. Finally it swam off, leaving me with a memorable encounter that I have never forgotten.

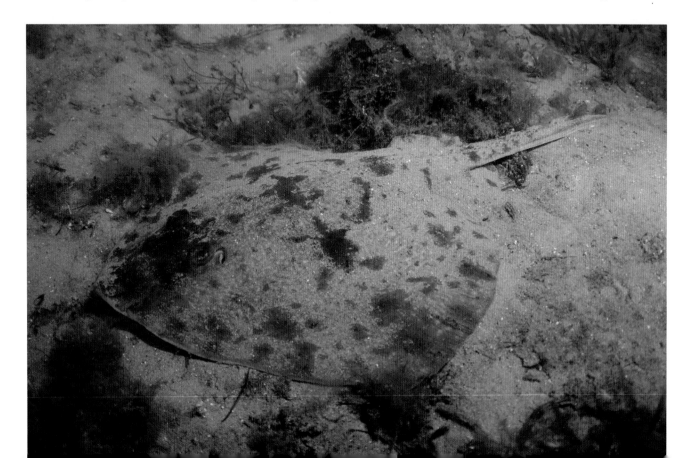

▲ THE LONG SEARCH

The largest skate species found off southern Australia is the impressive Melbourne Skate (*Spiniraja whitleyi*). This rarely seen species can grow to more than 1m (3.3ft) wide, and while it can turn up at any dive site in southern Australia, it is best seen off its namesake city, Melbourne. I have done a great many dives off Melbourne looking for this elusive ray, so was very surprised when I finally found one off Merimbula, in southern New South Wales. Swimming over a rocky ridge the last thing I expected to see was a Melbourne Skate, so I was stunned to find this impressive animal resting on the bottom. Not wanting to startle it, I slowly inched my way across the bottom, and lifted my camera for a few images. Fortunately the ray didn't seem to be worried about my presence, and allowed me to get right next to it for some wonderful pictures. It even spun around to face me head-on, to get a better look at me. After this encounter I had a smile on my face for a week.

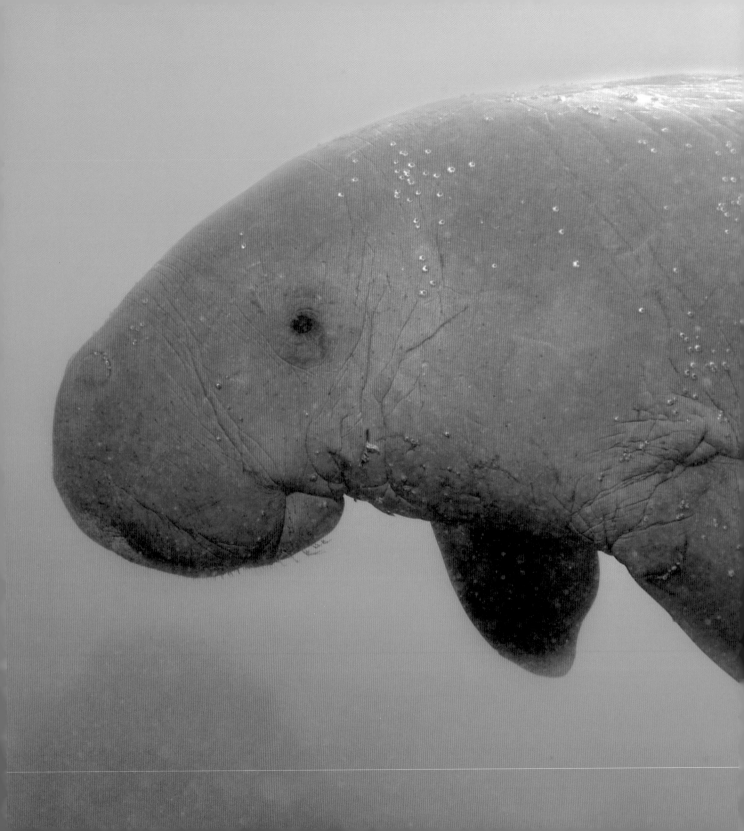

DUGONG

The Dugong (Dugong dugon) is the most common and widespread member of the sea cow family, which also contains the manatees. This marine vegetarian is found in the tropical waters of the Indo-West Pacific, especially in areas with seagrass. A shy and retiring animal, encounters with Dugongs are very rare.

◀ AN UNEXPECTED COMPANION

Australia is home to the world's largest population of Dugongs, but these shy animals are rarely seen by divers Down Under. Over the years I have seen many Dugongs from the surface, but only one underwater when diving off Bundaberg. Exploring a site called Barolin Rocks, I had a tip from the local dive shop that a Dugong had been seen the day before, so was ready for action with a wide-angle lens.

Unfortunately, when I jumped in the water I found that the visibility was terrible, barely 3m (10ft) with the sandy bottom very stirred up. After 15 minutes of searching I was certain there was no way I was going to see the Dugong, having done fruitless searches like this before. Just as I was thinking that I felt a presence on my right. I turned to find a very cute face with thick lips and a tiny eye looking at me – A DUGONG!

I couldn't believe it; the Dugong had snuck up beside me and was now staring at me from only a metre away. I slowly raised my camera and quickly snapped off a few photos of the 2.5m (8.2ft) long mammal. After swimming side-by-side for several seconds, a small Green Turtle suddenly shot off the bottom and startled the Dugong, causing it to kick its wide tail, turn and glide away.

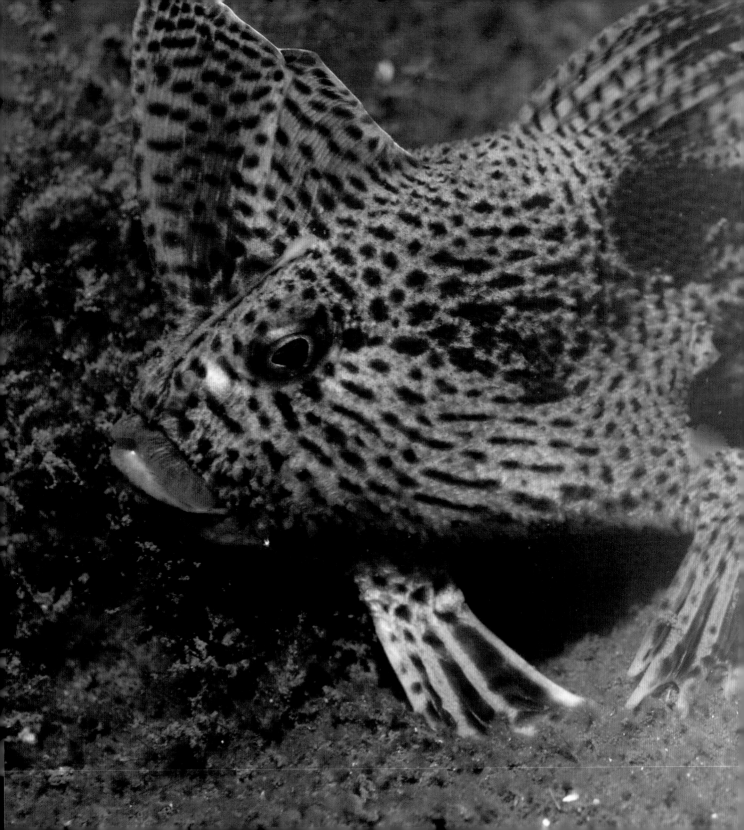

THE WEIRD

The oceans of the world are filled with some very weird creatures. There are fish with wings, insect-like fish, fish that walk and even fish that look like fruit. As strange as these critters are, they are also some of the most interesting marine life that a diver can encounter.

• • • • •

SNAKE EELS

Snake eels spend most of their time hidden in the sand with only their head exposed. This large family of eels contains more than 320 species that vary in length from 10cm (4in) to 3m (9.8ft). Like giant worms, snake eels are very efficient at burrowing into sand, even tail first. Feeding on crustaceans and small fish, they emerge from the sand at night to stalk prey. To encounter snake eels you have to dive muck sites, searching the sand for their small heads.

▼ MARBLE HEAD

Many snake eels have a bland sandy appearance to help camouflage them in their sandy environment, but not so the Napoleon Snake Eel (*Ophichthus bonaparti*). One of the most colourful members of this family, it has an elaborate marbled pattern covering the head, like this one encountered at Dumaguete, Philippines. However, that lovely marbled pattern doesn't extend down the eel's body, as the rest of it is banded. A number of snake eels have banded bodies, which is thought to mimic the pattern of sea snakes. This allows the snake eels to roam by day without being harassed by predators.

▲ OUT OF THE SAND

The most common snake eel seen throughout South-East Asia is the Longfin Snake Eel (*Pisodonophis cancrivorus*). Generally seen with their heads poking vertically from the sand, I got a real surprise when this one swam past me at Lembeh, Indonesia. I have occasionally seen snake eels with banded patterns swimming around during the day, but never a Longfin Snake Eel. The out-of-sand encounter only lasted a few minutes before the eel found a new home, slowly reversing tail-first into the sand until only its head was exposed.

EYE CANDY ▶

Snake eels occasionally find themselves with a little friend that likes to sit on their head. In this image is a Longfin Snake Eel with a Magnificent Shrimp (*Ancylomenes magnificus*) on its eye. I had been hoping to see this strange behaviour for many years, and after seeing hundreds of snake eels on my dives throughout South-East Asia, I finally encountered this pair at Lembeh, Indonesia. The Magnificent Shrimp is a type of commensal shrimp and generally found on sea anemones. They do clean fish, but it is still not understood why they sit on snake eels. They probably provide cleaning services, but I'm not sure where they go when the snake eel hunts or disappears into the sand.

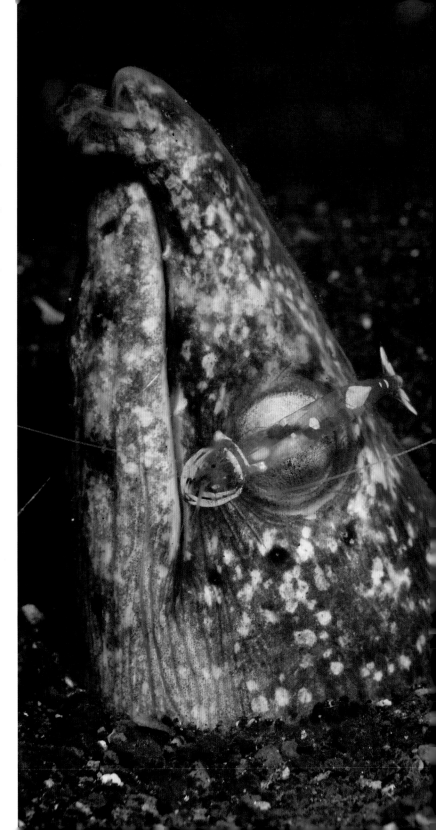

CATFISH

The catfish family contains more than 2,000 species, but the great majority of these fish are found in freshwater. The catfish found in marine environments have venomous spines, so should always be treated with respect. With barbels around their mouth that look like cat's whiskers, catfish are always interesting to observe, especially when they feed.

▼ ROLLING MAUL

The most common catfish divers encounter throughout the Indo-Pacific region is the Striped Catfish (*Plotosus lineatus*). Always found in schools, they grow to 35cm (14in) in length. Almost every time I encounter a school of Striped Catfish they are feeding, as is shown in this image taken at Anilao, Philippines. These hungry fish seem to spend a lot of time grubbing for food, and watching them digging in the sand is fascinating. They never stay in one spot to feed, but are constantly leap-frogging each other as the school moves forward. While interesting to watch they can make photography a challenge, as when a large school moves they can quickly reduce the visibility by generating a cloud of silt.

TOADFISH

The toadfish family contains 80 species of very weird little fish that are overlooked by most divers. It doesn't help that their name is hijacked by a number of other fish species that look nothing like a toad. The real toadfish have a toad-like head, with a wide mouth and big eyes. These strange fish are very well camouflaged, which makes them difficult to find.

◄ TOAD IN THE HOLE

Toadfish spend much of their life hidden in caves and ledges. Ambush predators, they use their camouflage to great effect to capture a wide variety of prey. I have seen a number of toadfish over the years, but the most common species is the Eastern Toadfish (*Batrachomoeus dubius*), which is found off the east coast of Australia. The one in this image was encountered off Sydney, living in a hole. As weird as these little fish look, they are incredible parents. During the breeding season the male will sing to attract females. They then lay their eggs and he guards them until they hatch. He also guards his offspring until they are large enough to fend for themselves and move into their own hole.

FROGFISH

Frogfish are one of the most enigmatic creatures of the marine realm, but also one of the most bizarre. A member of the anglerfish family, frogfish use a head-lure like a fishing rod to attract prey. They also don't like to swim, so walk across the bottom on their hand-like fins. The frogfish family contains 50 species and encounters with these weird critters are always a joy.

▼ *PYLON JUMPER*

Many divers travel to South-East Asia to encounter frogfish, but some of the most interesting members of this family are only found in southern Australia. One of them is the incredible Tasselled Frogfish (*Rhycherus filamentosus*). While all frogfish have camouflaged skin patterns, this species takes matters to a whole new level, with filaments and tassels that exactly match the algae that it sits on. I only found this one under Blairgowrie Pier, Melbourne, because it moved, jumping to another part of the pylon.

▲ WARTS AND ALL

Frogfish, like all fish, yawn to stretch their jaw muscles. As ambush predators they often sit still for hours, waiting for prey to come within striking range, which is sure to lead to boredom and the inevitable yawn. Capturing frogfish in a yawn is often very difficult and time consuming. I once sat for more than ten minutes to capture a yawn and when it finally happened the auto-focus on my camera decided to go to sleep. Sometimes you get lucky and get a yawn as soon as you settle down with the frogfish. Which is what happened when I encountered this Warty Frogfish (*Antennarius maculatus*) off Dumaguete, Philippines.

227

◀ *A BAD CASE OF HICCUPS*

Fish can't get the hiccups, as they don't have a diaphragm which goes into convulsions to cause the condition, but I'm pretty sure that the Painted Frogfish (*Antennarius pictus*) in this image had something very similar to a bad case of the hiccups. I encountered it at Sogod Bay, Philippines, and when I first saw it I thought it was yawning. It didn't do a full yawn, but was constantly opening and closing its mouth every minute. Four days later I returned to the same site and the fish was still hiccupping. Maybe fish hiccup without a diaphragm?

NIGHT SNACK ▶

The largest member of the frogfish family is the impressive Giant Frogfish (*Antennarius commerson*). Growing to a length of 30cm (12in), they are twice the size of most other frogfish and also seem to eat twice as much. This lovely orange Giant Frogfish was encountered at Dumaguete, Philippines, but I had a more exciting encounter with this species in another part of the country, Sogod Bay.

Over the years I have seen a number of frogfish in hunting mode, ready to snatch passing fish, but it wasn't until a night dive at Padre Burgos Pier that I got to see a proper kill. Encountering a large black Giant Frogfish, I watched as it eyed off a passing parade of small cardinalfish. Finally one fish came within its strike zone, and bang, it was sucked down in a flash. It was incredible to watch, but impossible to photograph as the frogfish attack speed has been clocked at six milliseconds.

▲ *THE DETOUR*

The Hairy Frogfish (*Antennarius striatus*) is quite common in Australia, but as it lacks the long hairy filaments found on individuals in South-East Asia it is generally known as the Striped or Striate Frogfish. I found this one at Port Stephens, and determined not to give its position away it allowed this Obscure Hypselodoris Nudibranch (*Hypselodoris obscura*) to crawl all over it.

HANDFISH

Handfish are closely related to frogfish and just as strange. This family is only found in Australia, with 14 species so far described. Handfish have hand-like fins and use them to walk across the bottom. They also have head-lures like frogfish, but don't appear to use them for fishing. Very rare, and with most species close to extinction, you have to search high and low to encounter one.

▼ MORE FEET THAN FINS

Tasmania is the best place to see handfish, with the Spotted Handfish (*Brachionichthys hirsutus*) the species most frequently encountered by divers. However, it is still extremely rare and endangered due to habitat loss from invasive species. The one in this image was encountered in very murky conditions off Hobart. I observed it for more than ten minutes and was fascinated to watch it walk, stand erect on its fins and also fan out its dorsal fins when I got close. Recently a captive breeding scheme has been started to ensure the future of the very unique Spotted Handfish.

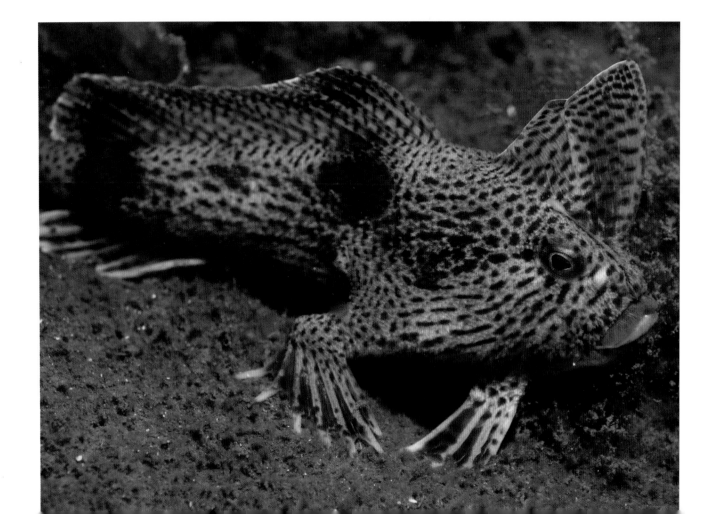

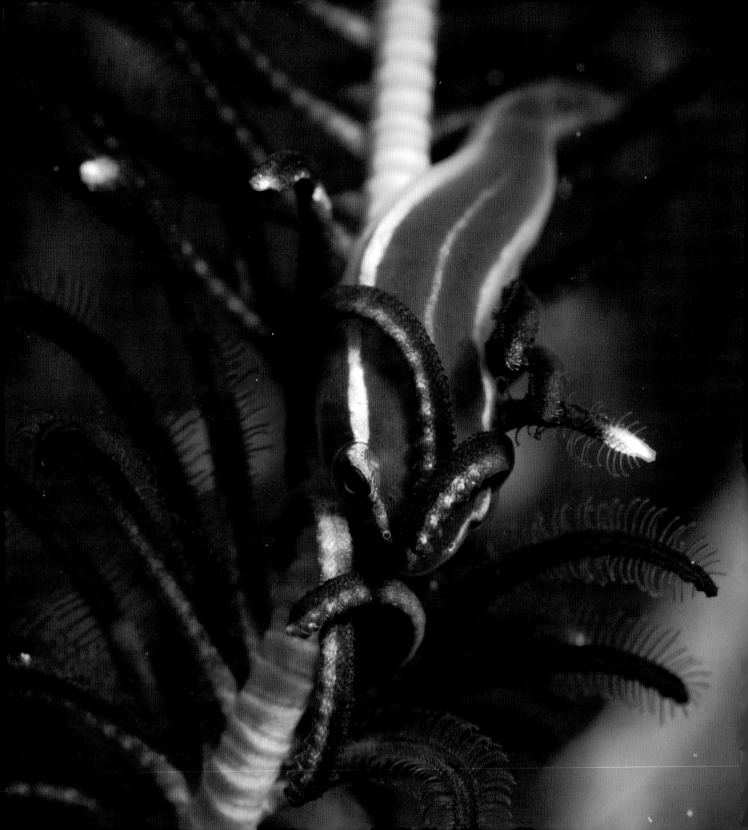

CLINGFISH

Clingfish are often found hiding in feather stars and sea urchins, but other members of this family cling to rocks, corals, sponges, seaweed and algae. The family contains about 100 species, and most feed on zooplankton and small crustaceans, but a few species also clean fish. Finding tiny clingfish is a challenge, with these weird little fish well camouflaged in their hiding spots.

◀ IN THE ARMS OF A FEATHER

The clingfish that divers see most often throughout the Indo-Pacific region is the lovely little Crinoid Clingfish (*Discotrema crinophilum*). These cute clingfish live exclusively on feather stars and usually have a colour and pattern to match their host. Reaching a length of only 3cm (1.2in), the species is often hard to find, and you generally have to search many feather stars in order to see one. The one in this image was encountered in Beqa Lagoon, Fiji, and I love the way it sits snuggly in the embrace of the feather star's arms.

▼ NIGHT SUCKER

The Tasmanian Clingfish (*Aspasmogaster tasmaniensis*) is only found in southern Australia and is mainly seen at night. These wonderful tiny fish have a pretty banded pattern and like all clingfish they lack scales, instead having a smooth soft skin. I encountered the one in this image on a night dive under Edithburgh Jetty in South Australia. This image clearly shows a key element of the clingfish – how they cling. Clingfish grip objects via a sucking disk formed by modified pelvic fins. The sucking disk in this clingfish can be seen below and behind the head.

PINEAPPLEFISH

The name kind of gives it away – pineapplefish look like a pineapple. These strange fish have a tough thorny exoskeleton and are yellow and black. That is not the only strange thing about them as they also have headlights – small bioluminescent organs located below the eyes that are used to attract prey. This family contains four species and all like to hide in caves and ledges.

▼ BUNCH OF PINEAPPLES

Pineapplefish are found only in the Indo-Pacific region, with Australia the best place to see these bizarre fish. The most widespread species is the Common Pineapplefish (*Cleidopus gloriamaris*), which is found in many parts of Australia. I encountered this group under a ledge at Cook Island, Tweed Heads. I always enjoy encounters with pineapplefish, as they are very amusing. They are very faithful to the same sites and one group occupied the same ledge off Port Stephens for seven years. These weird fish feed at night, departing their hiding spot to prey on small crustaceans. If you follow them around you may hear them croaking like a frog.

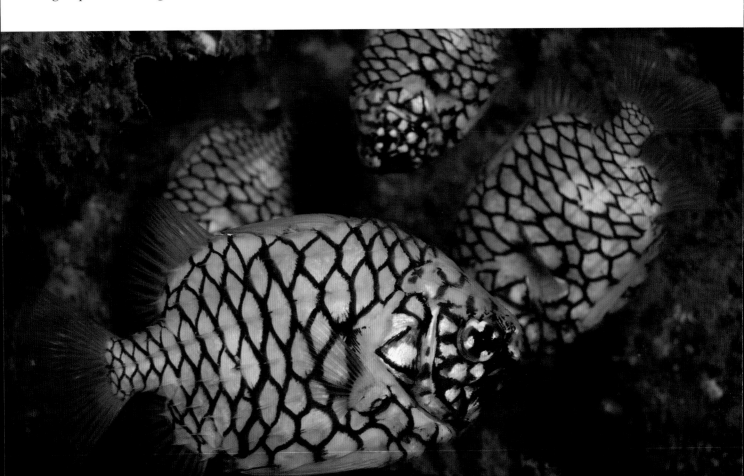

SHRIMPFISH

Also known as razorfish, as their bodies are razor thin and look similar to a cut-throat razor, shrimpfish have a very strange habit of swimming in a vertical position. These weird fish are generally found in schools and like to shelter among corals. The shrimpfish family contains five species, and while these fish are never difficult to find in the right locations, they are very camera shy and have a habit of turning away at just the wrong moment.

▼ SILVER BULLETS

Divers exploring the reefs of South-East Asia regularly encounter Rigid Shrimpfish (*Centriscus scutatus*) drifting over coral gardens or sandy bottoms. These strange fish feed on zooplankton and small crustaceans and have long tube-like snouts. I always find shrimpfish very entertaining and enjoyed following the group in this image across the sand while diving off Bali, Indonesia. They are fun to watch as they always have their head pointing down, but still managed to swim horizontally. And when gathered in a large school they move like a group of synchronized swimmers, turning together as they manoeuvre their way across the bottom.

SEAMOTHS

Looking rather insect-like, seamoths are one of the weirdest fish divers will see in the Indo-Pacific region. This small family contains only five members, and all have protective plating on their bodies, long snouts and pectoral fins that look like insect wings. These bizarre small fish are generally found on sand, slowly walking on their fins looking for food.

▼ RITUAL DANCE

The most common seamoth encountered in South-East Asia is the wonderful Pegasus Seamoth (*Eurypegasus draconis*). Nearly always found in pairs, these very decorative and delicate fish are captivating to watch as they feed or slowly walk across the sand.

The pair in this image was at Lembeh, Indonesia, and they performed a very slow ritual dance. This dance is a prelude to mating and involves the seamoths slowly dancing around each other for ages then suddenly swimming towards the surface to release their eggs and sperm.

VELVETFISH

Whoever came up with the name velvetfish obviously had a good sense of humour as their skin is more like sandpaper. They are part of the large scorpionfish family, as many species have venomous spines. With camouflaged skin, the 40 known species of velvetfish are easily overlooked sitting on the bottom.

▲ THE SAD CLOWN

Australia is the best place to see velvetfish, with a number of species occurring around this vast nation. A common species is the Mossback Velvetfish (*Paraploactis trachyderma*). The one in this image was encountered off the Gold Coast, found hiding in the seaweed. The Mossback Velvetfish is typically rather dull grey in colour, so I was quite surprised to find this one with a dash of yellow. The patterns and textures give this creature a very expressive face, making it look like a sad clown.

237

GURNARDS

The gurnards have large wing-like pectoral fins, but they can't soar through the air like flying fish. In fact these fish prefer to walk on spiny legs formed by modified pelvic fins. This strange family of fish contains more than 200 species that also have plated bodies and large eyes. Gurnards are best found on sandy bottoms, where they spend most of their time searching for prey.

◀ BLUE FANS

Gurnards are more commonly found in cooler temperate waters, with the Eastern Spiny Gurnard (*Lepidotrigla pleuracanthica*) found off the east coast of Australia. I encountered this one off Sydney, slowly walking across the bottom. Gurnards typically have their pectoral-fin wings folded away, but fan them wide to ward off predators. Thinking I was a potential predator, this one gave me a great display, even showing off the false eye-spot on its dorsal fin.

CONVICT BLENNY

Fish don't come much weirder than the Convict Blenny (Pholidichthys leucotaenia)*. This strange eel-like fish is actually not a blenny, but in a family of its own. Living in burrows in the sand or coral, Convict Blennies are rarely seen by divers, but their bizarre behaviour is worth witnessing.*

▼ MUCUS SUCKER

If you are ever lucky enough to encounter a Convict Blenny, the first thing you will see is a school of juveniles. With black and white stripes, they can easily be confused for Striped Catfish, but they behave very differently. In this image, taken at Dumaguete, Philippines, the adult Convict Blenny can be seen spitting out a mouthful of sand, while swarming behind it are the juveniles. I watched this family for quite some time, the adult constantly maintaining the burrow, while the juveniles were swimming around the reef and

darting in and out of the burrow. It was strange and fascinating to watch, but I didn't realise how peculiar until I did more research on Convict Blennies.

It appears that the adult Convict Blenny never leaves the burrow and spends much of its time maintaining the home. The more active juveniles roam the nearby reef and feed on plankton, but return to the burrow at night. The adult doesn't eat plankton, and this is where its gets very bizarre, because instead it sucks mucus off the skin of the juveniles.

SNAKE BLENNIES

Snake blennies are not actually blennies, but are grouped with a collection of eel-like fish called the clinoid blennies. Only found in Australia, the six species of snake blenny are small eel-like creatures that hide under rocks and debris.

▼ UNDER THE DEBRIS

Divers rarely see snake blennies, unless they start lifting rocks and searching the seaweed. I was very fortunate to encounter this Adelaide Snake Blenny (*Ophiclinus antarcticus*) at Edithburgh, South Australia. I was actually looking for frogfish, as a number of endemic species are found under this fabulous jetty. Lifting a lump of broken sponge I was very startled when this lovely Adelaide Snake Blenny slithered out. I had never seen this cute little fish before so shot dozens of images before it slowly snaked back under the debris.

241

ELECTRIC RAYS

One creature that divers never forget a close encounter with is an electric ray. Packing a punch of 200 volts, these small chubby rays have modified muscles that rub together to generate an electric charge. The rays use these electric shocks to stun prey, and also for defence, even against divers that accidentally touch, sit or kneel on them. The electric ray family contains about 70 species, and while some are locally common, most are difficult to find.

A NUMBING EXPERIENCE ▶

The most common electric ray that divers find in Australia is the Coffin Ray (*Hypnos monopterygium*). Also known as the Short-tailed Electric Ray and Numbray, the Coffin Ray is named because of its coffin-like shape, not because you could end up in a coffin after touching one. This widespread species is easily overlooked as it buries under a layer of sand, and most divers have their first encounter by accident.

I had my first encounter with a Coffin Ray when snorkelling as a ten year old. Seeing a strange ray on the bottom I thought it was dead, so reached out to give it a poke with my finger. I quickly learnt that was a big mistake when I got a massive electric shock up my arm. You would think I would have learnt from that first encounter to avoid touching Coffin Rays, but I have been zapped many times since. Fortunately I didn't get an electric shock when I photographed this one off Brisbane.

◀ THE ELECTRIC WRECK

I have found electric rays frustratingly difficult to find on my many dive adventures. I have dived numerous locations where they are reported to be common, and not seen a single ray. However, I once dived an unusual wreck in Egypt's Red Sea that was covered in Panther Torpedo Rays (*Torpedo panthera*).

I had hoped to see this species in the Red Sea, but didn't find one until a dive on the *SS Rosalie Moller*. I expected the electric rays to be hidden under a layer of sand, so was very surprised to find several of them simply resting on the deck of the ship. Even then they were not easy to find because of their small size and camouflaged skin pattern. They were so well camouflaged that I almost lay to top of one when taking a photo, saved at the last minute by my very attentive wife Helen.

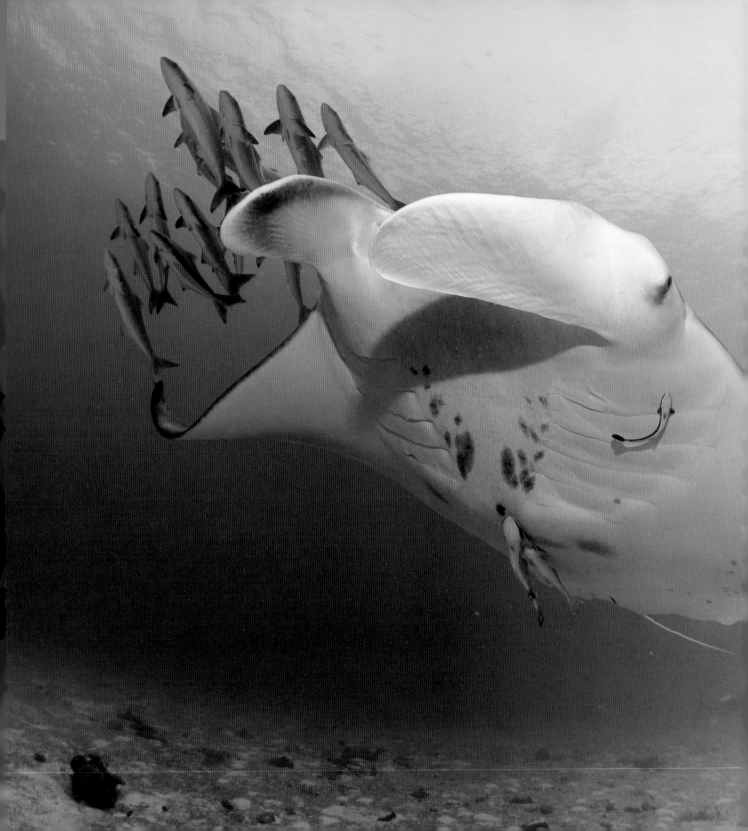

THE MAJESTIC

There are many marine animals
that are simply majestic to watch
as they glide through the water.
These creatures take your breath
away, either from their size,
grace or other-worldly presence.
Encounters with these animals are
always unforgettable.

• • • • •

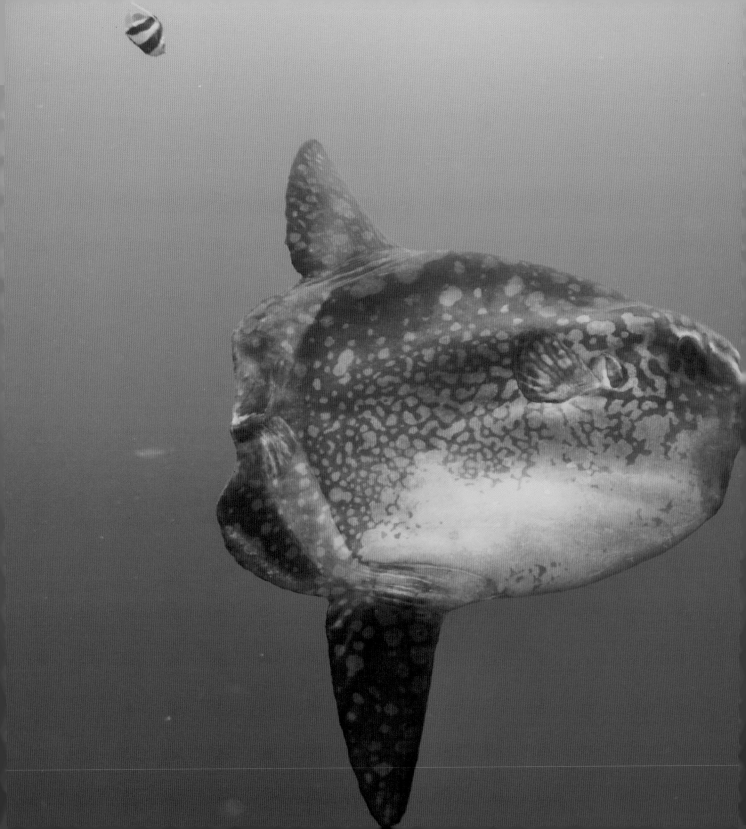

SUNFISH

..

The sunfish are the largest of all the bony fish, with the family containing five species. These massive fish have a very bizarre body shape, essentially a giant disk propelled by two paddle-like fins. Roaming the open oceans, sunfish are rarely seen by divers, but there are a few special places where they can be encountered.

◄ CHILLING WITH A SUNFISH

The only member of the sunfish family that divers regularly encounter is the massive Oceanic Sunfish or Mola Mola (*Mola mola*). These large fish can grow to more than 3m (9.8ft) tall and primarily feed on sea jellies. Mainly found in the open ocean, often close to the surface, they occasionally make forays inshore to get cleaned. The most famous Mola Mola cleaning station is found off Nusa Penida, near Bali, Indonesia.

Nusa Penida is located in the deep Lombok Channel, where cold upwellings provide abundant food for the Mola Mola. Between feeds they visit a site called Crystal Bay to rid themselves of parasites. These giant fish are best seen from July to November, and during this period thousands of divers brave the chilly waters of Crystal Bay. The Mola Mola in this image was one of two I briefly encountered getting cleaned by Schooling Bannerfish (*Heniochus diphreutes*). Unfortunately the encounter was far too brief, as a group of over-enthusiastic divers charged at them and scared the giant fish back to the depths.

THRESHER SHARKS

With their elongated tails, the thresher sharks are a very unique group of creatures. They use these long tails to stun fish, cracking them overhead like a whip. The thresher shark family contains three species which mainly live in deep water, but like the sunfish they also journey into shallow water to get a clean.

▼ DAWN SERVICE

Thresher sharks can be seen at numerous places around the world, but to enjoy a really close encounter with one you have to journey to Malapascua, Philippines. Offshore here is a sea mount known as Monad Shoal, and the local dive operators visit this site at dawn to watch the Pelagic Thresher Sharks (*Alopias pelagicus*) getting cleaned.

Watching the parade of Pelagic Thresher Sharks at Monad Shoal is a breathtaking experience. The sharks have no fear of divers and patrol the wall and the gathered divers. I even saw one head to the surface and breach. However, I had the best encounter when I moved away from the other divers. Settling near a coral head and slowing my breathing right down, the wonderful shark in this image became accustomed to my presence and on each pass around the coral head it got closer and closer. After three slow passes its cleaning was done for the day and it disappeared back down the wall.

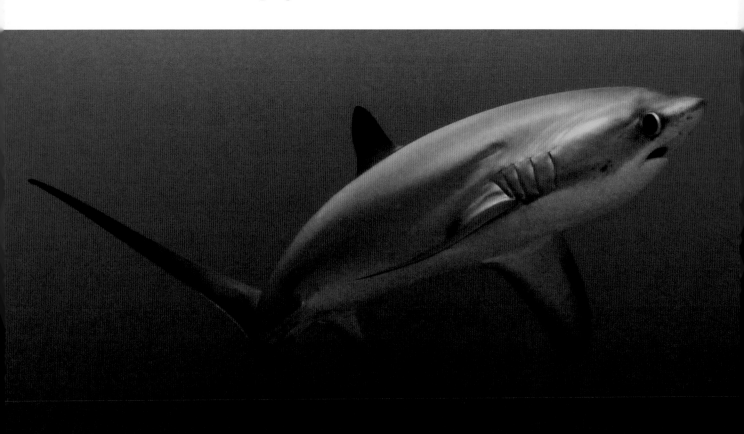

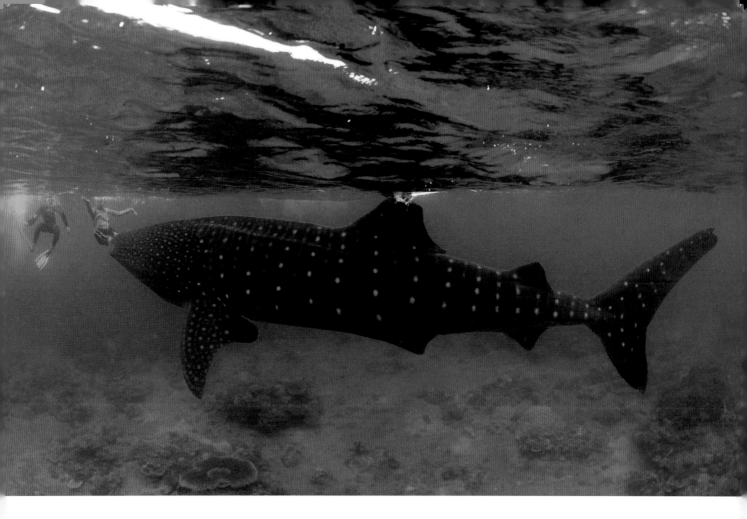

WHALE SHARKS

*The largest fish in the sea is the majestic Whale Shark (*Rhincodon typus*). Growing to a length of 14m (46ft), these incredible creatures feast on tiny plankton. Several decades ago encounters with Whale Sharks were very rare, but in recent times many locations have been found where they gather to feed.*

▲ *GENTLE GIANT*

I have been fortunate to encounter Whale Sharks at a number of destinations and still get a buzz from seeing these graceful giants. One of my favourite encounters was at Sogod Bay, Philippines. Whale Sharks gather here from November to May and can turn up anywhere in this sheltered body of water. Looking for the sharks is half the fun, as in Sogod Bay they don't use spotter planes, but employ local fishers with their canoes. Once spotted it is into the water to swim with these impressive creatures. The one in this image was about 6m (20ft) long and it was magic to watch it slowly cruising over the corals.

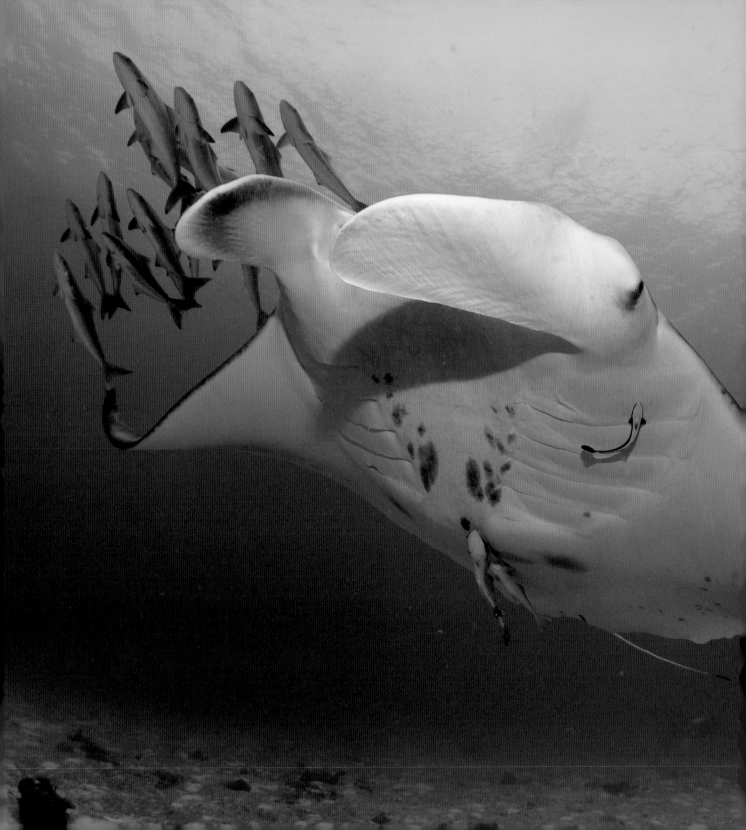

MANTA RAYS

Manta rays are part of the devilray family which also contains the similar-looking mobula rays. These massive rays are very distinctive with their cephalic fins on each side of the head that help to funnel plankton into their wide mouths. The manta ray family only contains two species, and both are very majestic animals of the deep.

◀ THE CURIOUS FLYING CARPET

I encountered my first Reef Manta Ray (*Manta alfredi*) off Lady Elliot Island, Australia. This Great Barrier Reef island is one of the best places in the world to see manta rays, and in a week-long stay I encountered dozens. Most of the giant rays were simply swimming around, like this one I photographed on a later trip, but others were feeding and some were also getting cleaned. I also discovered how curious these magnificent rays are.

On one dive I was exploring a giant coral head, peering into every ledge for small critters, when I suddenly felt like I was being watched. Turning around I found I was being observed by a Reef Manta Ray, its eye only a foot away. The curious creature was checking to see what I was peering at, and once satisfied it glided away.

253

DOLPHINS

Dolphins are among the most graceful and majestic animals on the planet. Watching these creatures effortlessly swim through the water is always a joy. While they spend much of their free time playing, dolphins don't waste much of their leisure time on divers. The dolphin family contains about 40 species, and most are very shy and elusive animals.

▼ IN A SPIN

While there are a number of locations around the world where dolphins interact with people, most underwater encounters are frustratingly very brief. I have seen dolphins underwater countless times, mainly racing by in the distance, but I had one unforgettable encounter in the Maldives that left me in a spin.

I was diving in a channel at Meemu Atoll looking for sharks when I heard a distinctive series of clicks and whistles. Peering into the blue, the source of the noise could be faintly seen – a pod of dolphins. I swam like crazy into the middle of the channel and was rewarded with an extraordinary sight, a large pod of Spinner Dolphins (*Stenella longirostris*). A group of 50 streaked past and were quickly followed by another group, then another and another. It was an incredible spectacle as pod after pod of these delightful creatures swam by, totalling several hundred animals. The procession only lasted two minutes, but the encounter is locked in my memory forever.

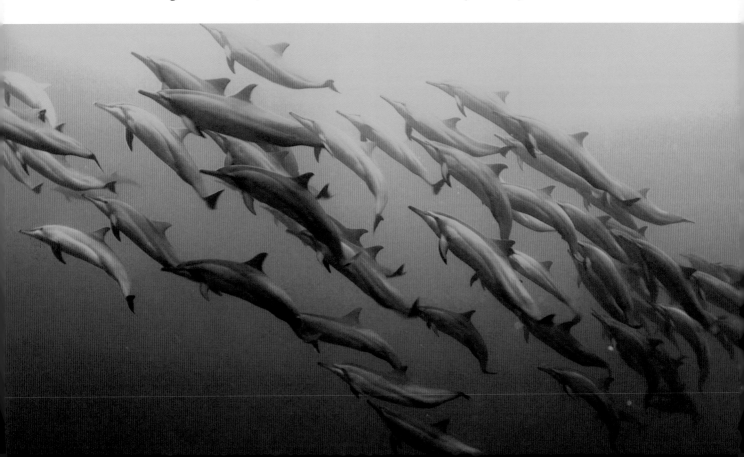

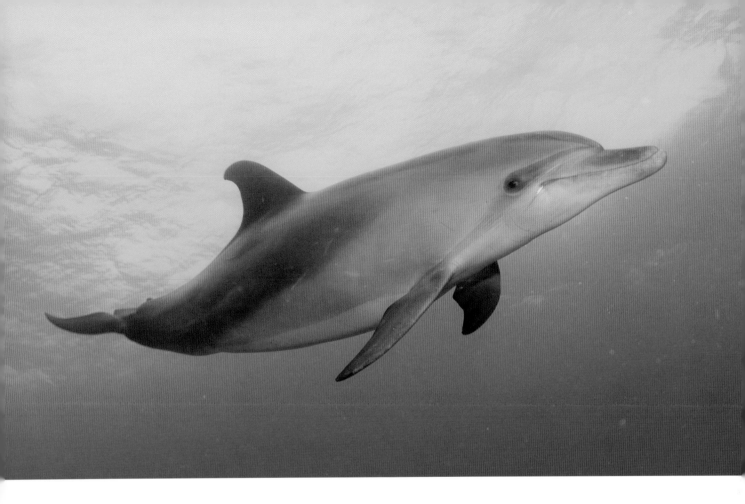

▲ DOLPHIN HOUSE

The bottlenose is the best known species of dolphin, due to *Flipper* and having to perform at dolphin shows. There are actually three distinct species of bottlenose dolphins. While these dolphins appear to be more friendly than other species, they are just as elusive. However, I did have one unforgettable encounter with Indo-Pacific Bottlenose Dolphins (*Tursiops aduncus*) in the Red Sea off Egypt.

Diving a site called Dolphin House you would expect to see dolphins, but I didn't expect to see them at night, so had a macro lens on my camera. Just before I plunged into the water a group of dolphins appeared. No time to change lens, I jumped in and headed in the general direction of them. I could hear clicks and whistles, then suddenly I was surrounded by dolphins. I couldn't believe it, I had a dozen around me and they were in a very playful mood. One dolphin quickly singled me out and was closely circling me, only a metre away. It was a magical experience that ended as quickly as it started, and after only a few minutes the dolphins had departed. Fortunately I got to explore Dolphin House the next morning with a wide-angle lens, and captured this image.

WHALES

The largest animals to ever live on this planet are also some of the most elusive, the whales. These massive mammals are very shy and private, and most don't want anything to do with people; and who can blame them with our history of whaling. About 50 species of whales are recognised, and while most are wary of divers, close encounters are possible and unforgettable.

THE SINGING GIANT ▶

One of the more friendly members of this family is the Humpback Whale (*Megaptera novaeangliae*). These large whales are encountered in their winter breeding and calving areas in both the Southern and Northern Hemispheres, and are famous for their haunting songs. While many divers have had long encounters with a curious Humpback, most of my meetings have been very brief, like these two photographed off Mooloolaba, Australia. I have seen them underwater many times and I am always amazing at how quickly they move for such a large animal. The thing I most enjoy is hearing them sing – at times this singing is so loud you can feel it vibrating your body. It was once thought that male Humpback Whales sang to attract females, but these songs are more likely used for navigation.

◀ *SEEKING FRIENDS*

Only one species of whale appears to enjoy the company of humans and even seeks us out – the wonderful Dwarf Minke Whale (*Balaenoptera acutorostrata*). These whales go out of their way looking for boats and divers, and will stay around for hours and sometimes days. Spending the summer in Antarctic waters, during winter they frolic around Australia's Great Barrier Reef. This one was encountered on the Ribbon Reefs, which is considered to be the best place to see one of these friendly whales. There were actually two whales, a mother and calf, and while we could see them swimming together on the edge of the visibility, it was only the mother that came in close to inspect our group of snorkelers. It was a magical experience to have this majestic creature swim around us, seeking out a little human contact.

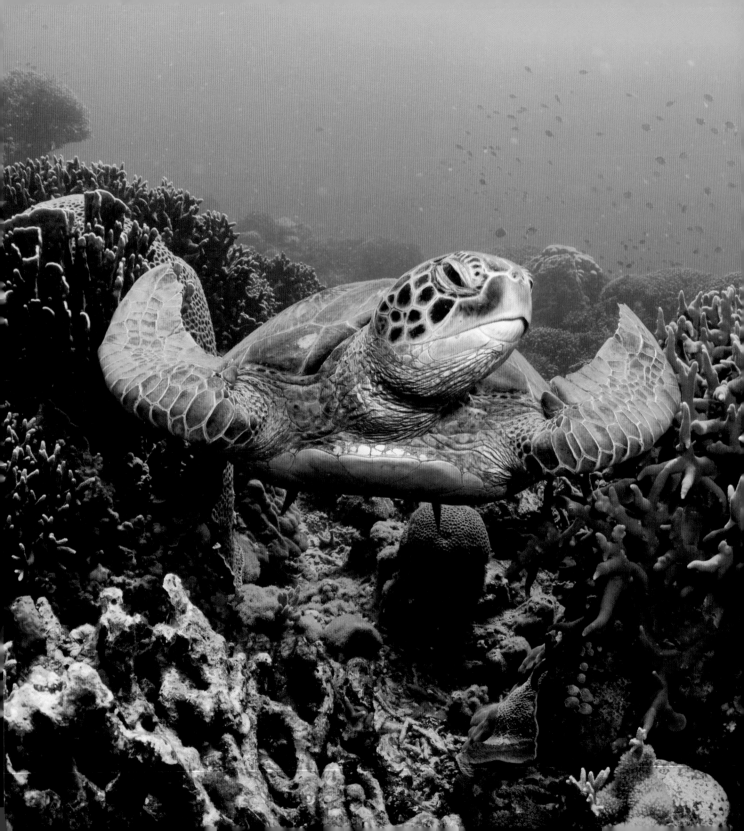

INDEX

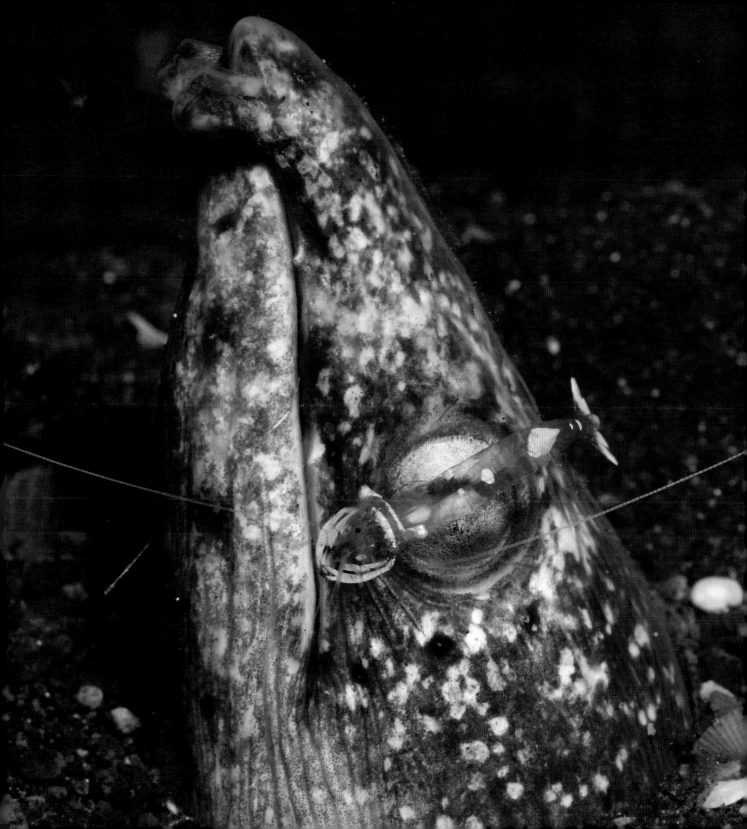

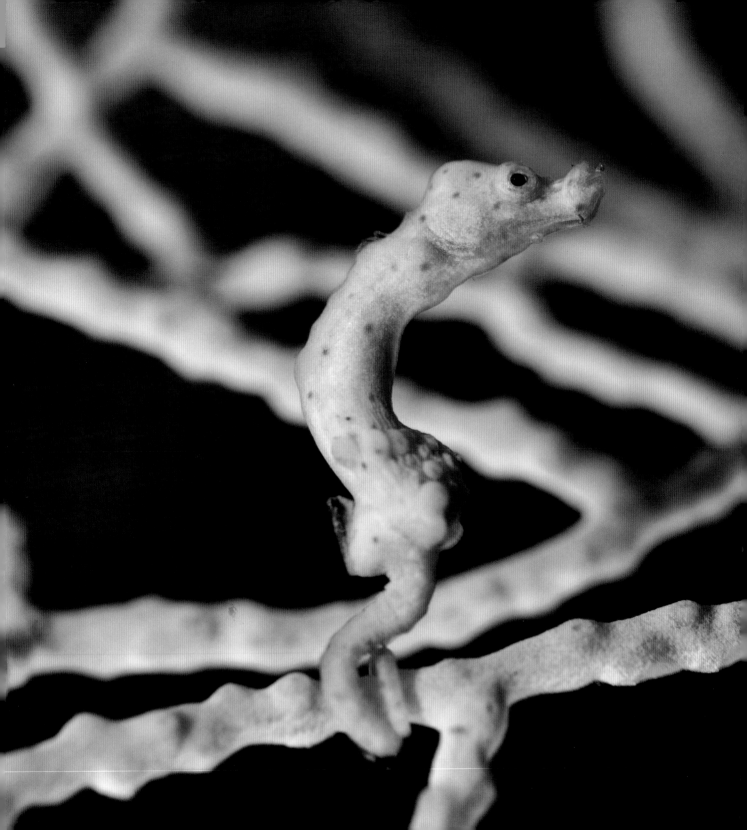

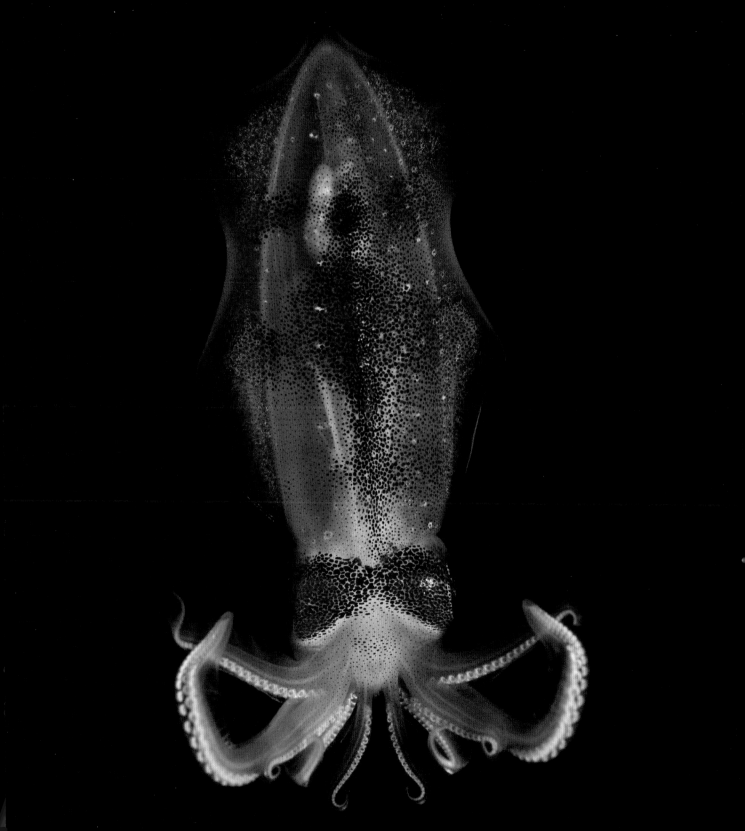

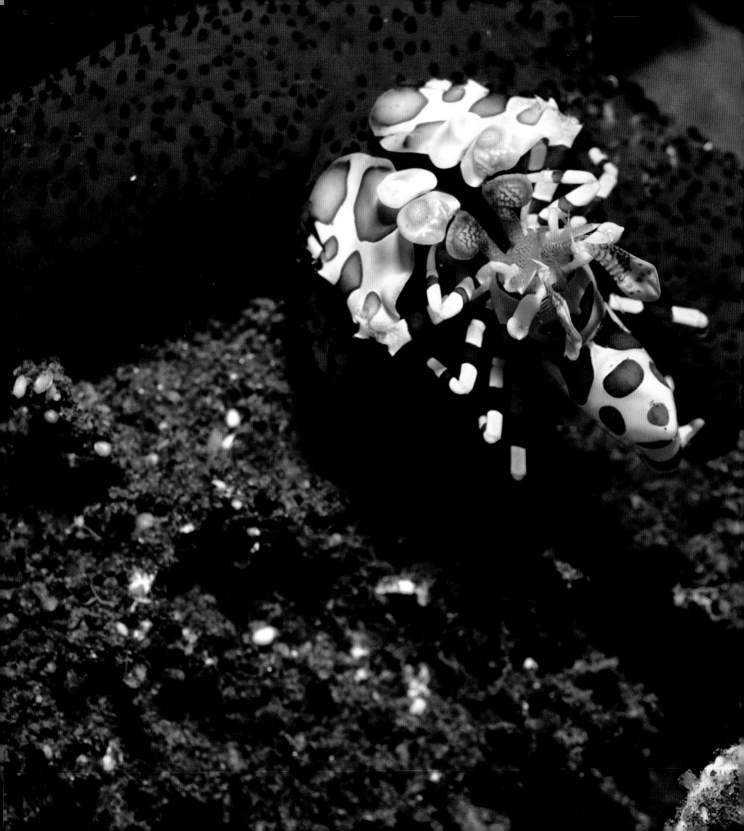

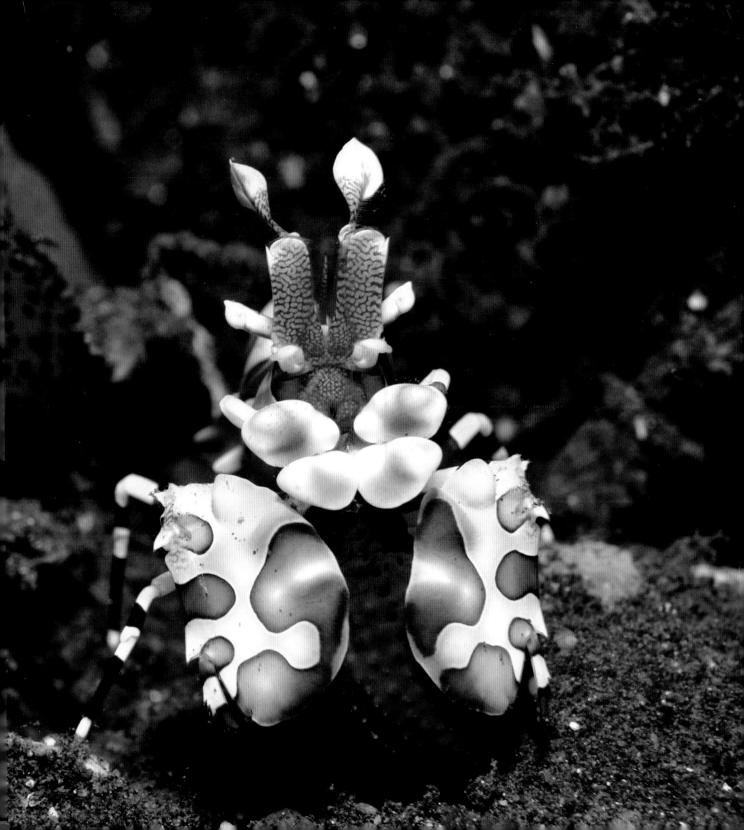

First published in 2018 by Reed New Holland Publishers Pty Ltd
London • Sydney • Auckland

131–151 Great Titchfield Street, London W1W 5BB, UK
1/66 Gibbes Street, Chatswood, NSW 2067, Australia
5/39 Woodside Avenue, Northcote, Auckland 0627, New Zealand

newhollandpublishers.com

ISBN 978 1 92554 618 7

Group Managing Director: Fiona Schultz
Publisher and Project Editor: Simon Papps
Designer: Sara Lindberg
Production Director: James Mills-Hicks
Printer: Toppan Leefung Printing Limited

10 9 8 7 6 5 4 3 2 1

Keep up with New Holland Publishers on Facebook
facebook.com/NewHollandPublishers

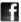